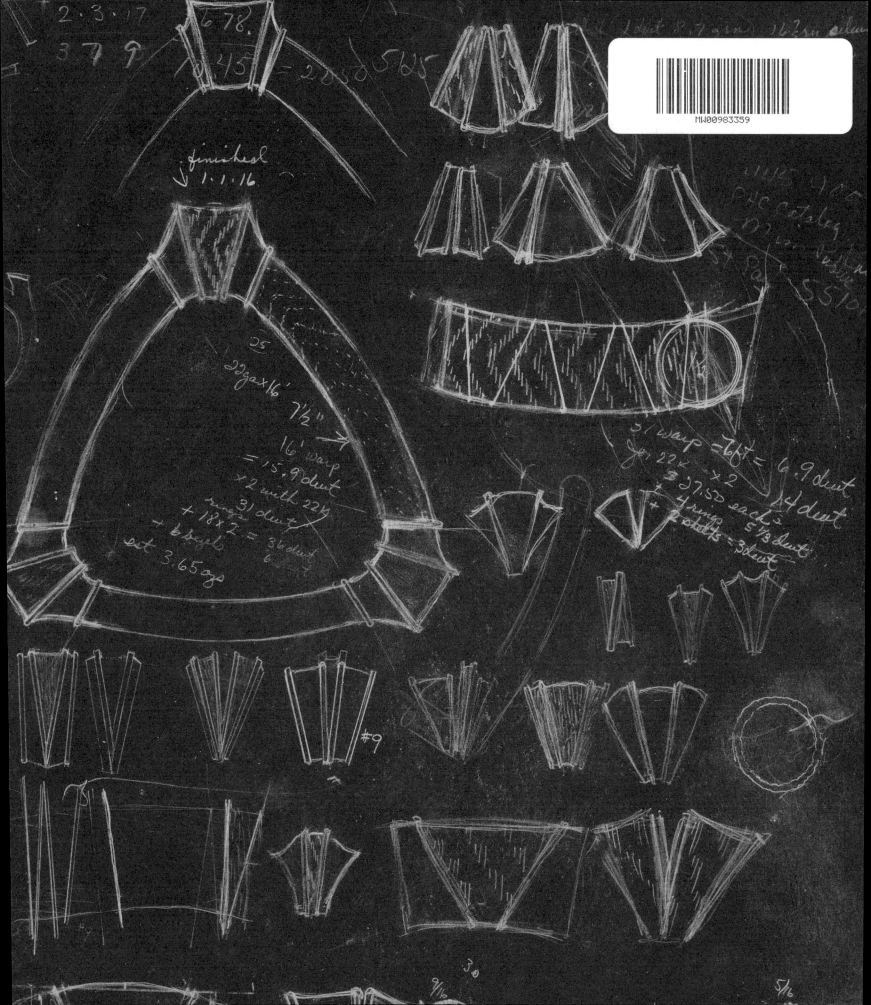

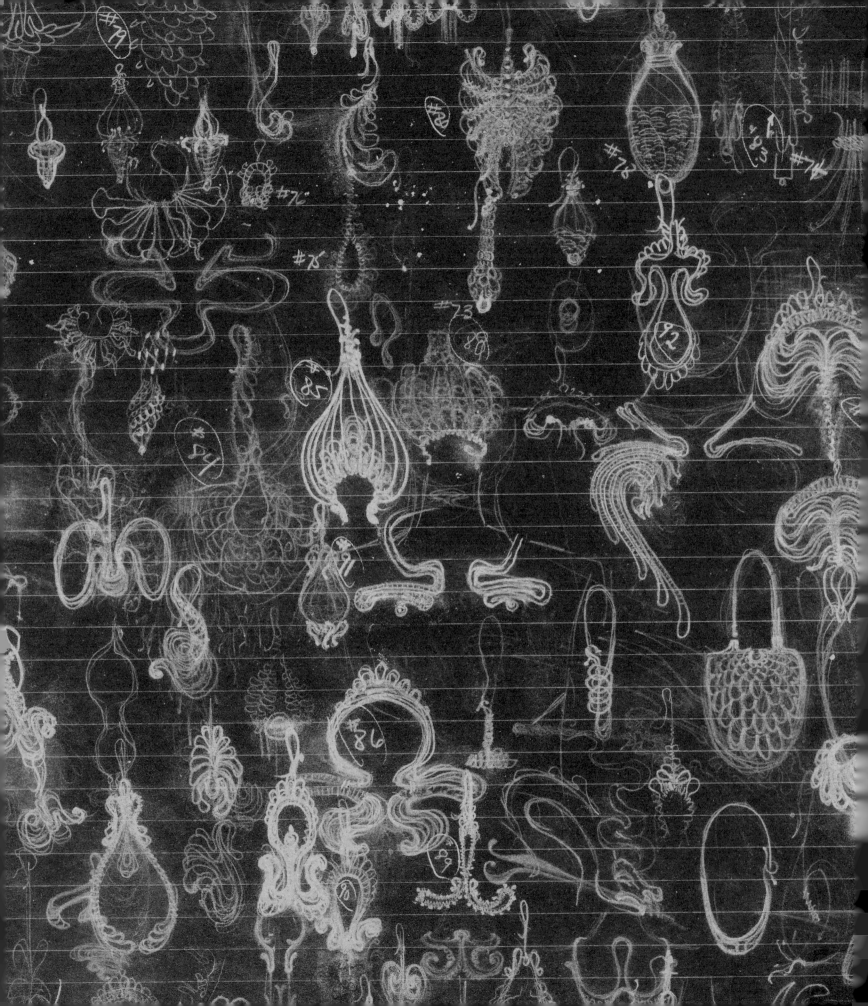

KNITTED, KNOTTED, TWISTED & TWINED

# KNITTED, KNOTTED

BELLEVUE ARTS MUSEUM

# TWISTED & TWINED

## THE JEWELRY OF MARY LEE HU

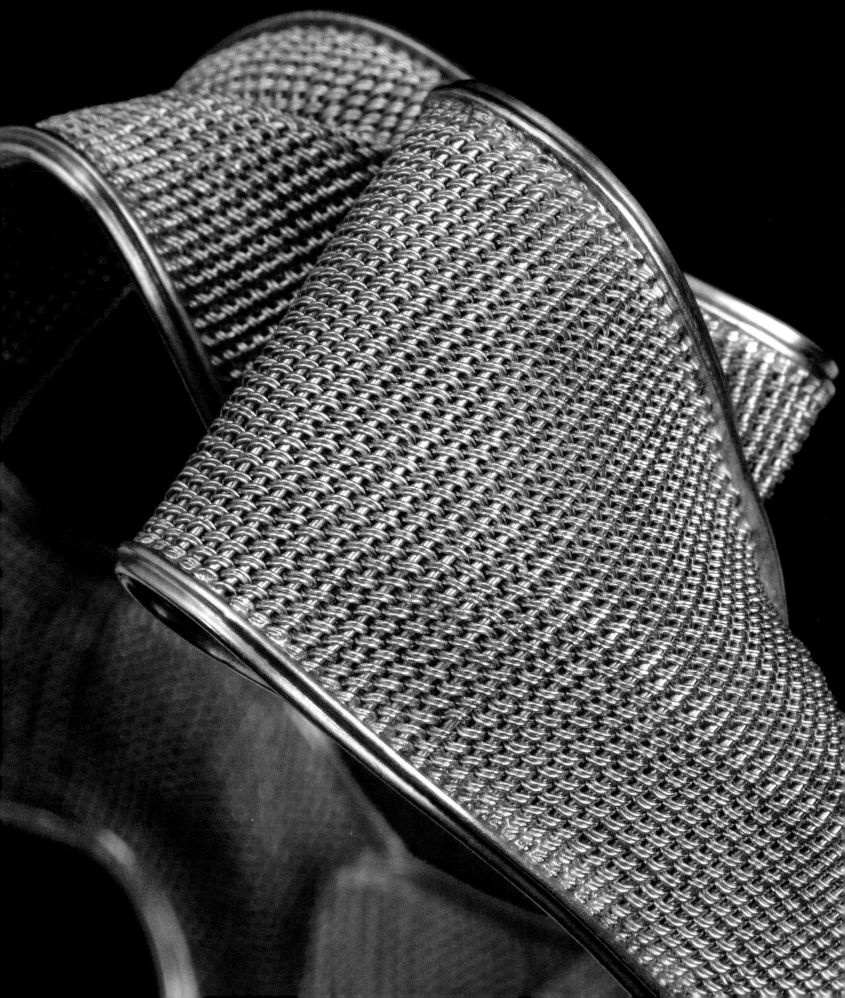

# CONTENTS

6

**FOREWORD**

Stefano Catalani

8

**THE REWARDS OF CONSTRAINT: THE WORK OF MARY LEE HU IN CONTEXT**

Janet Koplos

20

**A HARMONY OF THE SPHERES: THE JEWELRY OF MARY LEE HU**

Jeannine Falino

33

**PORTFOLIO**

118

**CHRONOLOGY, EXHIBITIONS, AND COLLECTIONS**

129

**WORKING WITH WIRE**

138

**GLOSSARY**

143

**CHECKLIST OF THE EXHIBITION**

148

**BELLEVUE ARTS MUSEUM TRUSTEES AND STAFF**

150

**ARTIST'S ACKNOWLEDGEMENTS**

# FOREWORD

*Knitted, Knotted, Twisted & Twined: The Jewelry of Mary Lee Hu* is one of a series of exhibitions and monographs published by Bellevue Arts Museum celebrating leading Pacific Northwest–based figures in the contemporary American craft movement. The series was inaugurated in 2005 to pay tribute to the richness, fecundity, and relevance of the work being created with great skill and lasting vision by some of the region's finest makers, while honoring and strengthening the Museum's mission of exploring art, craft, and design regionally, nationally, and internationally.

This retrospective exhibition and its accompanying splendid publication constitute the first comprehensive look at Mary Lee Hu's oeuvre. With approximately one hundred exquisite chokers, earrings, rings, brooches, and neckpieces, drawn from public and private collections nationally and internationally, *Knitted, Knotted, Twisted & Twined* traces the evolution and refinement of Hu's processes and skill from her earliest experimental pieces in the late 1960s to the confidence and mastery of her contemporary creations. This handsome catalogue will remain to honor her achievement long after the exhibition closes. It reveals, through the insightful, in-depth essays of Janet Koplos and Jeannine Falino, the major turning points in the artist's creative trajectory, and presents a brilliant record of her accomplishments.

First introduced to metalsmithing in high school, Mary Lee Hu continued her exploration of the medium in college, earning her BFA from Cranbrook Academy of Art in 1965 and her MFA from Southern Illinois University at Carbondale in 1967. Shortly after graduation Hu began teaching, settling at the University of Washington in 1980, where she taught in the Metals program until her retirement in 2006. Over the past forty years, she has affirmed her distinctive voice in the world of jewelry.

Using wire the way hand weavers use threads, Hu has blazed a trail both as artist and innovator, exploring the nexus between metalsmithing and textile techniques, often through the recovery of precedents from the near and ancient past throughout the world, following her innate aspiration to perfection and her stubborn curiosity in pursuing aesthetic challenge. Her graceful and apparently effortless creations, formed by intricate twining, twisting, and knotting, investigate both the possibilities and limits of wire as they fuse fiber art and jewelry, structure and pattern, light and line.

The exceptional beauty and unmistakable style of Mary Lee Hu's jewelry is recognized and celebrated throughout the world through its inclusion in such major collections as the Victoria and Albert Museum and Goldsmiths' Hall, London; The Renwick Gallery, Smithsonian Institution, Washington, DC; the Museum of Fine Arts, Boston; The Metropolitan Museum of Art, New York; the Museum of Fine Arts, Houston; The Museum of Arts & Design, New York; and the Art Institute of Chicago. We are honored to have had the opportunity to play a critical role in her artistic life by offering to a wide audience this comprehensive and intimate look at her work.

The creation of an exhibition and catalogue having the scope and breadth of *Knitted, Knotted, Twisted & Twined: The Jewelry of Mary Lee Hu* could have not been possible without the support and assistance of many people. Selecting pieces representative of a lifetime of creativity was not easy; moreover, tracking down works disseminated all over the country, often with no more than a twenty- or thirty-year-old address or phone number in our hands, provided many puzzles. We are deeply appreciative of the artist's patience and cooperation throughout the planning of the exhibition and the

catalogue; her thoughtful comments and guidance have been invaluable and are in evidence throughout.

I want to thank the Windgate Charitable Foundation for their enthusiasm in supporting the idea of a publication since the early stages of planning; without their generous support this book could never have come into being. I am deeply thankful for the additional support so generously provided by the artist herself, as well as by Susan C. Beech, Bernice Bennett, The Florence Duhl Gallery Collection, Susan and Lonnie Edelheit, Facèrè Jewelry Art Gallery, Mary Jane Hashisaki, Jane Korman, Andy and Ginny Lewis, Nancy Abeles Marks, and Dorothy R. Saxe.

Very few exhibitions are realized without the assistance of avid collectors and the artist's galleries. We are particularly indebted to them because of their willingness in lending to the museum and sharing with a wider audience the works in their possession. Our gratitude goes to: Phillip Baldwin, Leanette Bassetti, Susan C. Beech, Bernice Bennett, Karen Johnson Boyd, Christopher Braun, Florence Duhl, Susan Edelheit, Daphne Farago, Marion W. Fulk, Emily Gurtman, Mary Jane Hashisaki, Mary Louise Hopkins, Karen Raven Kim, Brent and Diane Kington, Jane Korman, Pavia Kriegman, Andy and Ginny Lewis, Jeanne Lurie, Laurie Lyall, Jordan Mai, Nancy Abeles Marks, John and Jane Marshall, Elise Michie, Catherine Mouly, Nancy Demorest Pujol, Rita Rosen, Dorothy R. Saxe, Donna Schneier, Alexander and Rebecca Stewart, and Nancy Worden, as well as to the Arkansas Art Center; Columbus Museum of Art; Mobilia Gallery; Museum of Art & Design, New York; Museum of Fine Arts Boston; Metal Museum, Memphis; Racine Art Museum; Tacoma Art Museum; The Newark Museum; and Yale University Art Gallery. Last but not least, I would like to thank Susan

Cummins and Karen Lorene for their advice and help in securing loans.

*Knitted, Knotted, Twisted & Twined: The Jewelry of Mary Lee Hu* could have not been realized without the expert assistance of many colleagues. Registrar Ester Fajzi has been indispensable in successfully securing important loans from arts institutions and private collectors alike, and, with the help of Assistant Registrar Cornelia Kimmell, bringing them safely to the museum. Her dedication to this project has extended to coordinating the work of photographer Douglas Yaple, to whom we owe warm thanks for so many of the beautiful images in this publication. Head Preparator Vincent Warner has been an invaluable resource in planning the design and installation of this memorable exhibition, and Curator Nora Atkinson has offered her insights and expertise throughout its planning stages. Development Officer Audrey Fine has worked tirelessly to secure financial support, and we thank Graphic Designer Donna Lundquist for her sophisticated ideas. Beyond the museum, both the expertise of Jeff Wincapaw, designer at Marquand Books, and our editor, Sigrid Asmus, assisted us in creating this sophisticated publication.

I extend my sincerest appreciation and thanks to Bellevue Arts Museum Board of Trustees for their constant support, enthusiasm, commitment, and trust in the museum's mission and its dedicated staff.

Without question, we owe our greatest thanks to Mary Lee Hu for her creativity and depth of vision, which so clearly define the history and character of contemporary jewelry making in the Pacific Northwest and beyond.

Stefano Catalani
Director of Curatorial Affairs

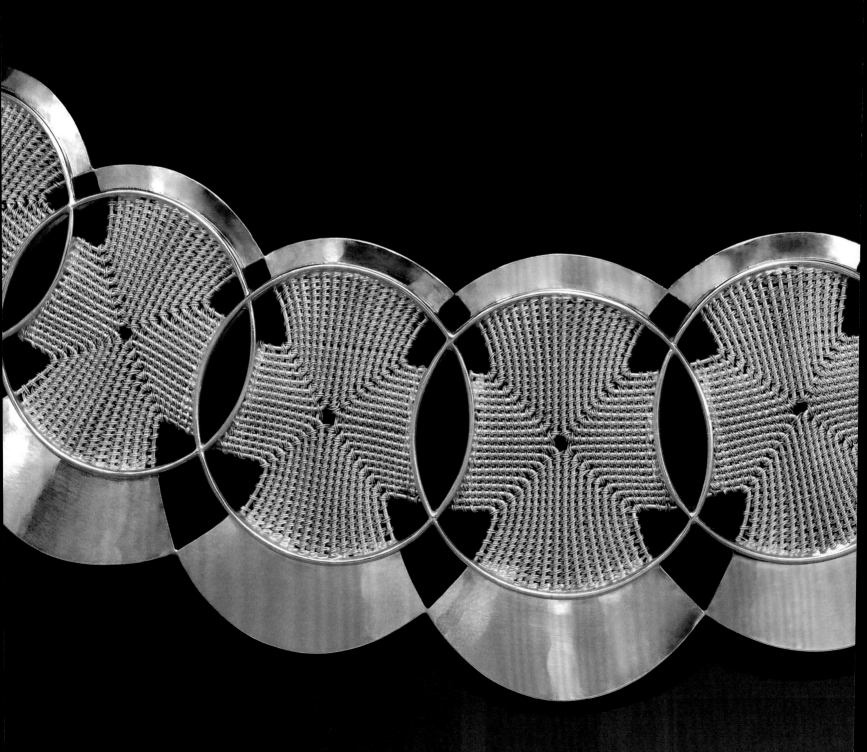

Mary Lee Hu had already discovered jewelry (precociously, in high school) as the 1950s turned to the 1960s. Nowadays we characterize the fifties as the time of suburbs, wives at home, bobby sox, and Eisenhower in office—mostly conventional and boring, although it was also the time of the Cold War, Sputnik, and the Beats. The sixties were more consistently a decade of shock and upheaval, including the new sound and look of the long-haired Beatles; the assassinations of John F. Kennedy, Martin Luther King, Jr., and Robert Kennedy; the Watts riots; the Free Speech Movement; the Stonewall uprising and the beginning of the gay rights movement; and protests against the Vietnam War. In art, the 1950s saw the dominance of Abstract Expressionist painting, while the 1960s experienced strongly contradictory styles, such as Pop Art and Minimalism.

These two decades were also a time of great changes in the crafts. As the fifties ended and the sixties began, Peter Voulkos in clay and Lenore Tawney in fiber spearheaded striking and ambitious changes in scale, physical aura, and metaphorical ambition in their mediums. Jewelry, too, was enduring reevaluation and the struggle of ideas. Among the conventions being tested were form, material, size, and craftsmanship itself. These changes in the crafts were not deviations from aesthetic continuity, because there was none. In all mediums, many traditional techniques had been lost long before, in the change from artisanry to industry. When the crafts burgeoned after World War II, with veterans inundating the art schools, there was a real problem with knowledge flow: Who knew enough to teach?

In the face of this problem, Margaret Craver organized the Handy & Harman summer workshops in metalsmithing techniques between 1947 and 1951, importing European masters to lead classes. Schools hired Europeans to teach, as well. The dominant style of the 1950s was the elegant and tasteful Scandinavian mode, shaped by the long-term success of manufacturers such as Georg Jensen and by those immigrant teachers, for example John Prip and Hans Christensen, who were recruited from Denmark in 1948 and 1954 respectively to teach at what is now the School for American Crafts. Craver herself studied in Sweden.

Other craft teachers across America researched and practiced on their own, barely staying ahead of what their students were doing in class. Thus the rediscovery and mastery of techniques themselves were routes to success at mid-century, something that brought attention to individuals and advancement to teachers. In ceramics, Glen Lukens first gained attention for re-creating an Egyptian Blue glaze; F. Carlton Ball derived stature from being one of the first studio potters in California who could throw on the potter's wheel; Laura Andresen was noted for mastering porcelain, which was then seldom used outside industry. In metals, Bob Winston pioneered lost-wax casting, John Paul Miller is famed for his reintroduction of granulation, Phillip Fike recovered the niello technique, and Brent Kington led the expansion of blacksmithing.

It was Kington who recognized the potential of textile techniques in metal for Hu, when, as a graduate student under his tutelage at Southern Illinois University, Carbondale, she had the bright idea of fulfilling assignments in both textile and metals classes with the same work. He told her to make two pair of earrings per week as a way of testing wire. She plunged into it, doing her first experiments in brass and then switching to fine silver wire. She started by knotting, but rapidly discovered that wrapping or weaving was better because the metal didn't become rigid from so much bending. That was in 1966. Then she began to use what might have been an earring as a pendant and moved into necklaces. By 1974 she began to use twining as her favored method.

Marriage to a Chinese mathematician she met at Carbondale soon led to an interruption in Hu's career development when they temporarily moved to Taiwan. Although her husband died suddenly while they were there, this permanent interest in and connection to Asia, along with her subsequent travels in South and Southeast Asia, were to prove a tremendous boon to her knowledge of other textile traditions in metals. Yet the sojourn in Taiwan briefly—and literally—distanced her from the ongoing developments in America.

### PREDECESSORS AND SENIORS

The American scene was then an active one across all generations. Among those jewelers reaching their creative maturity in the 1960s and about twenty years older than Hu was Charles Loloma (1921–1991). He had studied ceramics at Alfred University but gradually began to make jewelry which, in its materials—such as turquoise and silver—referred to his Southwestern Native American origin. He operated with great freedom because he was a Hopi and the Hopi had no metal jewelry tradition, unlike the neighboring Navajo and Zuni peoples. Among his innovations was setting a variety of flat pieces of stone in channels, so that they projected outward and created a profile that might suggest landscapes or cityscapes as well as modernist abstract compositions. He also sometimes set stones on the inside of a ring or bracelet, to provide a private experience for the wearer. His massing of stone conveyed the vigor and strength of the individual elements, so that each color or surface had a graphic identity.

Miyé Matsukata (1922–1981), born in Japan but long resident in the United States, likewise was not constrained by tradition, since the forms of jewelry in Japan were traditionally not much more than hair and belt ornaments. Her elements—gold, precious stones, and ancient artifacts including coins, ceramic fragments, or bones—were held in open, abstract compositions that could be compared with biomorphic motifs in painting.

Among jewelers just a decade older than Hu, the innovations of the 1960s involved considerations of size and technical mastery, as well as unexpected materials. Stanley Lechtzin (b. 1936) is a prominent example. Lechtzin, in the mood of the time, wanted to work bigger, but found that in large dimensions cast metal was too heavy to wear. His innovation was to adapt the industrial technology of electroforming to produce a thin,

lightweight shell of metal. Further, he created this shell around carved Styrofoam or poured wax, achieving shapes and textures entirely new to jewelry, some of which could almost be called grotesque. All were at least intimidating in their rough, gem-stabbed beauty.

Fred Woell (b. 1934) used the detritus of industry rather than its techniques: he incorporated buttons, bottle caps, beer-can tops, bullet shells, staples, and the like in works that made sociopolitical comments or that expressed emotional messages. In his Badge series, none of the presumed sources of value were present: no precious materials and no evidence of great skill. The value lay in the concept or message of the maker. That was an exceptional position in jewelry, which has typically been defined by other terms.

Another innovator of the generation just before Hu is Arline Fisch (b. 1931). Fisch, after graduate school, studied jewelry techniques in Copenhagen, and on the second of her stays there, in 1966, she produced a blend of metal and fabric that she called *Body Ornament*. Inspired by Peruvian garments in which tiny panels of gold were sewn onto fabric, she composed chased and forged segments of sterling silver into a treelike shape that reached from shoulders to shins on the front of a plain black garment, and included a related but simpler back panel as well. This dramatic and beautiful work was more akin to stage costume or perhaps the regalia of royalty than to something an ordinary person could wear even for a special occasion (how could you sit down?). But it made a point and had an impact.

Fisch had also been teaching weaving and had created a few other more modest blends of fiber and metal. When she was asked to write a book on textile techniques in metal she began to research various methods and also look into the history. Fisch not only published the book (*Textile Techniques in Metal for Jewelers, Sculptors, and Textile Artists*, 1975) but made a great number of works in such techniques.

Some early, densely woven bands of silver by Fisch incorporate a fringe of feathers. A passel of dinner rings made in the late 1970s and early '80s used elaborate braid construction instead of jewels. But, besides the *Body Ornament*, her most memorable works are some airy, spreading collars and other less-common forms that she knitted of wire (fig. 1). Fisch seems to have preferred gauzy constructions of wire strong enough to hold a form. She is indelibly associated with textile techniques in metal because of the book and because of her explorations. In addition to knitting she wove strips of sterling silver, platinum, and aluminum—with an occasional touch of gold—in a great variety of forms, including pleated collars, spiraling brooches, and spreading necklaces that hug the shoulders, all in relatively large scale.

**COMPARISONS AND DISTINCTIONS: THE 1970S**

While Fisch and Hu are equally identified with textile techniques (and Hu's work was well-represented in Fisch's book), at only three or four points have their works approached similarity. One, of course, is that basic use of textile techniques. Another is that they both played with the

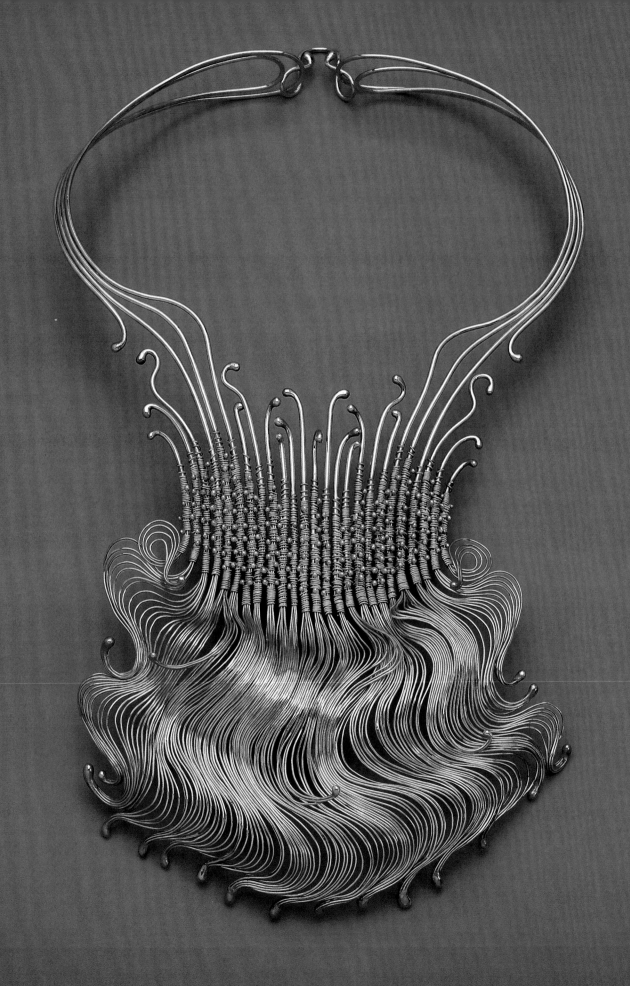

ethnic or hippie look of pectoral-type necklaces in the late 1960s and early '70s (something that many others explored around this time, with Albert Paley the most prominent among them). Fisch's *Bee Pendant* of 1969 could be compared with neckpieces Hu made between 1973 and 1976. Hu's *Neckpiece #9* (1973) and *#13* (1974) both evoke Chinese winged creatures—dragon or phoenix—not surprising because by then she had gone to Taiwan. But more indicative of her future is *Neckpiece #26* (1976), a mostly silver work that evokes not wings but a waterfall. The whole is all but precisely symmetrical, yet its constant curves create a feeling of spontaneous, fluid movement. Even the clasp at the back does not stop the eye's motion, because it depends on two double wire lines folded into loops. At the sides of the neck the four lines are tightly compressed, and then they open at the throat, where the outermost line terminates as if in a drip, while the other three, spaced out, disappear into a row of rising linear splashes, their balled ends inverting the drip effect. This row is constrained by a rising and falling band of gold wire horizontally wrapped around the vertical silver, with the balled ends of the wires giving a foamy texture. The water effect plays out in several inches of parallel undulations of great numbers of finer silver wires. The repetition and consolidation of line—although not this kind of representationally suggestive image—would thereafter characterize her work.

But to return to the comparison: another similarity between Fisch and Hu is that both have made whimsical creatures—with Hu constructing a turtle, a crab, a bird, and lots of insects as technical challenges between 1967 and 1974, and Fisch later making aquatic creatures as a play on her name. And both, in passing, made plaid pieces in textile techniques in 1971.

Yet these exceptions prove the rule: all in all, it's easy to distinguish between their work. Fisch tends to be flamboyant, open, large scale. Hu's work is more contained, highly worked, gracefully repetitive in line. While the majority of the work by both artists immediately calls up the word "elegant" (Fisch's retrospective was in fact called *Elegant Fantasy*), Hu has an advantage in this respect because of her nearly exclusive use of gold after 1985. In addition to the preciousness that comes with our knowledge of the very high cost

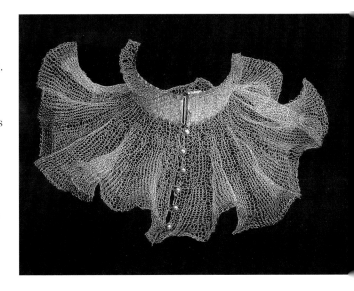

of this material today, gold has a visual warmth that prevents tight structuring from seeming machinelike and cool. Fisch has made a great deal of work outside of textile techniques and has been strikingly committed to experiment both in shape and form, having produced flowers, fans, boxes, "spirit houses," hats, cuffs, buckles, and more. Hu has chosen elemental shapes such as the circular choker—a tight form inspired by ancient torques—and has chiefly elaborated within these formats. Although she has stretched her repertoire with a few brooches and earrings—which tend to have greater variety of form and to be more pictorially free in form—and some rings, one might say that Fisch moves outward, Hu inward.

A few more comparisons to the jewelry of the 1970s might be in order. Pectorals have already been mentioned. The seventies were also a time of baroque expressiveness, of more and more. Donald Willcox provided a snapshot of the time—and what we can now see as both delights and horrors—in a book titled *Body Jewelry: International Perspectives* (1973). It was an effusive period of frivolous complexity in some cases—untamed macramé, for example—yet even among the most eminent jewelers of the time there was a strong push toward ornamentation. This makes a surprisingly sharp contrast with the avant-garde modes of art then current, Minimalism and Conceptualism.

Albert Paley's pendants were vast elaborations, described by long lists of materials as well as multiple parts, organized in asymmetric, unbalanced configurations of force and drama. Richard Mawds-

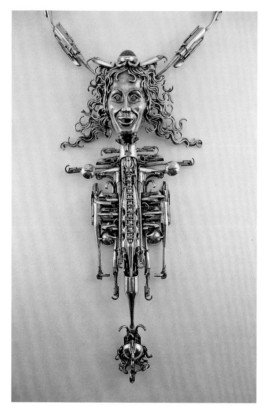 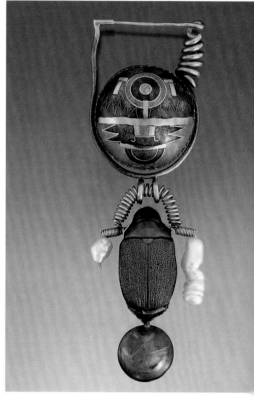

ley's pendants of the same era (fig. 2) were similarly fabricated, but made of diminutive tubing so that a figurative element, such as the torso of Medusa below her repoussé head, seems composed only of bones. It exists as an image and then as a congeries of line, and is strikingly unrestful. William Harper's enamel jewelry pieces of the time (fig. 3) were generally smaller and consisted of fewer elements than Paley's or Mawdsley's, but they are by no means simple. Harper focused on color and shape in the enamels that are the central feature of his

1970s brooches, and he also made a specialty of exotic additions such as snake rattles or beetle carapaces. As a consequence his jewelry pulls the eye this way and that in movement similar to if more diminutive than that provoked by Paley's. Even Mary Ann Scherr's medical-device jewelry was decoratively patterned.

All Hu's works, even the early neckpieces that are her most baroque works, are more reductive than these. Her *Neckpieces #9* and *#13*, mentioned before, along with *#17* and *#18* (both 1974) play on the image of wings. Although they are mostly silver and linear, and in this much like Mawdsley's work, they are full of curves and gradated steps that in size and position give them a fluid smoothness. Their unitary material, visual coherence, and symmetrical balance differ sharply from the works of Paley and Harper. However, these works do share her peers' emphasis on the frontal object or ornament. That's also the case with the first few works that she called Chokers, also from the mid-seventies.

### HER OWN TRAJECTORY

Between 1978 and 1980 Hu shifted her focus from the chest to the neck itself and simplified the Chokers into ring shapes with back fastenings. In each case she has twined a fabric-like, more-or-less-flat band that she varies by means of contour, subtle color change, different edge treatments, interior waves, or a small front feature such as a Kewpie flip. These variations are not flagrant. They seem to be the product of isolation and focus, or

perhaps are a natural extension of her lifelong interest in drawing. Her emphasis on structure and pattern can be compared with the austere yet sensuous line drawings of leaves and flowers that Ellsworth Kelly made in the 1950s, or with the categorizing and defining diagrammatic drawings that Sol LeWitt made in the 1960s. One might also remember—although Hu never cites such influences—that American sculpture had involved line more than mass ever since Alexander Calder's work of the 1930s, and that by the 1950s a great many sculptors were working in a linear idiom, including David Smith, Ibram Lassaw, Herbert Ferber, Theodore Roszak, and Richard Lippold. Calder's own jewelry had been a major influence on American jewelry of the 1940s, and regardless of whether Hu thought about it—or even knew about it—it shaped the context in which her structured and patterned work emerged.

Hu's inwardness, her intense focus, provides exhilarating rewards to the viewer's close-up attention. It brings to mind the phrase "God is in the details" (variously attributed to Flaubert or Mies van der Rohe, and interpreted as meaning that whatever one does should be done thoroughly, or that deep search will yield a vision of perfection). A force of life or sense of presence is discovered in the minutiae of Hu's chokers, for example: the simple ring shape evolves, its minute integers of visible structure intimating cells, its parallel lines evoking the systematic ordering of human intelligence. Take a piece as placid as *Choker #55* (1980). Its raised silver ribbing might remind one

Figure 2. Richard Mawdsley, "Medusa" Pendant
1979–80; Sterling silver, lapis lazuli, fabricated and repousséd; 8½ × 3¾ in. Collection of Metal Museum, Memphis, Tennessee

Figure 3. William Harper, **Pagan Baby #12: The Green Scarab**
1978; 14K and 24K gold, silver, bronze, scarab shell, pearls, bone, glass, cloisonné enamel, fine gold, fine silver; 3⅞ × 1¼ × ¾ in. The Museum of Fine Arts, Houston; Helen Williams Drutt Collection, gift of the Caroline Wiess Law Foundation

of denim or twill fabric, and it is a narrow band that could have been woven on an inkle loom. But the band in this case is not flat: it cups slightly, which makes a shadowy space under it when worn. And more importantly, there are five swells in the band, so that it recalls natural phenomena—contour lines on a map, eddies in water currents, wind marks in sand—without actually depicting any of them. Symmetry here provides an underlying systematic stability but avoids rigidity. While each part predicts the next, one's view (or touch) is carried by the repetitive movement so that the whole feels easily, gracefully inevitable.

Ultimately, one of Hu's great strengths is this visibility of structure: anyone looking at a necklace or bracelet can follow a line as it moves in interaction with others and resolves itself into a cooperative and harmonious pattern. Other strengths are the clarity and balance that are easiest to see in her chokers of the 1990s that are composed of repetitive elements rather than continuous line. A stellar example is *Choker #78* (1991), in which the play of positive and negative is particularly noticeable. An amazingly complex structure, it is based on thin circles that overlap, each within a larger oval that is defined by both positive elements and negative space; each circle is filled with a broad cross shape constructed of parallel lines. These shapes almost might be tiny baskets that just need to be folded and lashed at the seams to become volumetric. On the other hand, they also vaguely evoke prehistoric axe forms. The overlapping rings are more like Venn diagrams than Olympic rings or links of chain but can momentarily evoke those as well. The perfection of this piece, as well as its material, recalls the work of John Paul Miller—the granulation virtuoso a generation older than Hu but likewise inspired by the past, and likewise committed to gold despite its expense. Hu's works of this kind are in the tradition of fine jewelry rather than sharing the democratic modesty of the original Arts and Crafts Movement or the eccentric expressiveness of much studio jewelry.

The simple shapes and the clear structure of her works reveal an incredible universe of creative possibilities. Textile techniques seem to offer infinite variation. This is the reward of constraint: it fosters invention. Hu's contentment with the sufficiency of silver and gold, with textile structure, with circular bracelet and choker forms, offers a comparison to happy constraints in other mediums, functional pottery for example. If one looks closely at a production line of handmade pottery, it becomes obvious that no two are alike, that human hands are neither inclined toward nor capable of machinelike consistency, and that subtleties can open up new associations, a different sense of character, and degrees of presence among forms that at a glance might be described as "the same."

In the 1980s Hu's preference for reductiveness, most extreme in examples from 1980 and 1981, was not shared by the major figures in her field, where complicated and irreverent were more the words of the day. A few examples: Marjorie Schick was producing complex and overscale "collar" constructions of brilliantly painted wood (fig. 4), Hiroko and

Choker #78
1991; 18K and 22K gold
6⅜ × 8⅞ × 1½ in. Collection of the artist

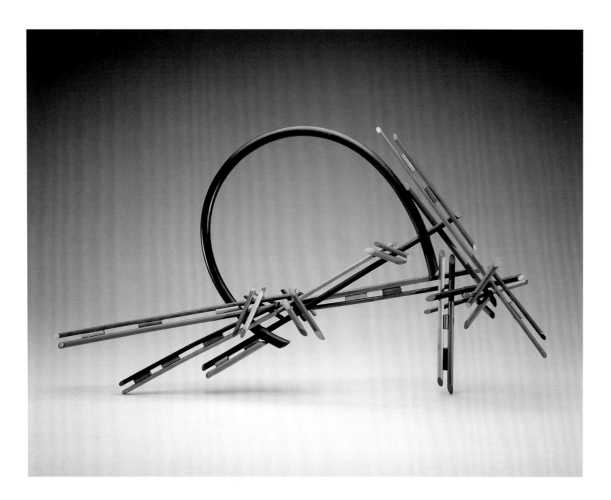

Gene Pijanowski were making parodistically precious, shoulder-width expanses of Japanese gold-foil paper cord, Joyce Scott was creating beadwork necklaces of colliding pop culture imagery, Robert Ebendorf was forming large-bead necklaces of Styrofoam and Chinese newspapers. Hu, meanwhile, was following her own trajectory that, oddly and surely coincidentally, can now be seen to have more in common with the classicism that emerged in studio

furniture in the eighties, as well as a certain post-modern virtuosity that emerged in ceramics at about the same time. Yet her oeuvre cannot adequately be described by either of those words. It is not truly classical because it does not refer to any specific precedent, and—although superlative skill and control certainly characterize Hu's work—to speak of its "virtuosity," a term usually applied to showiness, misses her kind of contained effect.

Figure 4. Marjorie Schick, **Necklace**
1984; Wood, rubber, paint; 12 × 21⅝ × 1¹⁵⁄₁₆ in.
The Museum of Fine Arts, Houston; Helen Williams Drutt Collection,
gift of the Morgan Foundation in honor of Catherine Asher Morgan.

It's tempting, although maybe unfair to others, to call Hu's achievement one of artistic maturity. She does not seem to be searching for novelty and she is confident in her mastery; the sheer pleasure of working a new pattern seems to sustain her. More of the major jewelers of the 1990s show this combination of modesty and mastery—for example Pat Flynn and Sharon Church—although conceptual and social-commentary work would probably be described as the dominant mode of that decade.

Hu's works make no comments. They have no metaphoric aspirations. They are not about anything but themselves—their materials and their making. When the artist talks about her work, she tells how the process of making one piece led to a discovery that shaped the next piece. The nonspecialist viewer will not know about these connections specifically, yet they can be intuited through the gradual introduction of new treatments when the work is seen in chronological display, and from their non-referentiality and self-sufficiency. Thus, for example, *Bracelet #60* (1999), and *Choker #83*, which followed it the next year, show a striking change from the geometric repeats of chokers from the 1990s—those structured with *X* and *O* forms, especially. This gold bracelet in fact consists of a band of diminutive, regular mesh with two glossy edges running the length of the piece: it looks like a swath of narrow fabric finished with satiny seam binding tape.

But the most impressive formal aspect is that Hu has scrunched it up, and the wire holds that imposed form. The result is that it looks like a fluttering ribbon, light, festive, celebratory. One loses all sense of how long it would be if it were fully stretched out, and succumbs to the joyful pleasure of meandering line. Yet in the back of the mind is an awareness of the extravagance of so much extra gold, much more than is needed to span the wrist.

The way Hu is engrossed in her process may seem particular to craft traditions, but that's not necessarily so. This approach is attuned to a strong but subtle undercurrent in twentieth-century art —it can be claimed for most abstract painting throughout the century, and, late in the century, showed itself in installations and other artworks that might be called obsessive for their multiplicity of elements or their repetitive aspects of creation. Such installations can be wonderfully engaging— consider Tara Donovan's assemblies of millions of plastic cups or drinking straws, each carefully placed to create a temporary topography, and clearly conveying the artist's attention and actions as she makes beauty and wonder out of a utilitarian throwaway. Hu's structures likewise offer the tracks of their making, but in a scale that is intimate, a form that eschews the monumental in favor of the personal, and in a material of great preciousness. In her chosen form of work she offers these distillations of time and skill as a gift of pleasure, both for the viewer and for the wearer.

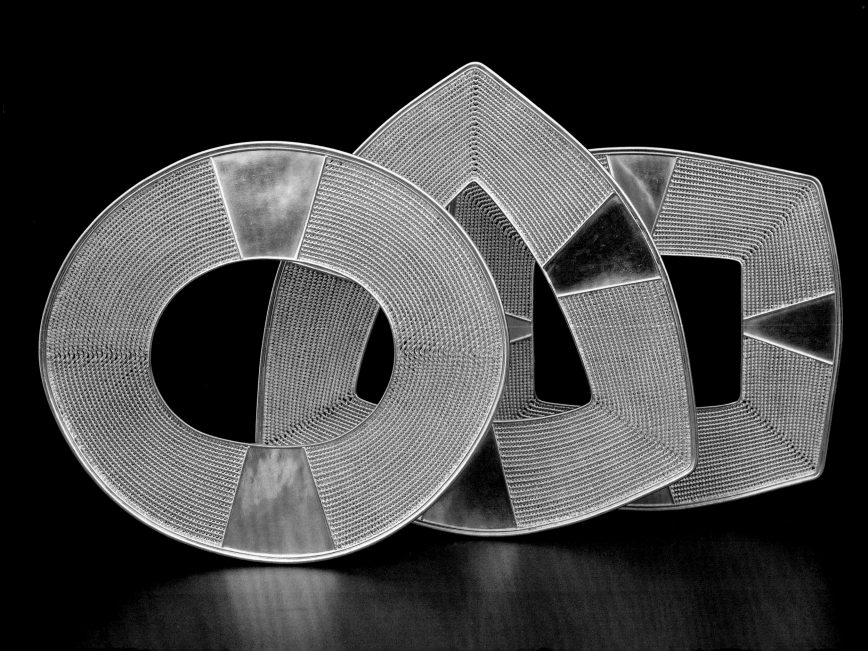

Artist, teacher, researcher, collector, traveler, bibliophile—Mary Lee Hu has pursued many roles in a career-long odyssey to design and fabricate wire-based jewelry. In so doing, she has taught the wires to perform a visual symphony, as they turn to and fro in a tightly orchestrated pattern of "knitted, knotted, twisted, and twined" silver and gold.[1] Today, nearly fifty years since she began this inquiry, Hu is still deeply engaged in creating a "harmony of the spheres" with wire.[2]

It takes a particular kind of person to devote their life to this subject, one who is—apart from being artistic—curious, imaginative, logical, and persistent in equal measure. This is Mary Lee Hu. With little information in the West on her chosen subject, Hu has traveled the world seeking historic, commercial, and ethnic examples of the genre, which she has patiently deconstructed to reveal their mysteries. As a result, she is among the vanguard of a small circle of international artists who base their work upon weaving methods.[3] Hu's hard-won expertise provides her with a rich vocabulary of forms, shapes, and patterns from which she works. The result is a body of ornament that, in its ingenuity and abiding beauty, rivals the ancients.

### EARLY YEARS

The pleasure that Hu derives from the introspective and contemplative activity of weaving probably dates to her childhood, when she and her science-minded brother each had their own workbenches, and where she focused on art projects. Hu also benefitted from watching and helping her father,

a mechanical engineer at NASA, who skillfully tackled household projects. It was probably her father who endowed her with strong organizational skills and a problem-solving frame of mind that was especially helpful when she began to work with wire.

The family encouraged Hu's early passion for art with extra classes wherever possible, but she didn't commit to a particular material until the age of sixteen, when she took a metalsmithing class for the first time at a high school program run by the University of Kansas. Her project was to fashion a linked bracelet out of silver—and it was love at first sight.[4] Despite the sizzling Kansas summer, Hu realized that she had found what she was looking for, saying "getting in the Quonset hut at ninety-five degrees and turning on a torch . . . was great."[5]

Because the Cranbrook Academy of Art required undergraduates to take two years of academics prior to their arrival, Hu attended Miami University, in Oxford, Ohio. At that time no metals department existed at the university, so Hu balanced her coursework by attending a six-week summer class at the Rochester Institute of Technology after her freshman and sophomore school years. At Rochester, she studied under Danish master Hans Christensen and instructor Alex Sand, made friends with fellow students Bernie Bernstein and Dutch-born and trained Hero Kielman. Christensen was totally focused on technique, and his abilities impressed her. Hu recalled a visit to his home where she "saw a piece in his collection . . . and was just blown away—a square teapot— I didn't know you could raise a square."[6]

Bracelet #43
1989; 18K and 22K gold
4¾ × 5⁹⁄₁₆ × ⅛ in.
Collection of Museum of Fine Arts, Boston;
The Daphne Farago Collection

Bracelet #44
1989; 18K and 22K gold
5½ × 5½ × ⅛ in.
Collection of Museum of Fine Arts, Boston;
The Daphne Farago Collection

Bracelet #45
1989; 18K and 22K gold
4½ × 5⅛ × ⅛ in.
Collection of Museum of Fine Arts, Boston;
The Daphne Farago Collection

Christensen taught his students to create cardboard templates for their hollowware designs that were shaped into three-dimensional form by raising, planishing, filing, sanding, pumicing, and polishing. Christensen had previously been a modelmaker for the Danish silversmithing firm, Georg Jensen, and his teaching followed the craft's historic emphasis on smooth, reflective forms. Hu was pleased that her bowl matched her template, but in retrospect she remarked that the results looked spun.[7] Her experiences with jewelry during those summers were modest, but a small pendant basket made of flat wire curiously pointed the way to her future.

**CRANBROOK AND CARBONDALE**

Hu transferred to Cranbrook during her junior year, and graduated in 1965. At Cranbrook, she did not feel that she entirely measured up to expectations, but this may have been partly due to the teaching methods of department head Richard Thomas, who pressed his students onward with sparing praise. The graduates and undergraduates worked in the same studio together and on the same projects, so she was able to see and learn from graduate students like Chunghi Choo, Al Ching, and Curtis LaFollette, among others. The key lesson she learned from Thomas was that there was no right or wrong way to achieve a particular result; each person needed to find the method that worked best for him or her.

She traveled to New York after graduation in hope of finding work, but learned that she was not well-prepared for the commercial world. For instance, Hu did not know the definition of a rendering, a scale drawing that visually describes a work to be fabricated. The experience also drove home the realization that fashion and novelty, twin drivers of the retail world, held little attraction for her.

So Hu was glad when, late that summer, she was invited to attend Southern Illinois University at Carbondale to study for her master's degree in fine arts. Carbondale proved to be a turning point in her career because of her professor, L. Brent Kington (fig. 1). Unlike Thomas, who worked behind closed doors, Kington was approachable and developed his own projects in the school's open studio, where students could easily observe and interact with him.[8] Hu was one of only two graduate students during her first year, and she had plenty of access to him; her bench was directly opposite his. She admired Kington's powerful work ethic,

Figure 1. Mary Lee Hu and L. Brent Kington, in the mid-1980s.

recalling the many wax sculptures he created each evening for casting by day at the studio. After Hu received her MFA, she taught in the art department but retained a bench in the metals studio, located between new graduate students Elliot Pujol and Gary Noffke, where she continued to develop her own work in wire.

Unlike Thomas, Kington also invited other metalsmiths to Carbondale for workshops. In this way she met Philip Fike, who taught the mixed-metal craft of niello, and Heikki Seppä, who focused on reticulation. Kington also brought his students to Springfield, Illinois, for a conference where Hu met craftsmen working in all media from around the country, and where she first gained a sense of kinship and community with them.

It was also at Carbondale that Hu first began to experiment with wire, which was to become the focus of her career. A weaving class, in which she studied macramé, turned out to be the catalyst. Charged with creating a macramé project, Hu decided to make her work of wire, thus enabling her to submit one work for two different classes. Kington saw promise in the wirework, and encouraged her to investigate this new interest to see what sort of artistic possibilities it might reveal. Knowing there was little published on the subject and much to learn, Kington set her the task of making two pairs of earrings per week from Thanksgiving 1966 through August of 1967, when she graduated.

It was not long before Hu figured out that wire, unlike fiber, was not suitable for knotting, but that it could be well-utilized in wrapping and looping techniques. As she recalled, "I'm fighting the natural inclination of wire. Threads will tie knots, wire doesn't like to." Next she thought, "What do I like about this? It's the play of light off the surface—the sparkle and the pattern. And I really like those half-hitch knots up on edge and wires coming out from in between them. All I have to do is take a bunch of wires and wrap a wire around them, and then bring one out and wrap [it] around again [and] I will get very much the same look, but I'm not tying knots."[9] With this discovery came a flood of experiments and the thrill of realization that she had stumbled onto something worthwhile.

Hu started out working in brass wire, but found the resistance too much for her fingers; she soon moved to fine silver, knowing that it was softer than sterling. She also continued with her other studies, taking a drawing class to improve her interest in line, realizing that it could contribute to her exploration of wire, which soon evolved into a study of insect and animal forms. She appreciated the linear and decorative quality of wire, saying "I equated wire to the lines in a drawing, in that I could build my shape with a lot of repeated strokes and cross hatches. Combining wire with wire and more wire gave a surface embellishment of texture. Yet I wasn't making form and then embellishing it; I was actually making it out of the wire structure."[10] The simplicity of the materials and the practice of weaving, which involved working the metal with her hands, also had great appeal: "I don't separate myself from my material with a lot

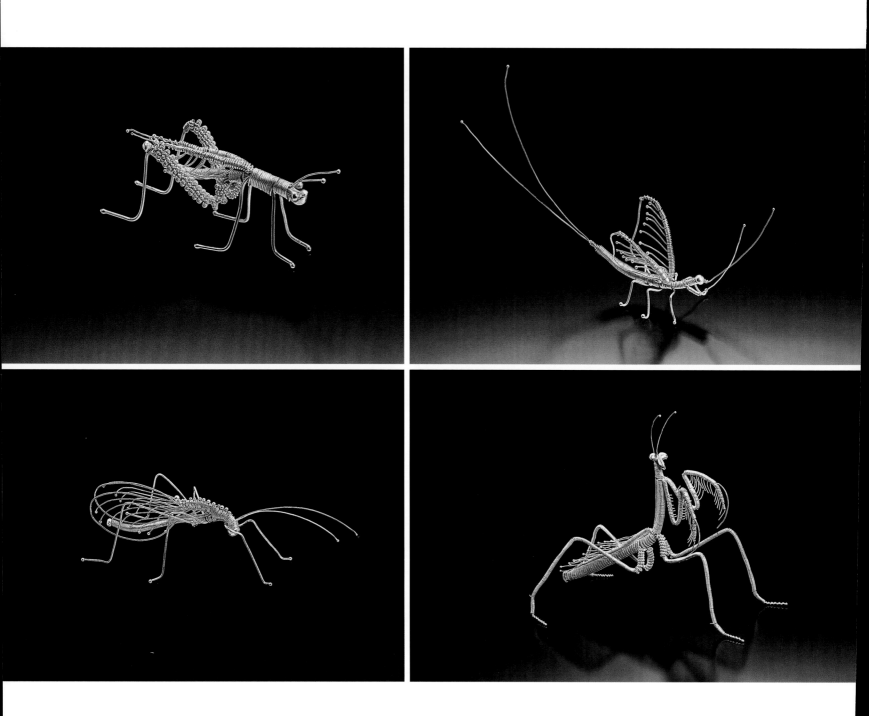

From top left: **Grasshopper**, 1967; Fine and sterling silver, 2¼ × ¾ × 1 in. Collection of Pavia Kriegman

**Mayfly**, 1967; Fine silver, 4 × 1 × 3½ in. Collection of Laurie A. Lyall and Heikki M. Seppä

**Cricket**, 1967; Fine silver, 4⅜ × 2 × 1 in. Collection of Mary Lou Hopkins

**Praying Mantis #2**, 1974; Fine and sterling silver, 4½ × 3¾ × 1½ in. Collection of Mary Jane Hashisaki

24

of tools . . . I'm working from one end of the piece to the other, doing all the work on it. When I move from it, it's finished completely. It's the way a weaver works, not the way a metalsmith works."[11]

As many of her wire shapes tended to have tapered ends that lent themselves to curvilinear shapes, they were eminently suitable for insects as well as such sea creatures as octopus and squid. Each one formed its own kind of technical experiment in which she tried out variations, and experimented with color as well, using copper magnet wire covered in lacquered colors of forest green and burgundy red to create various patterns. A series of curvilinear, fin-de-siècle-style headpieces sprung from her fingers next, two of which were included in an exhibition called *Face Coverings* held at the Museum of Contemporary Craft in 1970 (right).

**TAIWAN**

In 1967, Hu married Chinese-born Tah-Kai Hu, called TK, who became a professor of mathematics at Western Washington State College (now University) in Bellingham, Washington (fig. 2). TK's teaching position allowed Hu the luxury of focusing upon her own work. Within a few years, however, he wanted to travel to Taiwan where he and his family had moved after World War II, and where Mary could experience Chinese culture. In 1971, a visiting professorship at the National Taiwan University at Taipei made a yearlong trip possible. But their idyll did not last; TK died suddenly at the end of the school year in 1972.

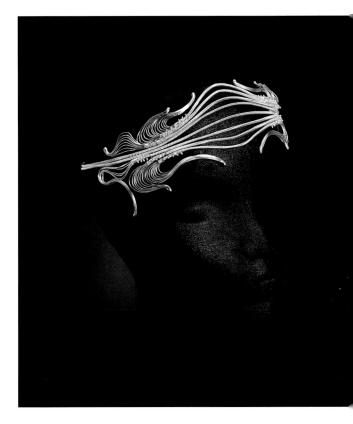

How to go forward in the face of such terrible and unexpected loss? Hu's choice was to delve ever deeper into her work, while continuing her study of Chinese life.[12] She remained in Taiwan an additional year, learning more Chinese, and visiting museums. She had already made an important sculptural breakthrough in her neckpieces, starting with *Neckpiece #8*, which employed boar's tusks as a rigid neck form, and from which descended a basket-like pendant with lizards and hanging tendrils. After TK's death Hu created a

Headpiece #5
1975; Fine and sterling silver
2½ × 6 × 7½ in. Collection of the artist

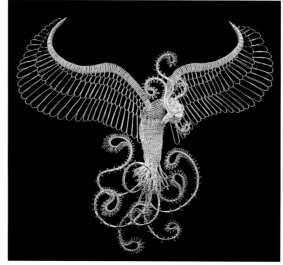

majestic pectoral in the shape of a phoenix, her first great masterpiece in a career of brilliantly resolved wire ornaments. Whiplash-curve tendrils abound, while wrapping and looping gives a distinctive airborne appearance to the body and tail. Tellingly, Hu's choice of the firebird, an ancient symbol of rebirth, revealed her determination and will to surmount deep personal tragedy.

## TRAVEL AND STUDY OF ETHNOGRAPHIC JEWELRY

Hu always loved to travel. In 1966, she took a six-week camping trip with her college roommate that took them from "Carbondale to the Carlsbad Caverns, up to Santa Fe and Taos, over to the Grand Canyon, Bryce Canyon, and Zion National Park, Las Vegas, down to Los Angeles, up to Sequoia National Park, over to San Francisco, up the coast to the Olympic Peninsula, and to Ohio through

Yellowstone and the Tetons."[13] While in Taiwan, she visited examples of secular and temple architecture, as well as private homes wherever possible. In 1973, when her father arrived in Taiwan near the end of her stay, Hu satisfied her wanderlust in a major way by taking a fifteen-country journey with him through the Far East, Southeast and Central Asia, Southern Europe, and North Africa.[14] A second trip to Bhutan, India, Nepal, and Burma followed in 1975 with her father and brother, led by the internationally recognized Sherpa guide Tenzing Norgay (fig. 3).[15] They fired a lifelong passion for travel for Hu, who was powerfully attracted to indigenous peoples, their homes, their dress, and adornments. She returned with samples of the jewelry she had seen and filled with the desire to learn more (fig. 4). Some of her acquisitions formed the core of her study collection of

Neckpiece #9
1973; Fine and sterling silver, 24K gold, 12K gold filled wire, pearls; 12½ × 9½ × 7 in.
Collection of Museum of Fine Arts, Boston; H. E. Bolles Fund and Anonymous gift

Figure 2. Mary Lee Hu and Tah-Kai Hu at their wedding, September 9, 1967, Olmsted Falls, Ohio.

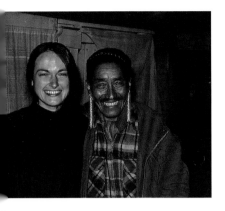

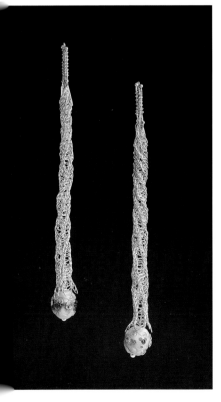

wire jewelry, while others fueled ethnic ornament interests. Both have remained a staple of her intellectual and technical activities, and are a continuing influence on her development as a jeweler.

Returning to the United States in the fall of 1973, Hu settled back home in Ohio with her father, incorporating some of what she had learned from her travels into her jewelry. For instance, the flat phoenix neckpiece, *Neckpiece #13*, of 1973, included knitted wire that was inspired by a Tibetan Khams Pa (Eastern Tibet) neckpiece that she had purchased. Ever on the hunt, Hu was continually analyzing, assessing, and experimenting with techniques that could advance her ability to move wire in new ways.

### TWINING

Back in the United States, Hu embraced two weaving methods that were ancient, ubiquitous, and eminently suitable to wirework. While living with her father in Ohio, Hu found a humble laundry basket and an Easter basket in the house that were made from woven reeds, and a twined Northwest Coast Indian basket. The chief advantage of both methods was their use in building tubular and hollow forms. For Hu, twining offered more possibilities, partly due to the dense surface texture she could achieve. She experimented with some twined miniatures based upon these domestic pieces, and soon moved on to fashion nonfunctional forms that delight the eye with their unique and imaginative shapes, some of which can be viewed both upside down and right-side up. In

some examples she also played with the end wires and treated them as if they were human hair, forming them into undulating shapes that appear to be in constant motion (see *Forms #1* and *#3*). These works represent a lively and unorthodox chapter in Hu's career during which she gave herself the freedom to think entirely outside of the canon of utilitarian vessels to create pure sculptural form. It is likely that she would have made more than the five major Forms in this series if they had found devoted patrons.

### TEACHING AND EXHIBITING

These discoveries were just as important, however, as finding a teaching job, since about eight years had elapsed since she had graduated from Carbondale, and the country was in the middle of a recession. Hu first worked in 1975 as a sabbatical replacement at the University of Iowa in Iowa City for Chunghi Choo, and then in 1976 for Elliot Pujol at Kansas State University, in Manhattan, Kansas, before moving on to the University of Wisconsin-Madison where she replaced Eleanor Moty. By the fall of 1977 she received her first teaching position at Michigan State University, East Lansing. However, after three years in Michigan, she was invited by John Marshall to join his metalsmithing program at the University of Washington in Seattle. Marshall found Hu to be bright, focused, and energetic. He also believed that students needed inspiration from professors whose aesthetics and techniques were very different from one another, and saw that Hu's richly worked wire jewelry

Figure 3. Mary Lee Hu and Tenzing Norgay, January 13, 1975, in Kalimpong, India. Tenzing is wearing a pair of Mary's earrings and her long braid is wrapped around his head. Dana W. Lee, Mary's father, was the photographer.

Earrings #83
1975; Fine and sterling silver, glass beads; 4½ × ½ × ⅞ in.
Collection of the artist

was an excellent complement to his own abstract explorations in hollowware.[16] Hu joined Marshall in the Metal Design Program in the fall of 1980, where she remained for twenty-six years until her retirement in December of 2006.

In addition to a teaching career, an active exhibition schedule was essential for professional advancement and for establishing a reputation. Long before she had moved to Taiwan, Hu had participated in a number of juried exhibitions. As she later reminded her students: "Enter shows; they won't remember your name the first couple of times, but if you are persistent, they'll start remembering you and then they'll start inviting you to submit your work."[17]

In the 1960s, her jewelry was seen at regional venues such as the *Mid-States Craft Exhibition*, held by the Evansville Museum of Arts and Sciences, then a very active venue for crafts, and the long-running annual, *Wichita National Decorative Arts and Ceramics Exhibition*. Her first big breaks came with the *Young Americans '69* exhibition mounted by the Museum of Contemporary Crafts (today's Museum of Arts & Design), which traveled nationally to twelve venues, and in exhibitions mounted in the early seventies by the Society of North American Goldsmiths (SNAG). After her Taiwanese sojourn, she renewed her efforts to find venues for her work, and in 1976 Electrum Gallery in London exhibited her jewelry with that by the Americans Arline Fisch, Richard Mawdsley, Eleanor Moty, and Hiroko Sato Pijanowski and her husband Eugene Pijanowski. It was her first international invitational show. Two years later she participated in a four-person show with Bill Harper, Mary Ann Scherr, and Heikki Seppä at the venerable Goldsmiths' Hall, also in London. Soon she began to sell her work to museums: Goldsmiths' Hall acquired two pieces in 1976, and two years later *Neckpiece #26* was purchased by the Yale University Art Gallery.

Momentum continued to build when she moved to Seattle, as museum curators included her work in landmark exhibitions related to jewelry and American craft. Meanwhile, Hu traveled the country giving lectures and workshops on her methods, often with a heavy bag of ethnic wire jewelry in tow, garnering praise and gathering young adherents as she went (fig. 5).

JEANNINE FALINO

Figure 4. Mary Lee Hu wearing a Tibetan dress and necklace, mid-1970s.

**TWINING SILVER INTO GOLD**

Once in Seattle, Hu continued her focus on twining as she built a new series of tubular necklaces and bracelets. Starting in the early 1980s, she began to weave long, narrow tubes in various twined patterns (fig. 6). Then she cut the tubes at angles, and forged connecting elements. While her necklaces conformed to a circular shape, the greater freedom provided by arm movement inspired her to experiment with triangular and square bracelets as well. This phase of her work, by virtue of technique, departed from the whiplash curves that characterized the jewelry of her early career in favor of volumetric expression. Twining also enabled her to create elegant, refined curves based upon her deft handling of the warp, as can be appreciated in one of her rare bracelets that included a carved lapis lazuli (see p. 80).

During the eighties, Hu departed from silver to work exclusively in gold. Up to this date, silver had been Hu's primary material, and she feared expending funds on gold if her pieces were not well-received by collectors. However, with growing interest in her work, and confident of her ability to create objects of singular beauty, she made the switch. High-karat gold has proved to be a perfect match for her skills, for it is more malleable than silver, and its softly reflecting quality reveals the subtlety of her compositions. As Hu describes it, "What I'm trying to do is get a really lush, rich, wonderful form that goes with the materials I'm using. Bright metal, reflective surfaces that compliment [a] . . . part of the body."[18]

The change to gold also led to her next technological shift, and to what Hu calls her "tessellated" series, composed of twined sections that, when assembled, arranged themselves into graduated, geometric patterns having circular, oval, and triangular negative spaces. The result was formal and geometric, features that suited the gravity of purpose that is traditionally associated with gold. Hu was well-acquainted with gold's connection to Egypt, Greece, and the Etruscans, for she had studied ancient jewelry in museums, in special exhibitions on Thracian, Scythian, and Irish gold that she saw in the 1970s, and in her growing personal library.[19] While it was not in her nature to emulate the designs of these cultures, she could create works that were in every way their equal. And she did.

The tessellated series were odes to the circle, the diamond, and the square, which she varied with subtle gradations in size to accommodate the shape of the body. The sense of complete order and resolution that emanates from the series is the chief inspiration for the title of this essay, and its corollary, the "music of the spheres," which posits that mathematical relationships possess qualities or tones of energy that are based upon proportion.[20] Arguably the greatest of Hu's career, their beauty lies in her elegant geometric compositions that resonate visually like a mandala or as sounds to the ear in the manner of classical music, and like music, they have a pliant, liquid quality that belies the rigidity of their form.

Figure 5. Mary Lee Hu demonstrating wire techniques for a group of students in the late 1970s..

## ORDER AND SUBVERSION

Hu fashioned tessellated works through much of the 1990s until about 1998, when she sought a new direction. First she twined a large tube, large enough to be a bangle bracelet, and then inserted concave sections that introduced a curving element to the design. While pleasing, this did not satisfy her, and yet she could not envision the next step for her work. It was not until a bit later that —partly out of frustration—she took a remnant of twined tubing and slipped it on a ring mandrel. Taking a rawhide mallet, she struck the tube, crushing it in the process. The result was an exciting shape and a powerfully liberating experience. Hu found that she loved the immediacy of the act and the daring of potentially ruining her carefully prepared work, not to mention the audacity of its unknown outcome.

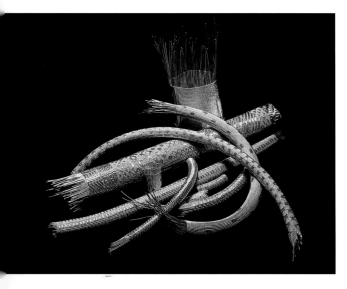

Hu learned to modify her twined elements by hand as well as by hammer, in order to gain more control. These new undulating forms were reminiscent of the Art Nouveau–style jewelry she had created in the 1970s. In response to these shapes, she began to use swirling, flat-wire settings to hold the weavings in place, the flattened wire appearing to serve as an elaborate fence against which fabric fluttered in an unseen current of air or water. Other works were ribbonlike in appearance, the apparent softness of the "ribbons" being an elegant foil to the hardness of the metal, and lending a luxuriant quality to the finished work. By 2002 she began to make brooches in a similar manner. Recently, she adapted this approach to begin a series of brooches based upon flowers.

In Hu's return to realism, however, she has left behind the tightly schematized insects and sea animals of the 1970s, this time using her gently crushed and de-constructed shapes in an impressionistic manner.

The mathematical and structural order of weaving is an underlying strength in all Hu's work. Her methodical approach to the woven form has led to decades of fruitful artistic growth, as each technical advance has provided a new springboard for her imagination. Significantly, her willingness to distort and even subvert this order has led to some of her greatest breakthroughs. Softly glowing in all its glory, Hu's jewelry is a symphony in which the planets are aligned and harmony reigns in the spheres.

The author offers thanks to Mary Lee Hu for her close reading of this text.

Figure 6. Log Pile, 1983. The artist made these twined tubes of various sizes in fine and sterling silver to explore pattern possibilities. Most of the smaller ones were later made into bracelets. The relative sizes can be compared with the medium-sized "log" that is twelve inches long.

1 The phrase is taken from the title of a lecture that Hu delivered on September 29, 1996, at the Museum of Fine Arts, Boston.

2 The phrase "harmony of the spheres" is used metaphorically, likening Hu's work to the Pythagorean theory bearing the same name. The theory proposes that the sun, moon, and each planet emit celestial sounds based upon their orbital revolutions that are imperceptible to the human ear, yet have a favorable effect upon earthly life. This theory is related to the "Music of the Spheres," which holds that mathematical relationships bear certain qualities, or tones of energy that are manifested in numbers, geometry, and sounds that are based upon proportion. See http://en.wikipedia.org/wiki/Musica_universalis, accessed August 27, 2011.

3 Some of Hu's peers include Arline Fisch (American, metal), Irene Griegst (Danish, metal), Annette Holdensen (Danish, paper), Markku Kosonen (Finnish, basketry), and Hisaka Sekijima (Japanese, fiber). For more information on these and other artists see the catalogue Flet / Braid (Aalborg, Denmark: Nordjyllans Kunstmuseum, 2001).

4 In all likelihood, Carlyle Smith, professor of metalwork at the University of Kansas, in Lawrence, was her teacher, as he was very active around the state in programs that encouraged young students to become involved in the arts.

5 "American Craftspeople Project: The Reminiscences of Mary Lee Hu," Oral History Research Office, Columbia University, 1988; hereafter Columbia, 8.

6 Oral history interview of Mary Lee Hu by Mija Riedel, Seattle, Washington, March 18–19, 2009, Archives of American Art, Smithsonian Institution; hereafter, Hu interview, AAA, SI. [Editor's note: this interview was not yet posted online as this book went to press.]

7 Hu interview, AAA, SI.

8 For Kington, see the exhibition catalogue by Debra Tayes, *L. Brent Kington: Mythic Metalsmith* (Whittington, IL: Illinois State Museum, Southern Illinois Art Gallery, 2008).

9 Hu interview, AAA, SI.

10 Telephone conversation between the author and Mary Lee Hu, August 13, 2011.

11 "Mary Lee Hu," in Robert L. Cardinale and Lita S. Bratt, Copper 2: The Second Copper, Brass, and Bronze Exhibition (Tucson, AZ: University of Arizona Museum of Art, 1980), 50–51.

12 Hu was studying Mandarin Chinese, and had taken up lessons in the guzheng (Chinese zither), while also studying Chinese temples and secular architecture.

13 Hu interview, AAA, SI.

14 The complete itinerary included Hong Kong, Singapore, Malaysia (Kuching, Sarawak, Kuala Lumpur), Indonesia (Bali), India (Calcutta, Agra, Delhi), Nepal (Kathmandu); Pakistan (Lahore, Peshawar, and the Swat Valley); Afghanistan (Khyber Pass, Kabul); Iran (Tehran, Isfahan); Turkey (Istanbul); Greece (Athens, Delphi, and several islands); Italy (Rome, Florence, Venice); Spain (Madrid, Toledo), Morocco (Casa Blanca, Marrakesh), and Portugal (Lisbon).

15 In 1953, Sherpa guide Tenzing Norgay and Sir Edmund Hillary were first to scale the summit of Mount Everest, the world's tallest peak. Over the years, Hu has taken numerous ethnographically focused trips. They include travels in 1986 (New Zealand, Papua New Guinea, Hong Kong, China, Tibet, Nepal); 1993 (Singapore, Indonesia); 2007 (Vietnam, Laos, Cambodia, Thailand); 2008 (Mexico, Hong Kong, Guizhou, Hangzhou, Shanghai, Taiwan); and 2010 (Hong Kong, Guizhou, Hangzhou, Shanghai, Taiwan).

16 John Marshall, conversation with the author, March 28, 2011, Edmonds, Washington.

17 Hu interview, AAA, SI.

18 Columbia, 27.

19 The exhibitions Hu attended at various locations during the mid-1970s were From the Lands of the Scythians: Ancient Treasures from the Museums of the U.S.S.R., 3000 B.C. to 100 B.C. (New York: Metropolitan Museum of Art, 1976); Thracian Treasures from Bulgaria (New York: Metropolitan Museum of Art, 1977); Treasures of Early Irish Art: 1500 B.C. to 1500 A.D.: From the collections of the National Museum of Ireland, Royal Irish Academy, Trinity College, Dublin (New York: Metropolitan Museum of Art, 1977). Hu interview, AAA, SI.

20 See note 2.

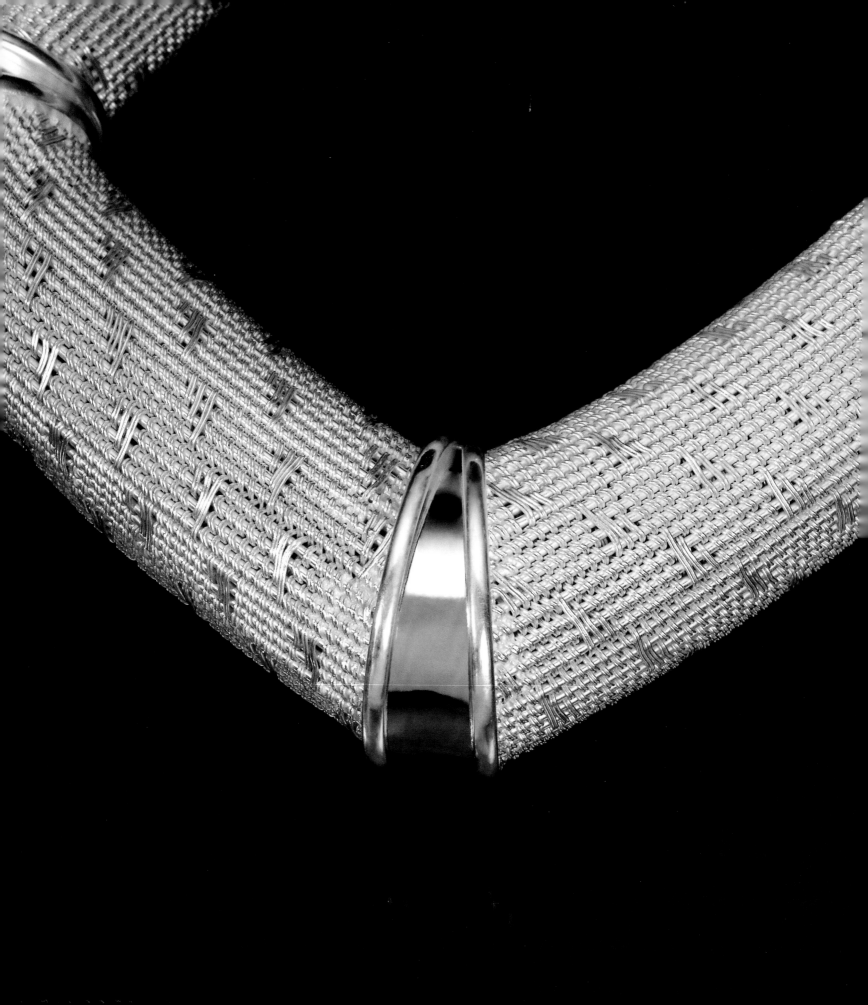

## An Early Precursor

When I decided that I wanted to become a metalsmith after taking a summer metalsmithing course, I knew I wanted to study at Cranbrook Academy of Art, even if they required two years of regular academics first. In 1963, between Miami University and Cranbrook, I attended a six-week summer metalsmithing and jewelry session at the Rochester Institute of Technology in Rochester, New York. We worked from eight to five, five days a week, spending half the week on Hollowware with Hans Christensen, and the other half on jewelry with Axel Sand—and I made three bowls and three pieces of jewelry. I don't know what gave me the idea, but for one of my jewelry pieces I decided to try weaving some wire I had flattened in the rolling mill. The air pressure for our smaller-scale soldering there came from a foot bellows, and I needed to solder down all the wire ends. I remember the concentration this took—getting pressure for the flame just right so as not to melt things. Yet the most frustrating part was that I was weaving a hanging, baglike form, and had trouble bending the flat wire strips sideways. This experience led me to only use round wire in graduate school three years later.

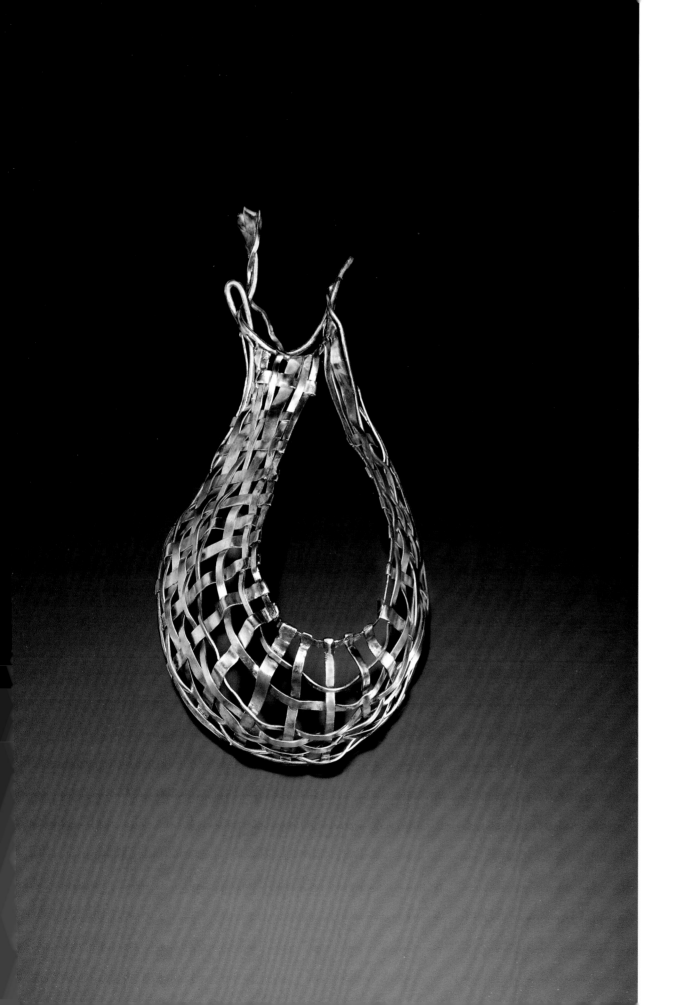

**RIT Pendant**
1963; Sterling silver
3¼ × 1½ × ½ in.
Collection of the artist

**Cast Brooch #1**
1966; 14K gold; 2½ × 2 × ⅛ in.
Collection of the artist

**Cast Brooch #2**
1966; 14K gold; 2¼ × 2¼ × ⅛ in.
Collection of the artist

**Cast ring**
1966; 14K gold; ⅞ × ⅞ × ⅞ in.
Collection of the artist

## Playing with Light

In graduate school at Southern Illinois University-Carbondale, after choosing macramé knotting in a weaving course that assigned us to investigate an off-loom textile process, I got the idea of making a necklace of knotted silver wire and maybe getting credit for both my metals and weaving classes. My metals teacher Brent Kington then suggested I investigate working with wire for my thesis project, saying that at the end of the semester he wanted to see finished work, not just some crumpled experiments, and he assigned me to make two pairs of earrings each week. Naturally, the first ones I made were of knotted wire. But even using pure silver, since it was so soft and easily bent, it was a struggle to tie rows of knots without crumpling the wires. So after two weeks I stopped to analyze what I liked about the knotting, and saw it was the play of light from the rows of knots. How could I achieve that quality without having to actually tie them? I began wrapping one wire around a group of other wires, pulling one out of the group when I wanted a line to curve across space. This let me achieve a crisp, controlled design in a fraction of the time it took to do the knotting. And now instead of taking a full day to make a pair of earrings, by noon Monday I could choose *which* pair to wear to lunch.

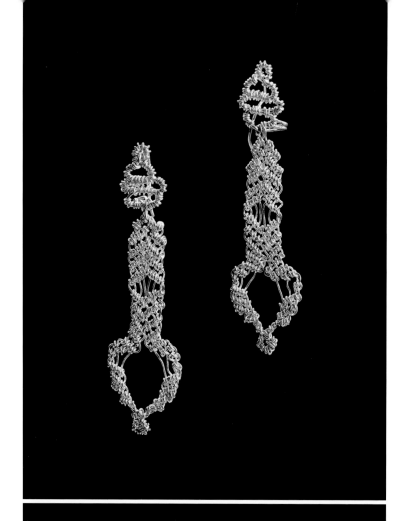

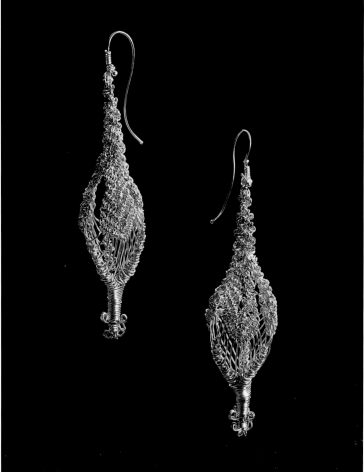

**Earrings #1**
1966; Fine silver
2¼ × ½ × ¼ in.
Collection of the artist

**Earrings #2**
1966; Fine silver
3 × ⅞ × 1¼ in.
Collection of the artist

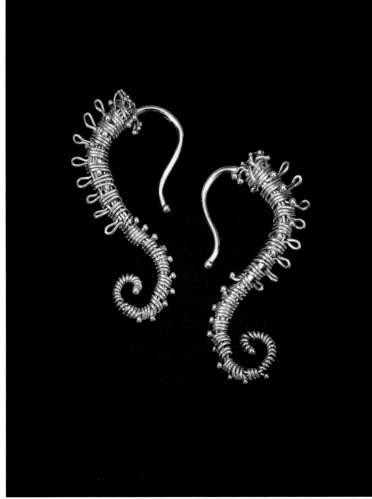

## Building My Vocabulary

When working with wire, finding a way to finish
the ends was always a problem. At first I just curled
them up around my pliers. Then I thought of melt-
ing them with a small torch flame. I was delighted
with the round, shiny balls that resulted and began
to use this effect in a variety of ways—to simply
end a line, to attach several wires in a group, or
to have balls hovering over the surface of a larger
wrapped element. It looked something like what is
called granulation, a technique of adhering many
minute gold spheres to a sheet of gold, found in
ancient Etruscan work I had seen and loved because
of its delicacy and intricacy. One week, I thought
to myself, "Why am I always taking a wire out from
the group of wrapped ones, cutting it short and
melting it . . . why not take it out and put it back in,
leaving a small loop?" I really liked the effect and
expanded it in the next pair of earrings by taking
about a foot of this looped wire and wrapping it up
around a pencil point and overlapping the loops,
producing what I thought was a great texture.

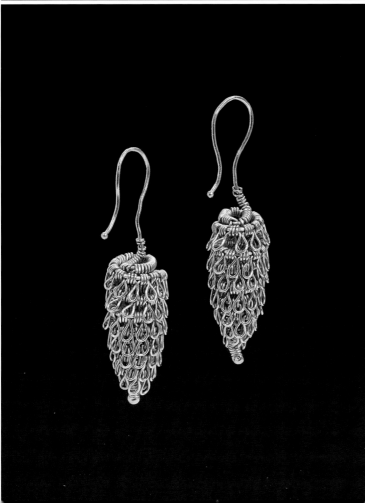

Earrings #36
1967; 14K and 24K gold
1⅛ × ½ × 1/16 in.
Collection of the artist

Earrings #37
1967; 24K gold
1⅝ × ⅜ × ⅜ in.
Collection of the artist

**Turtle**
1968; Fine silver; 7 × 1½ × 5 in.
Collection of the artist

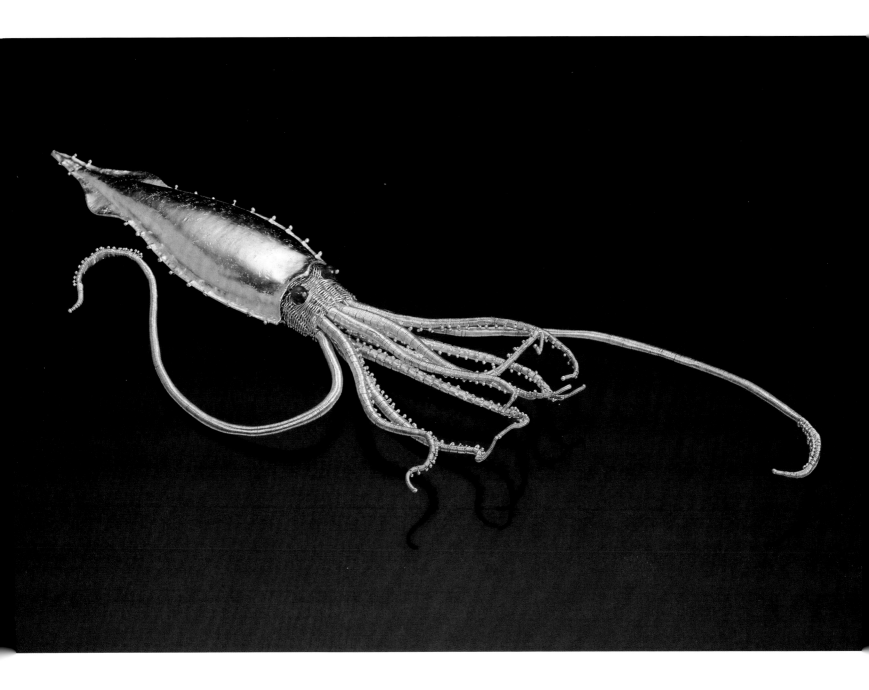

Squid
1968; Fine silver, tourmaline
12¾ × 5 × ¾ in.
Collection of the artist

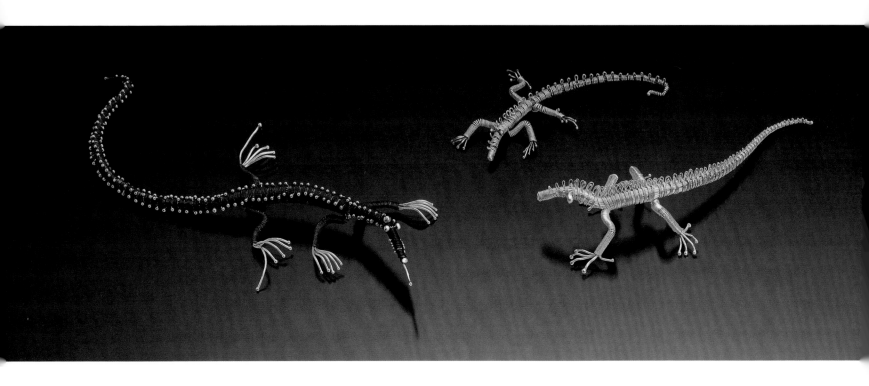

**Lizard #3**
1967; Fine silver, iron
6¼ × 2⅞ × ½ in. Collection of
Laurie A. Lyall and Heikki M. Seppä

**Lizard #9**
1967; 18K and 24K gold
2¾ × 1⅝ × ¼ in. Collection
of Brent and Diane Kington

**Lizard**
1967; Fine silver; 4 × 1½ × ¾ in.
Collection of Laurie A. Lyall and
Heikki M. Seppä

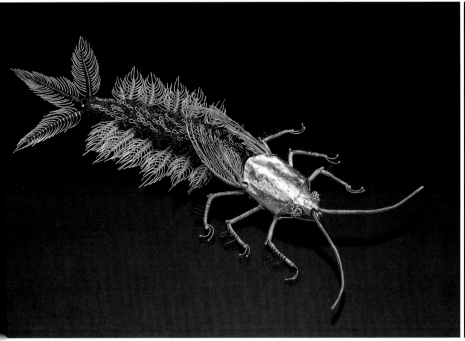

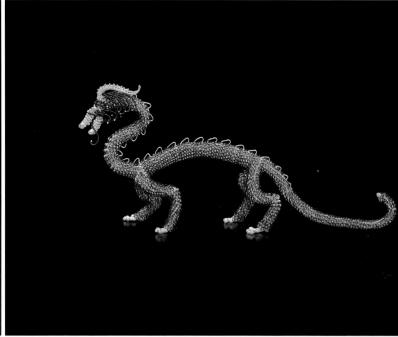

## A Dragon for TK

I began making the insects to help me learn to "draw" with the wire.
The lizards came soon after. There were a lot of lizards in Southern
Illinois and I made a lot of silver ones, finding them popular and good
sellers. My husband was Chinese, born in the year of the Dragon, so
I wanted to make a dragon for him. I had a picture of a bronze Chi-
nese dragon, perhaps from the Harvard Art Museum, and used it as
a model. I started with a larger-sized lizard body and then gave it
scales. First I made the complete form—melting back wire ends for
the eyes, toes (five of course, like an imperial dragon), the tips of the
mane, and the elbows. Then I made what seemed like about fifty feet
of looped wire and wrapped that around the body last, starting at the
tip of the tail, so that the looped scales would overlap.

**Aquatic Insect**
1970; Fine and sterling silver, lacquered
copper; 10 × 1 × 3 in. Collection of the artist

**Dragon #1**
1969; Fine and sterling silver, lacquered
copper; 8½ × 4 × 1 in. Collection of the artist

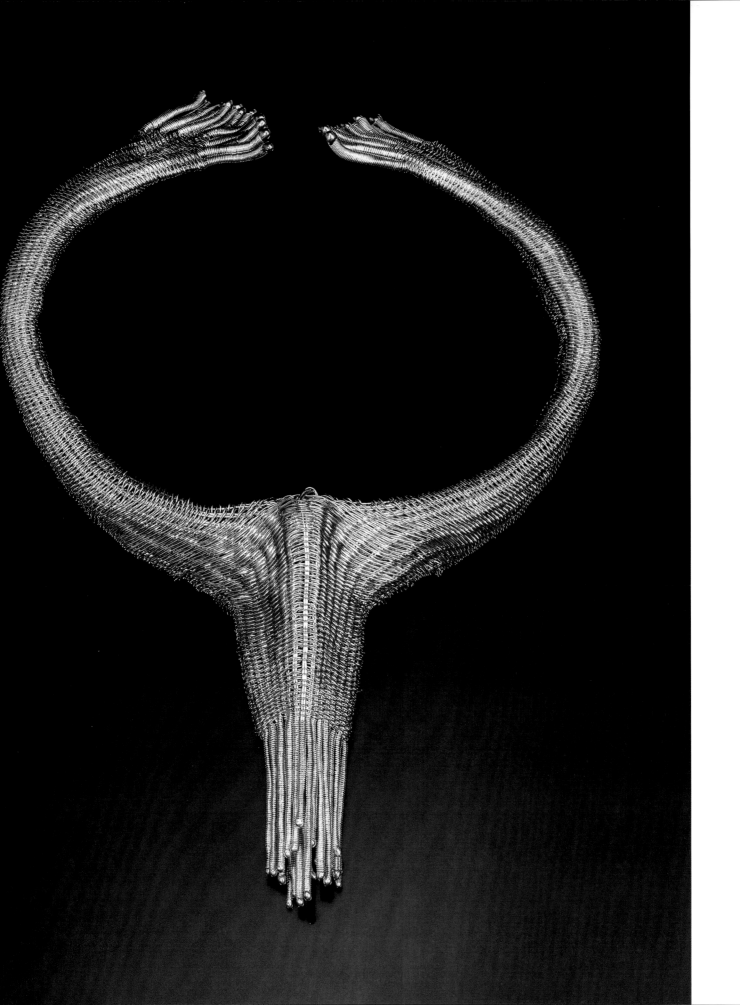

## An Oriole's Nest

I began weaving by making earrings in small
wire-basket forms, and had already made one
woven neckpiece (*Neckpiece #5*) when, in 1971,
my husband and I moved to Taipei, Taiwan,
where he was a visiting scholar at National
Taiwan University. I had taken some wire and
a few tools, so I thought I would use this time
to challenge myself with more complex woven
forms. I had grown up looking at some watercol-
ors of birds and their nests done by one of my
mother's relatives, and that gave me the idea of
a hanging bird's nest. I was also fascinated by the
banyan trees in Taiwan, with their tangled lines
of hanging roots, and the lizards there, running
up the walls and on the window screens at night.
The boar's tusks came from a local market that
I had begun to haunt, looking for indigenous
jewelry. It was only years later, while looking at
some of my early work, that I noticed the Roch-
ester Institute of Technology pendant was essen-
tially the same piece. It had taken me ten years
to learn how to make it.

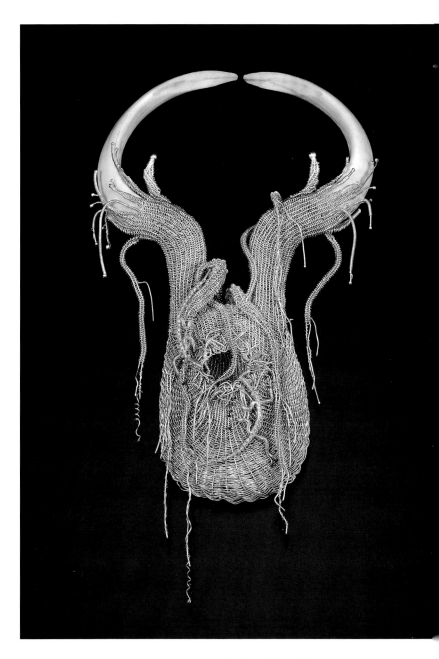

**Neckpiece #5**     (left)
1969; Fine and sterling silver
8 × 6½ × 1 in. Collection of the artist

**Neckpiece #8**
1973; Fine silver, 12K gold filled wire, boar's
tusks; 10 × 5½ × 1½ in. Collection of the artist

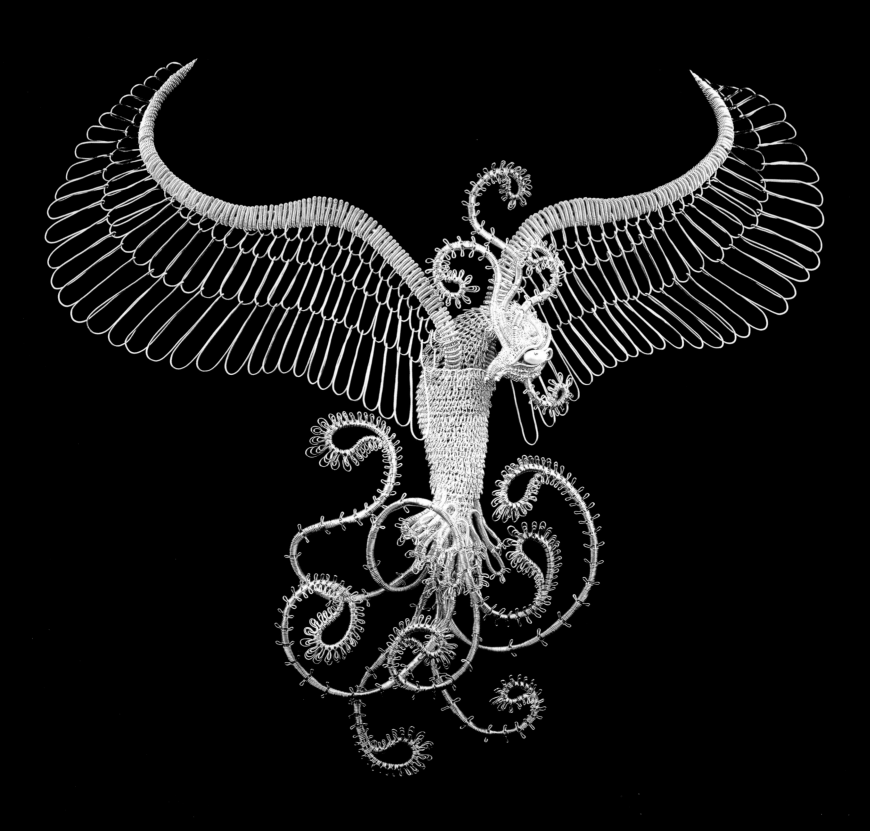

## A Phoenix for Me

While living in Taiwan, I studied many things Chinese—the language, the cuisine, a traditional musical instrument, and temple and traditional secular architecture. I also investigated many forms of art by going to the National Palace Museum, sometimes spending whole days in a single room as I drew the designs on the bronzes, ceramics, or jades. I had made the dragon for my husband several years before, so I thought I would make a phoenix (the symbol for the empress) for myself. I designed it to appear as if it were taking flight, with the wings going around my shoulders. Having seen the exhibition *Tutankhamen's Treasures* at the Cleveland Museum of Art in the early 1960s, where one of the pieces shown was an amuletic collar in sheet gold of a cobra with outstretched wings similarly going around the shoulders, I think it was definitely an influence here.

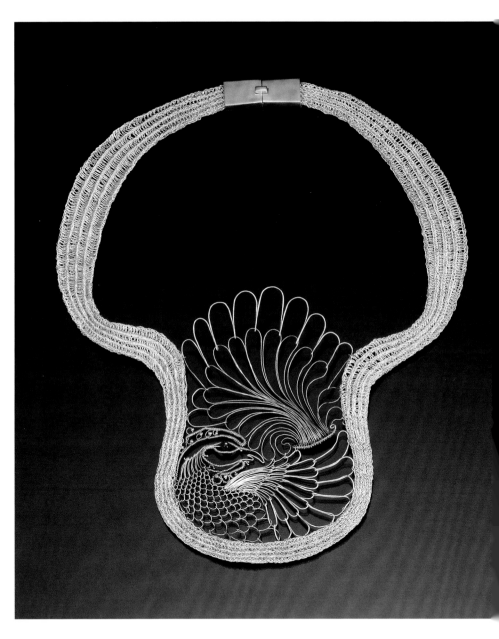

**Neckpiece #9**     (left)
1973; Fine and sterling silver, 24K gold, 12K gold filled wire, pearls
12½ × 9½ × 7 in. Collection of Museum of Fine Arts, Boston;
H. E. Bolles Fund and Anonymous gift

**Neckpiece #13**
1974; Fine and sterling silver, 24K gold, 12K gold filled wire, ruby,
pearls; 10 × 8½ × ½ in. Collection of Florence Duhl Gallery

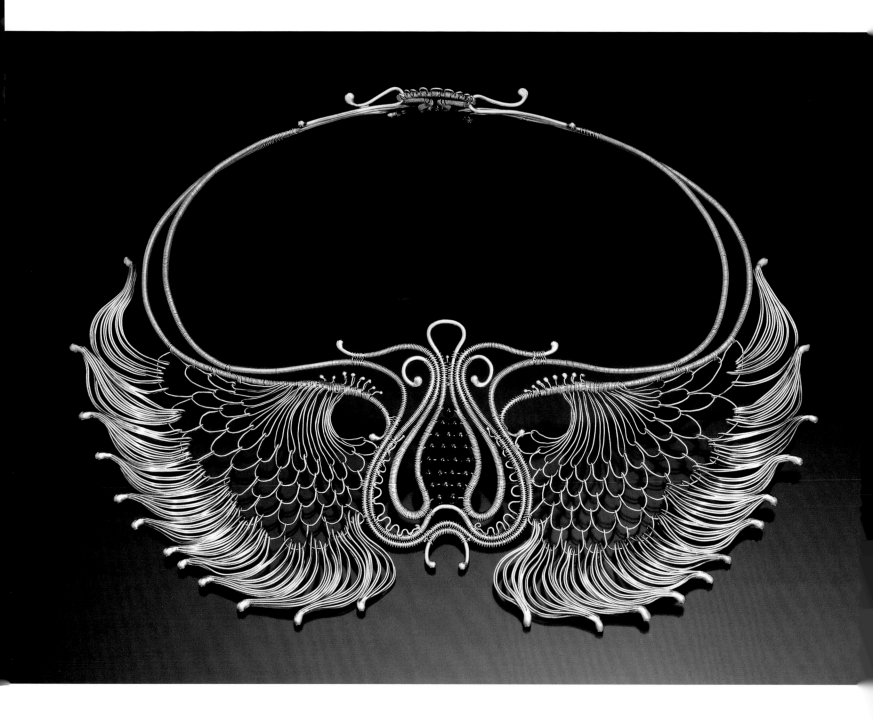

**Neckpiece #17**
1974; Fine and sterling silver, garnets;
10½ × 8½ × 1 in. Collection of Pavia Kriegman

**Neckpiece #18**
1974; Fine and sterling silver, 24K gold, and 12K gold filled wire;
17 × 8 × ½ in. Collection of Columbus Museum of Fine Art,
Curator's Committee for Decorative Arts Purchase Award 1975.039

## Losing the Literal

My husband died while we were living in Taiwan, so after returning in 1973, I lived in my father's house in Ohio, using the same basement studio I had set up in high school. I was exploring knitting, different types of weaving, and representational imagery (*Neckpiece #13* and *#17*). *Neckpiece #18* is the most extensive use of the "phoenix feather" or chain-link fence process of looping that I have done. I loved the patterns I could make, and I could cover a lot of territory using a minimum of materials with it, but the work was extremely slow and painstaking— one could not make a mistake, as any corrections would show. At this point my work was getting less literal—the wings were still there, but not the bird—and I was blending animal and vegetal ideas. When I submitted this work to an Ohio Designer Craftsman show at the Columbus Museum of Art in 1975, I won a purchase prize. That money allowed me to travel to London and Paris, and to see the Celtic torques and an exhibition of Scythian gold, both definite influences on my later work. I also met Barbara Cartlidge, the director of Electrum Gallery in London, and exhibited my work there for a number of years.

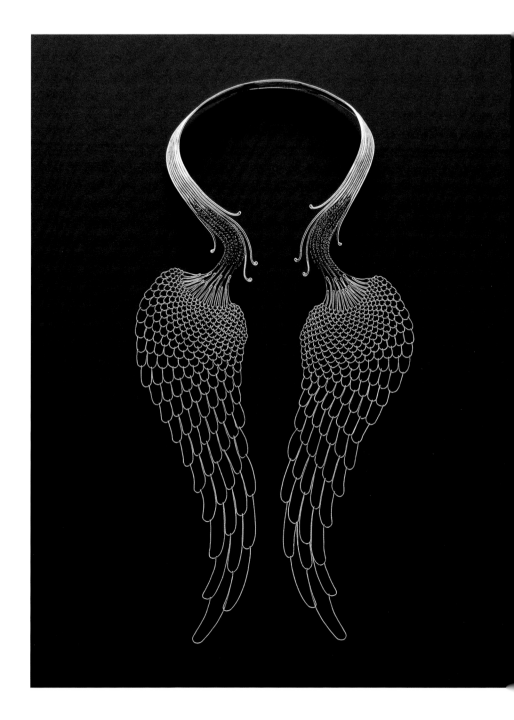

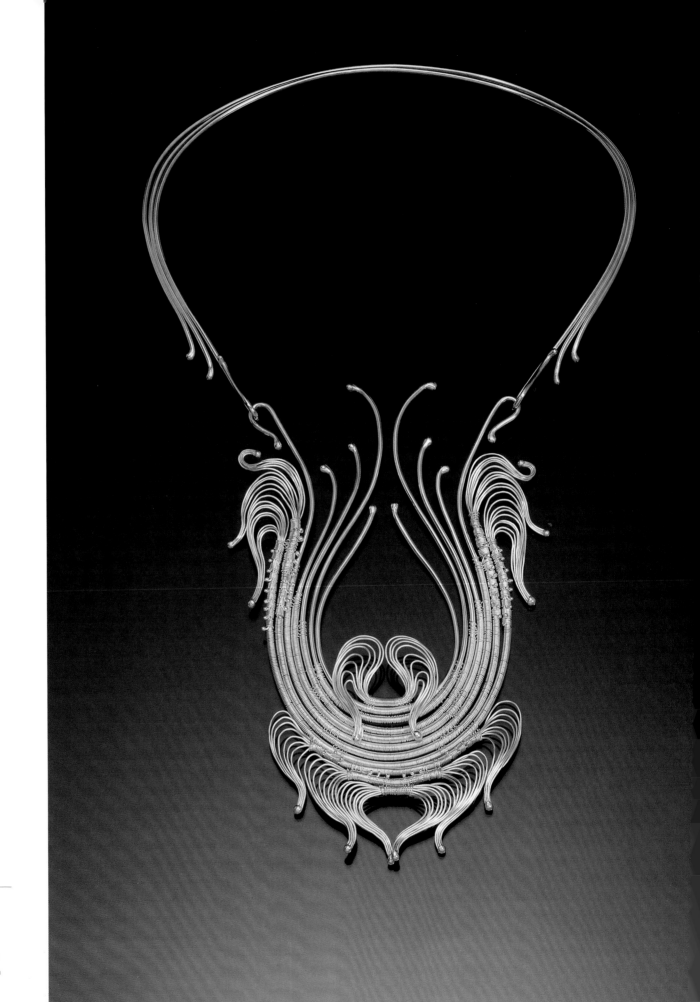

**Neckpiece #19**
1975; Fine and sterling silver
11¼ × 6½ × ½ in.
Collection of Tacoma Art
Museum, Gift of Flora Book,
1998.35.3A–C

**Neckpiece #22**
1975; Fine and sterling silver
9 × 6 × 1 in. Collection of
Karen Johnson Boyd; promised
Gift to the Racine Art Museum

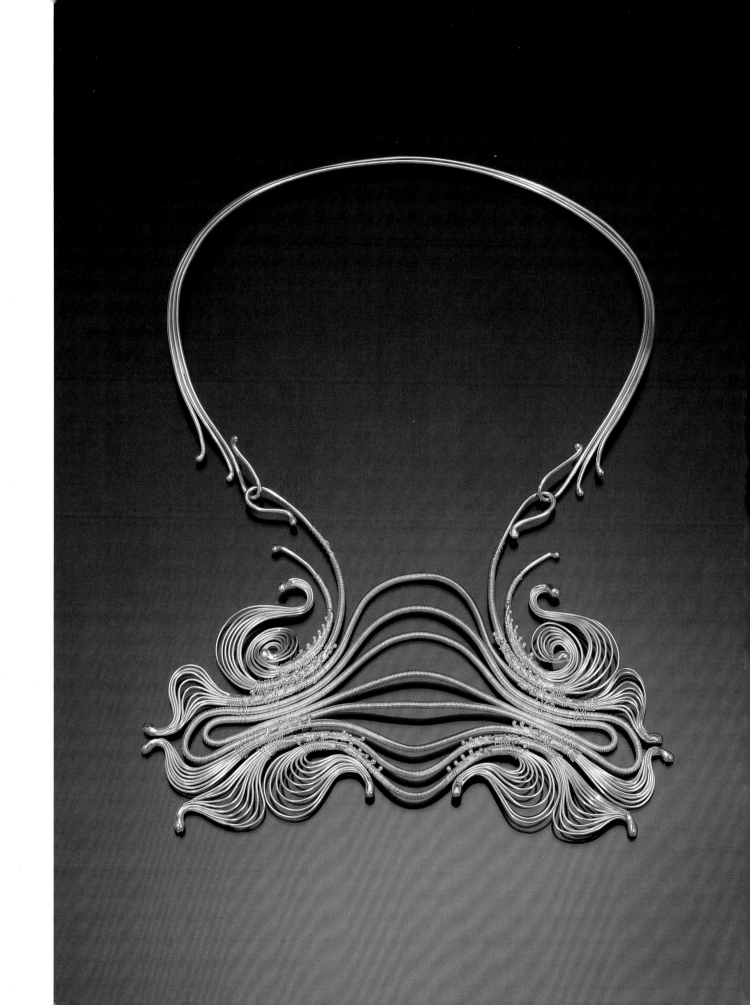

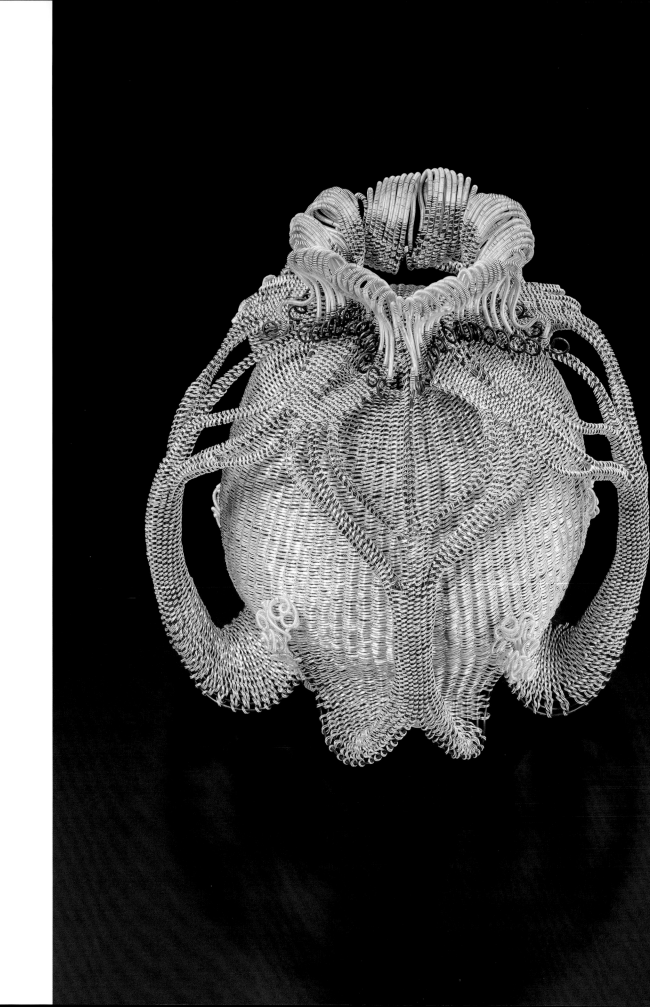

**Form #1 (one side)**
1974; Fine silver, lacquered
copper; 8 × 7½ × 7½ in.
Collection of the artist

**Form #1 (reverse side)**
1974; Fine silver, lacquered
copper; 8 × 7½ × 7½ in.
Collection of the artist

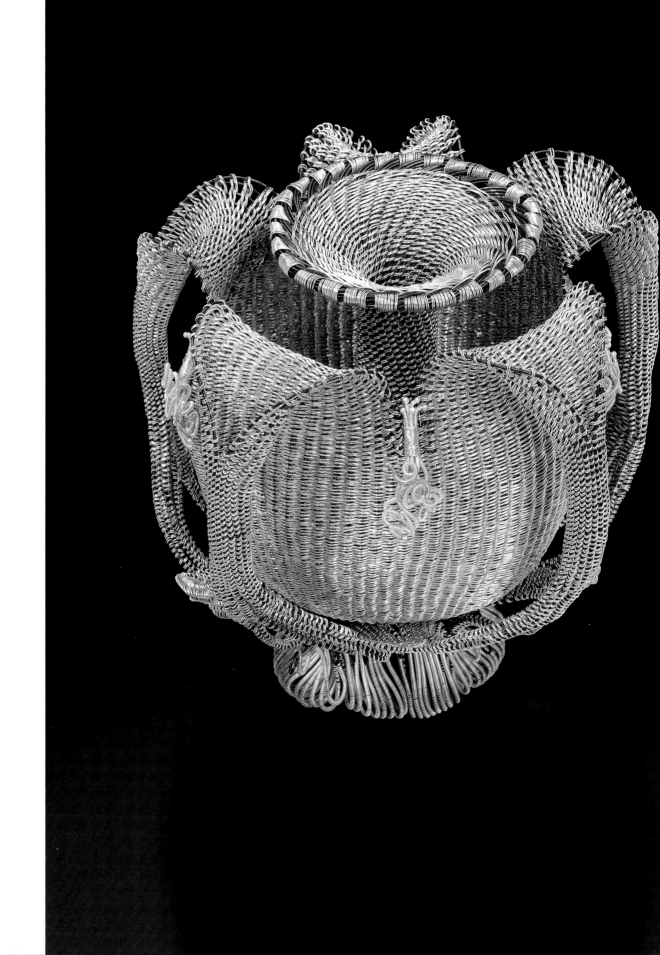

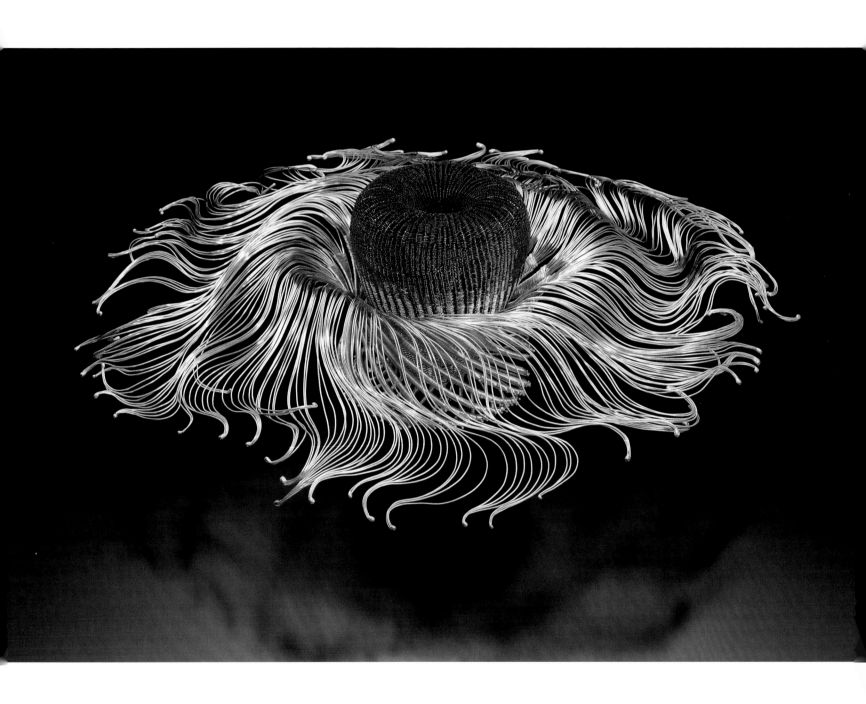

**Form #3 (one side)**
1977; Fine and sterling silver, lacquered copper;
6 × 18 × 18 in. Collection of the artist

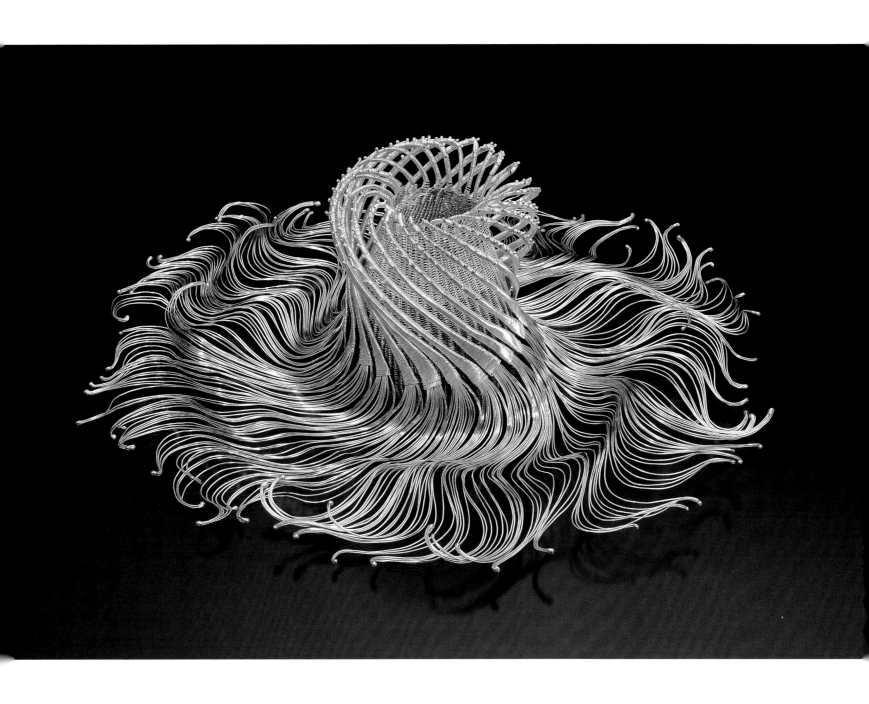

Form #3 (reverse side)
1977; Fine and sterling silver, lacquered copper
6 × 18 × 18 in. Collection of the artist

## Tide Pools

In the mid-1970s I was exploring different types of weaving by studying baskets. One was a Northwest Coast Native American basket made with strips of cedar bark, and I was attracted by its dense surface texture and the slight slant to the weft that comes from the twisting of the wefts. I discovered that this was called twining. Wanting to try twining but recalling how hard it was to weave flat wires at Rochester, I chose instead to achieve a flat element by twining with two round wires running parallel, allowing me maximum movement. The first major piece I made using this double twining was *Form #1*. Two years later, *Form #3* grew out of my making *Neckpiece #26*, where I was thinking about my mother's long wavy hair. I wanted to make another larger, non-jewelry piece, without weight and size constraints so that I could let it grow as large and heavy as needed to explore color patterning and longer parallel wavy lines. I was also thinking about the flow of linear things in the gentle currents of tide pools in Puget Sound where TK and I had lived before going to Taiwan. In working with a basketry process, I was not making a basket as such. What I wanted was to try to make the pieces of the Form series reversible—so that when looked at upside-down they would seem to be different pieces. I feel *Form #3* to be the most successful one.

Form #3 (detail)
1977; Fine and sterling silver,
lacquered copper; 6 × 18 × 18 in.
Collection of the artist

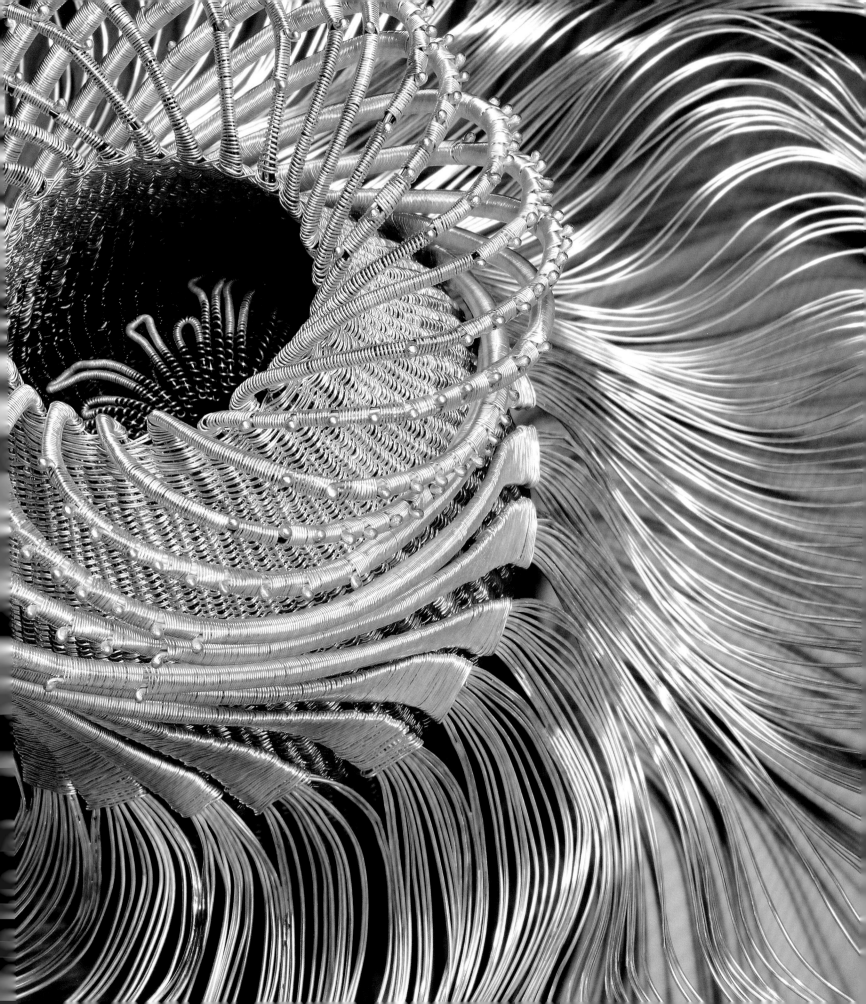

## The First Choker

While still working at my father's, I was also establishing my career by entering exhibitions, sending work to galleries, and starting to be invited to do workshops. The Akron Museum of Art invited me to be one of the exhibitors in a street fair tent they were sponsoring for the city's sesquicentennial celebration. This was a big deal for me and I was excitedly preparing for it. I didn't have enough work, and I only had a week left. I remember discussing this with my father at lunch one day, and thinking of ways to make simpler necklaces. Back in my studio, I tried making what amounted to a single earring, but worked on a heavier wire that went around the neck so that it became a necklace. By dinnertime I had the first one completed. Because it was so much smaller, resting high up on the neck, and also less complex than the neckpieces, I called it a choker—it was a real breakthrough for me. By week's end I had about a dozen completed. I did make a few more neckpieces, but then ended that series with *Neckpiece #26* of 1976 and concentrated on the Choker series.

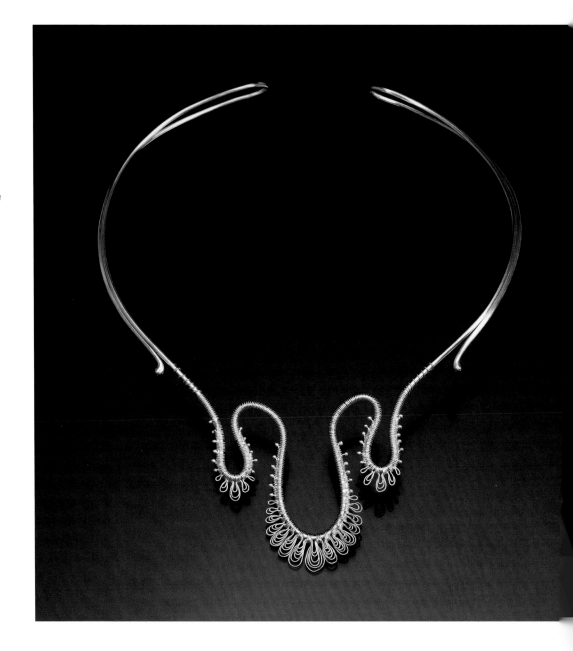

**Choker #1**
1975; Fine and sterling
silver; 6½ × 5⅛ × 1/16 in.
Private collection

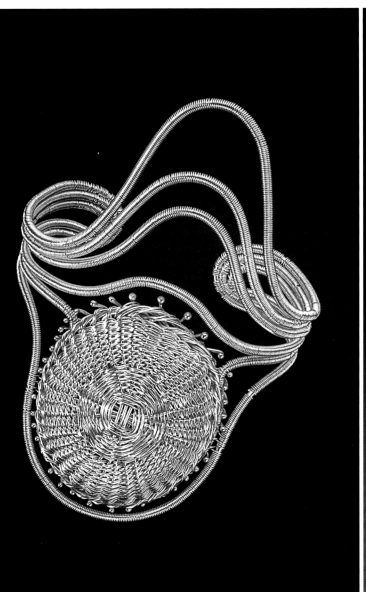

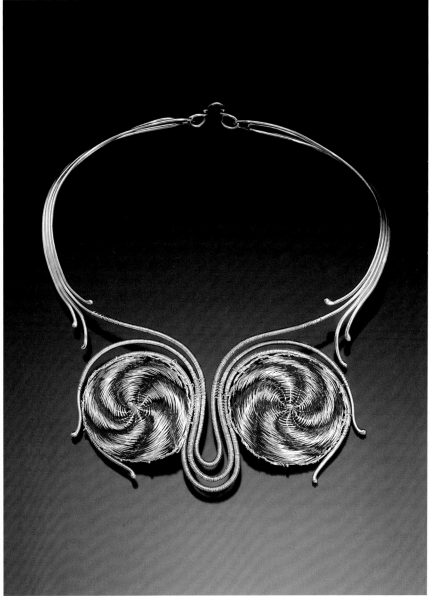

Bracelet #1
1975; Fine and sterling silver; 2 × 2¾ × 3¾ in.
Collection of The Worshipful Company of
Goldsmiths, London

Choker #9
1975; Fine and sterling silver, lacquered
copper; 7¼ × 6 × ¼ in. Collection of
Robert M. and Jeanne Lurie

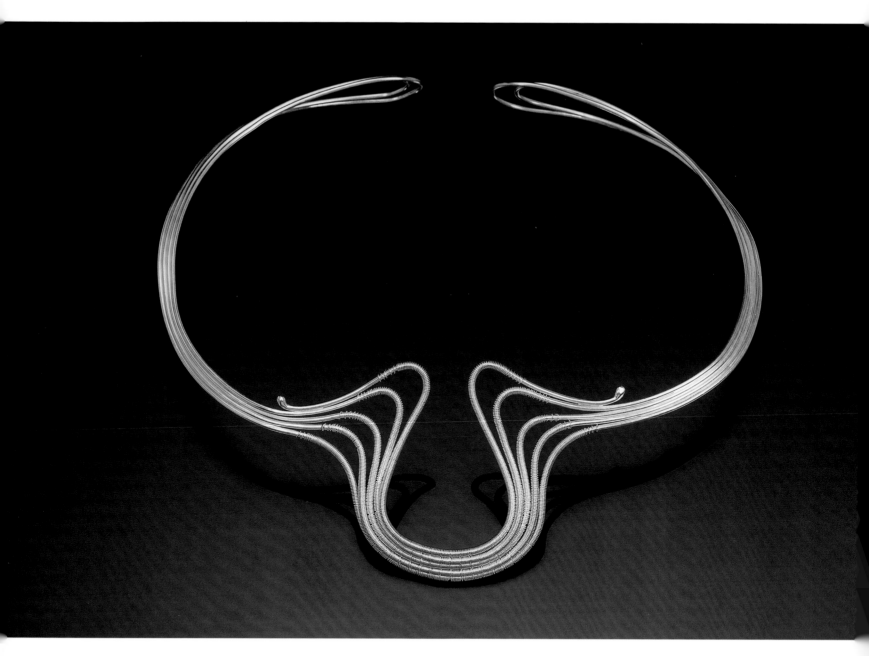

**Choker #25**
1976; Fine and sterling silver; 7¼ × 6½ × 1¼ in.
Collection of Nancy Demorest Pujol

**Choker #35**
1977; Fine and sterling silver, 24K gold, lacquered copper
electrical wire; 9 × 7 × 1½ in. Collection of The Metropolitan
Museum of Art, Gift of Donna Schneier, 2007 (2007.384.23)

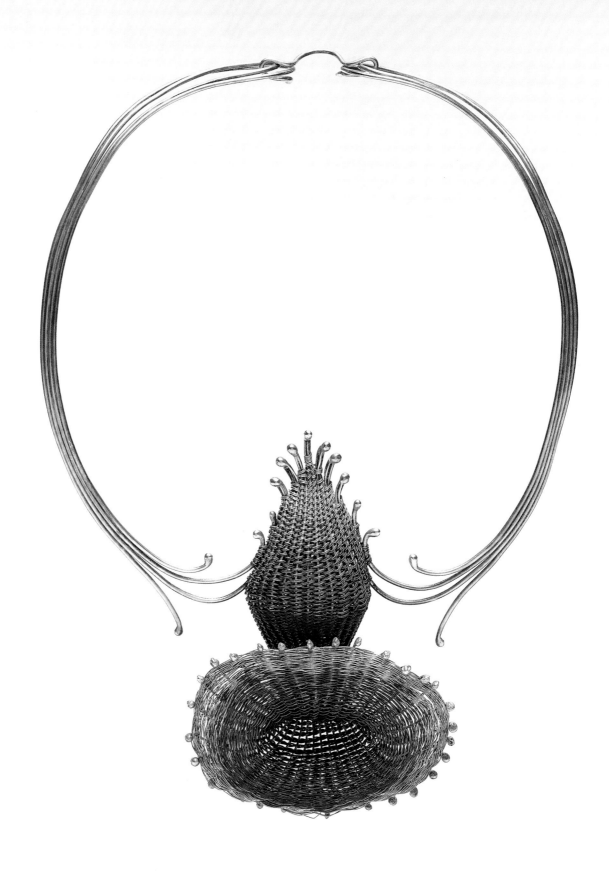

## 99 Cents at the Goodwill

In 2005, I received an email from a woman in San Francisco with an attached photo of my *Choker #26*. She asked if I had made it. She said she had found it in the Goodwill for 99 cents and loved it. She saw *HU* stamped on the back, and after some research wondered if the piece might be mine. I was very pleased to be able to tell her that yes, indeed, it was mine. I had sold it to someone in 1976, but had not kept a record as to whom, so now one of my lost ones was found. How it ended up at the Goodwill I will probably never know, but I used this story as an example to my students of the importance of signing their work.

**Choker #26**
1976; Fine and sterling silver, 18K
and 24K gold; 9½ × 6½ × 1¾ in.
Collection of Christo Braun

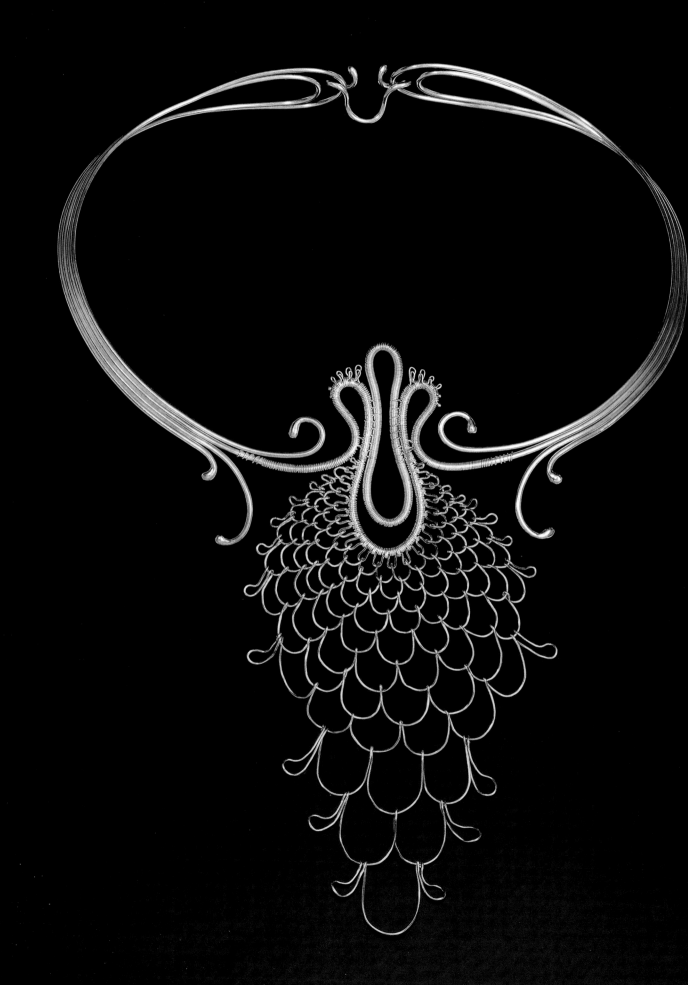

## American Art Rummy

A number of years ago a high school student in the Midwest sent me an email. She said she had to do a term paper on an artist and had chosen me because I was her favorite card in her art rummy card game. I asked, "What card game!" So she sent me a scanned picture of it. As it turned out, in 1989, the Smithsonian Institution had published an American Art Rummy card game, in which the cards pictured artworks in their collection in the categories of sculpture, photography, miniatures, folk art, paintings—landscapes, seascapes, portraits, still life, abstracts—and then crafts, where my *Choker #38* was pictured. I called the shop at the Renwick Gallery hoping to buy a copy but they had not had it in a number of years. Three cheers for eBay, there it was.

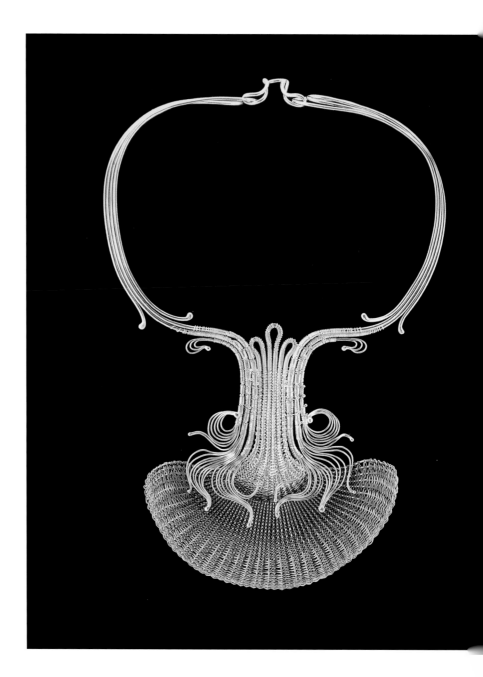

**Choker #38**
1978; Fine and sterling silver, 18K and 24K gold, with lacquered copper; 9 × 7 × 1½ in.
Smithsonian American Art Museum, Gift of the James Renwick Alliance 1985.22

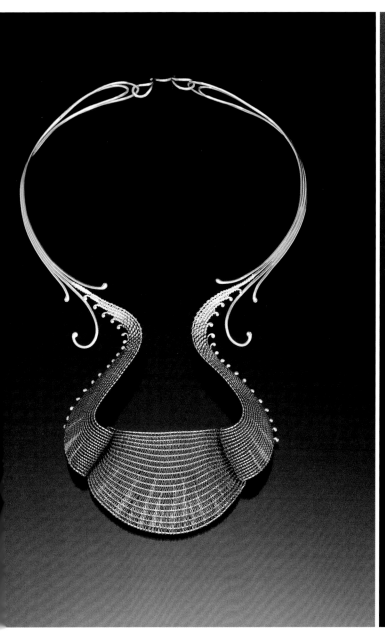

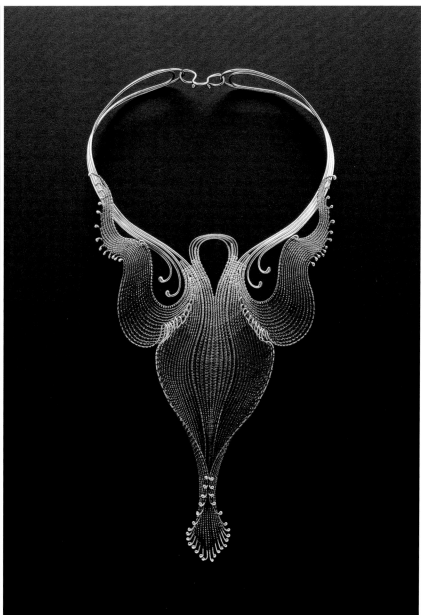

Choker #40
1978; Fine and sterling silver, 22K gold, lacquered
copper; 10 × 6½ × 1½ in. Collection of
Metal Museum, Memphis

Choker #43
1978; Fine and sterling silver, with lacquered
copper; 12½ × 6¾ × about 1 in. Collection of
Indiana University Art Museum, Bloomington, Indiana

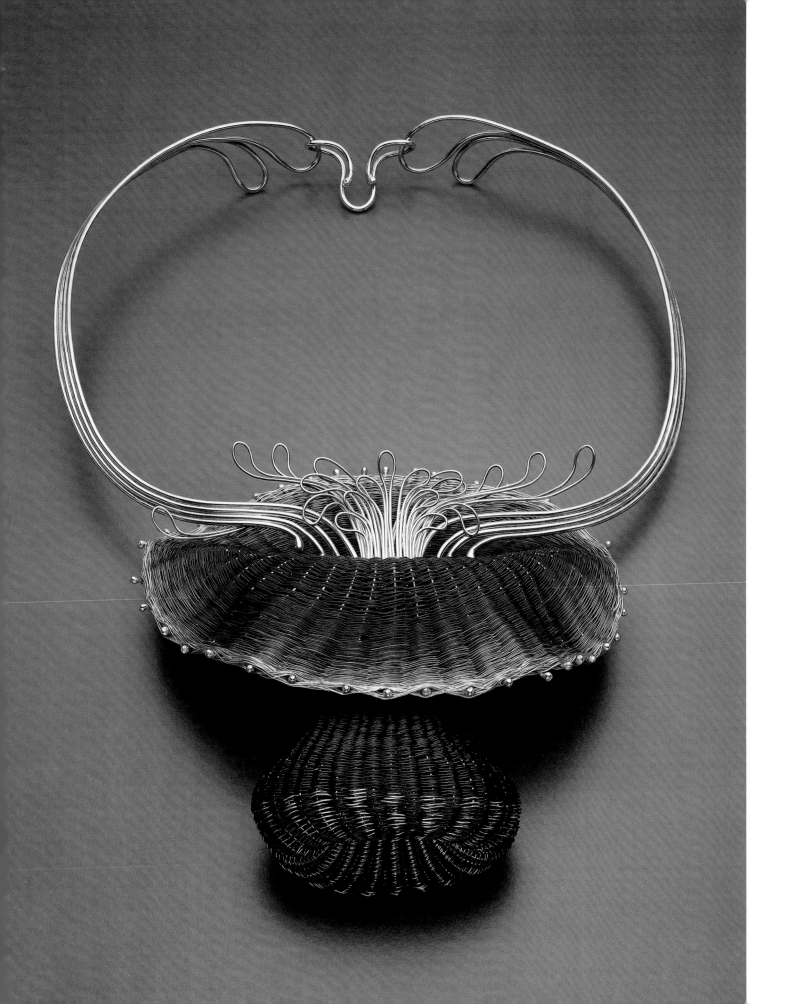

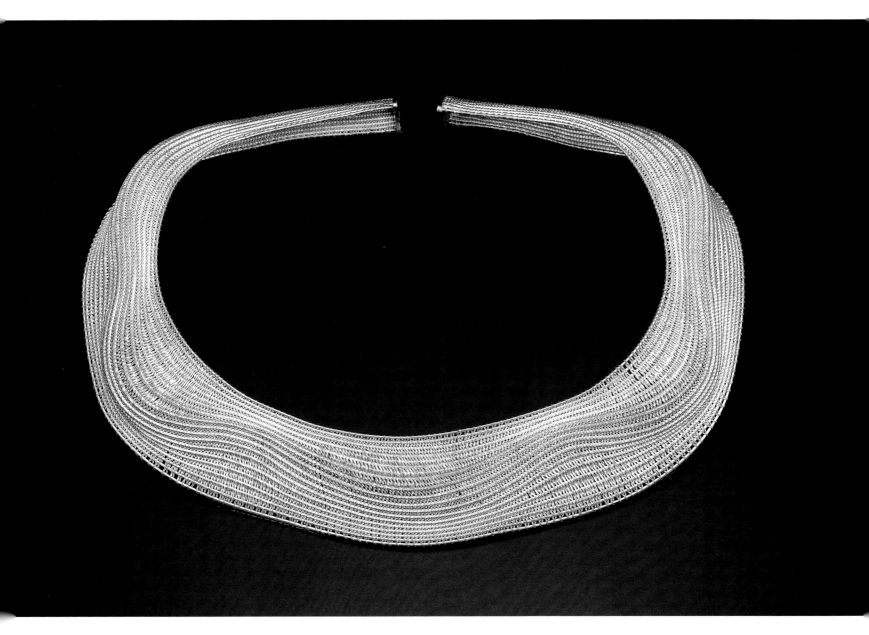

**Choker #48**
1979; Fine and sterling silver, 24K gold, lacquered copper
9¼ × 7 × 1¾ in. Collection of Museum of Fine Arts, Boston;
The Daphne Farago Collection

**Choker #55**
1980; Fine and sterling silver; 6 × 8⅜ × 1 in. Collection of Museum of
Arts & Design, New York. Purchased by the American Craft Council
with funds provided by the National Endowment of the Arts, 1984

## The Torques

By 1978, double twining had become my signature style and the Choker series—at first small, simple pieces—now included more elaborate, colored neckpieces. By then I had also seen a number of major exhibitions— Scythian gold, Thracian gold, Irish gold— and realized that my favorite pieces were the gold torques, strong forms that twisted around the neck. I decided to make torques. Of the historic ones, some were round in cross-section—solid groupings of twisted wires that looked like cables or ropes—others were flat, patterned sheets. I explored both forms, first twining hollow, patterned tubes and then various pattern ideas in flat sheet forms. Almost every one was designed to give me a fresh technical challenge. I made about nine-teen silver torques in the late 1970s and early 1980s before I switched to gold.

## Crappy Crafts

The challenge I gave myself in *Choker #58* was to do a slit tapestry-weave design with gold and silver. Having the two sets of wefts and battling to keep everything from get-ting tangled was definitely more fuss! I was teaching a lot of workshops in those days and would take the piece to work on in the airport and on the airplane; although this was a practice I stopped when I began to work all in gold. Once, as I was working on the plane, a woman across from me asked whether I was working from a pattern or did I make up my own designs. I said that it was my own design, and she said that was very good . . . she really did not like "crappy crafts."

Choker #58
1980; Fine and sterling silver,
with 24K gold; 6 × 7¾ × 1½ in.
Collection of the late Joy Rushfelt

Choker #59
1980; Fine and sterling silver
8¾ × 7½ × 1½ in. Collection
of Ginny and Andy Lewis

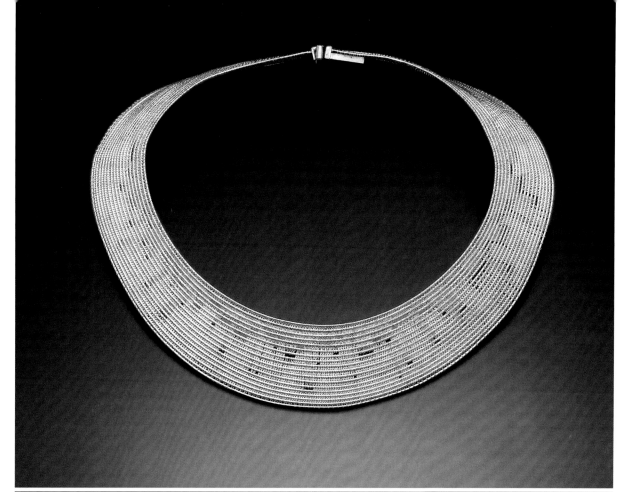

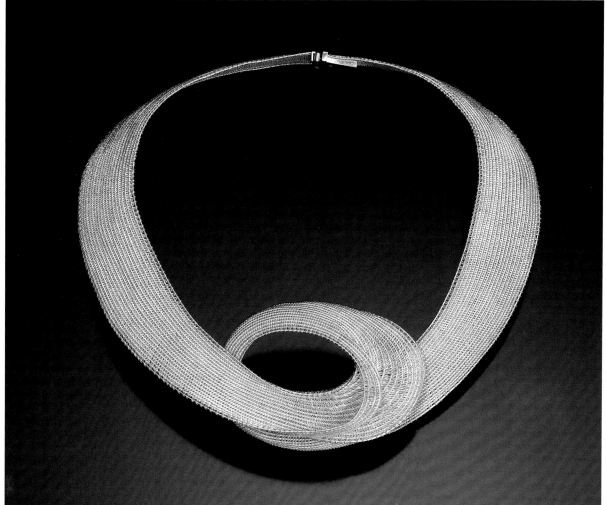

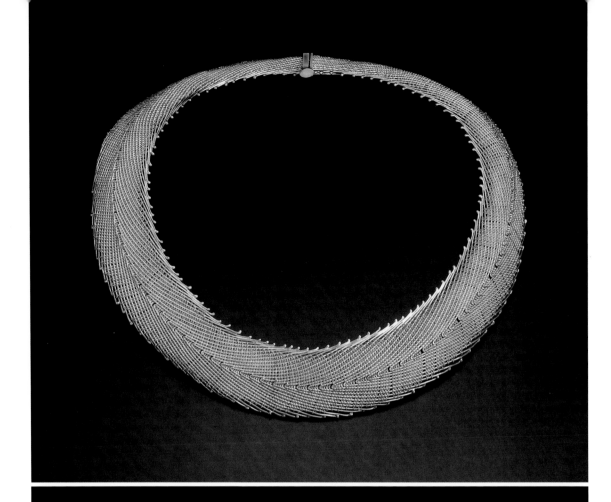

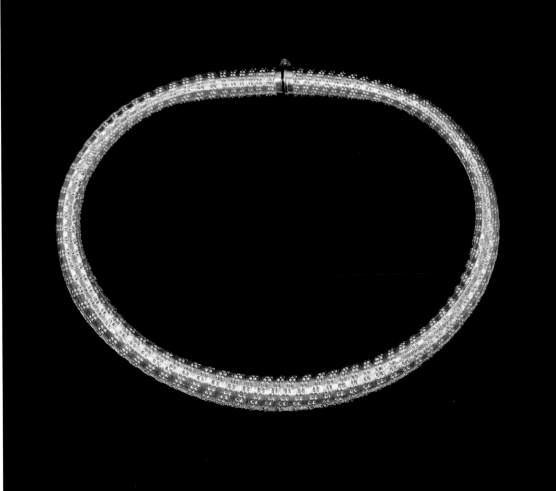

**Choker #61**
1981; Fine and sterling
silver; 7¾ × 8¼ × 1 in.
Collection of John and
Jane Marshall

**Choker #62**
1981; Fine and sterling
silver; 6¼ × 6¾ × 1 in.
Collection of K. Raven Kim

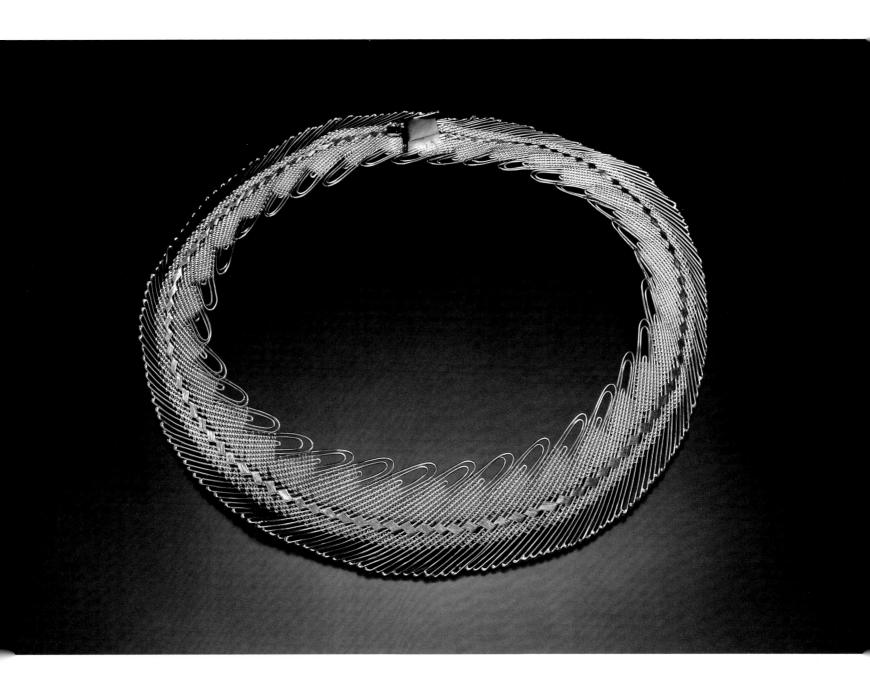

Choker #65
1981; Fine and sterling silver
with 22K gold; 7 × 8½ × 1 in.
Collection of Nancy A. Marks

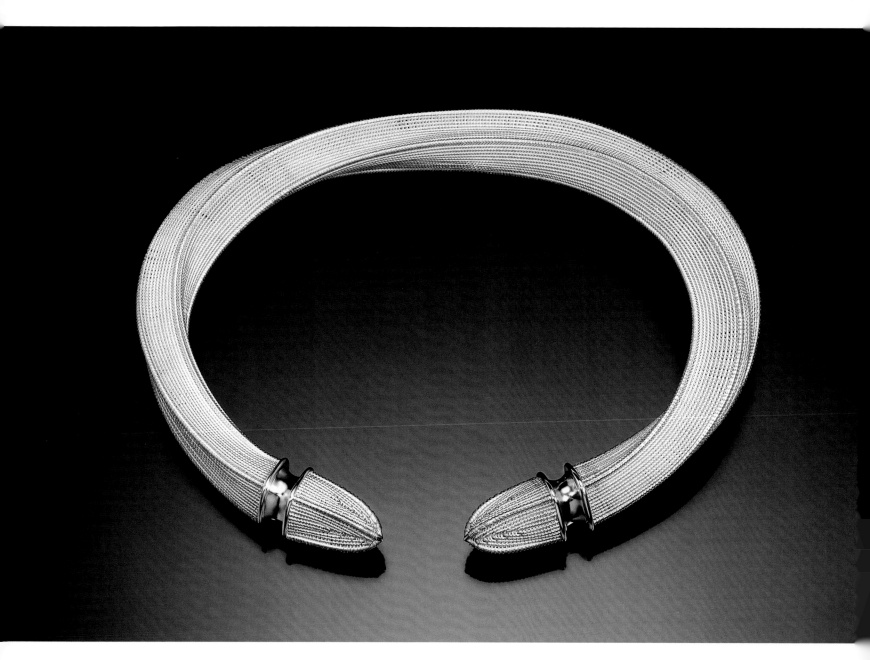

**Choker #67**
1984; Fine and sterling silver with 14K gold
6¾ × 8½ × 1 in. Collection of K. Raven Kim

**Choker #69**
1985; Fine and sterling silver with 18K gold
8 × 8 × 1 in. Collection of Emily Gurtman

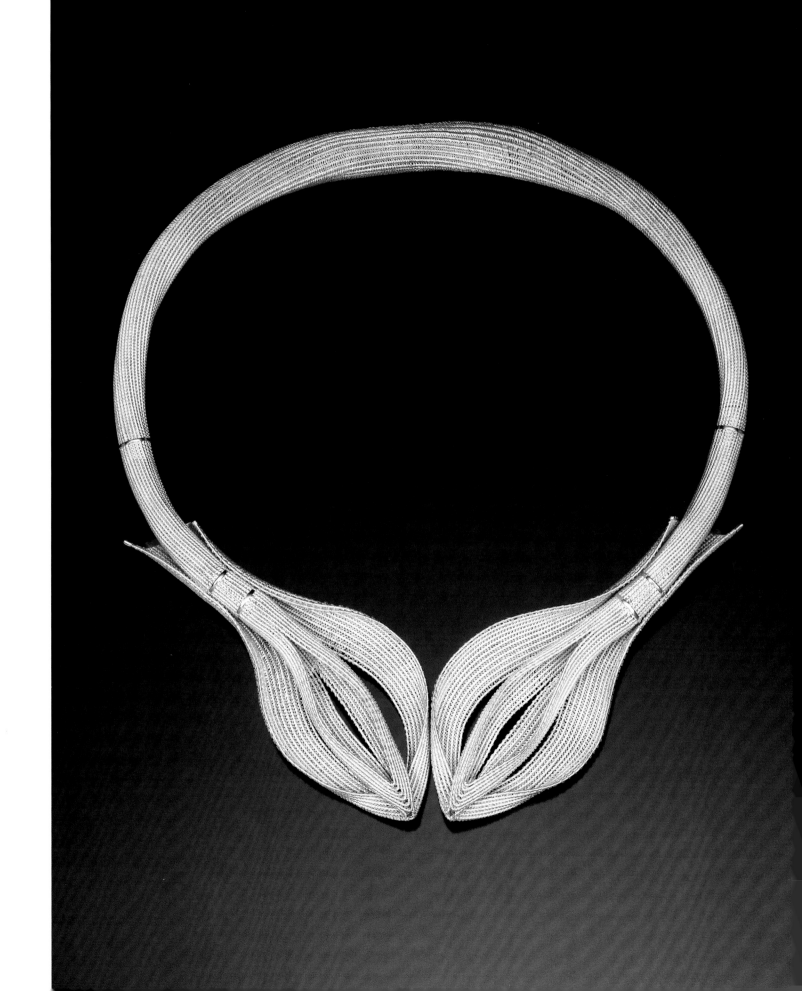

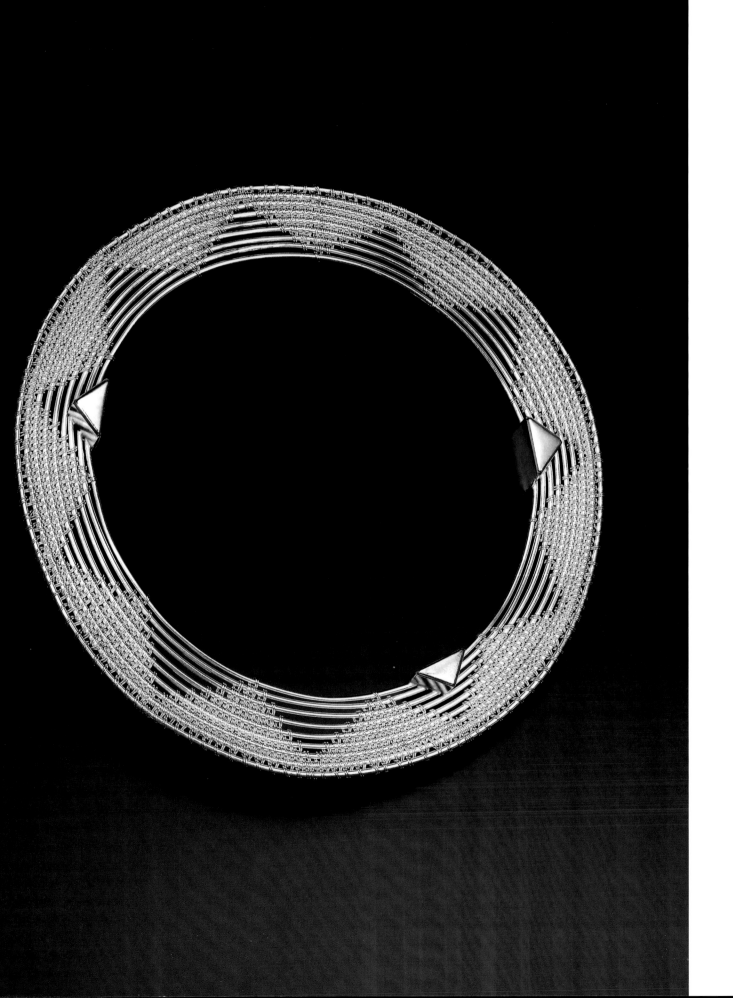

## Bracelets

The torques I made in the 1970s were both flat and tubular. The bracelets that followed were first based on a flat choker (*Choker #55*)—twined from one end to the other, and very free flowing and asymmetrical (*Bracelet #3*). Then I wanted to make a tubular bracelet but I couldn't bend a large tube in the tight arc needed to go around the wrist while still keeping the twining densely packed. So I tried cutting the tube into sections and soldering them back together, making a triangular or square bangle, and found that if I added some slightly larger element where they joined the transition looked better (*Bracelet #17*, *Bracelet #27*, and *Bracelet #30*). These segmented bracelets were a new departure as they were made in two stages. I was interested in the damascene patterns I could get on the twined surfaces, and first concentrated on drafting a variety of patterns and twining the tubes in many diameters (see the Log Pile, p. 30). Most of the tubes were slightly curved—my wire came in a coil, and as I measured off lengths to be the warp wires I just left them in the arc they had. Then, after accumulating a number of tubes, I started designing the bracelets. Now I was mostly concerned with the form the joints would take, and had fun forging sheet tubes into flared forms. I was designing them in profile and they became more geometric.

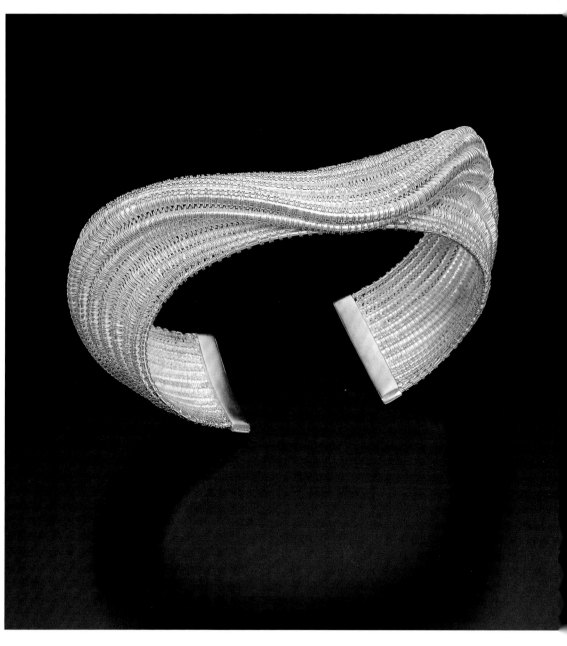

Bracelet #11    (left)
1982; Fine and sterling silver
3¾ × 3¾ × ¼ in. Collection of K. Raven Kim

Bracelet #3
1981; Fine and sterling silver
2¼ × 3½ × 1⅛ in. Collection of Phillip Baldwin

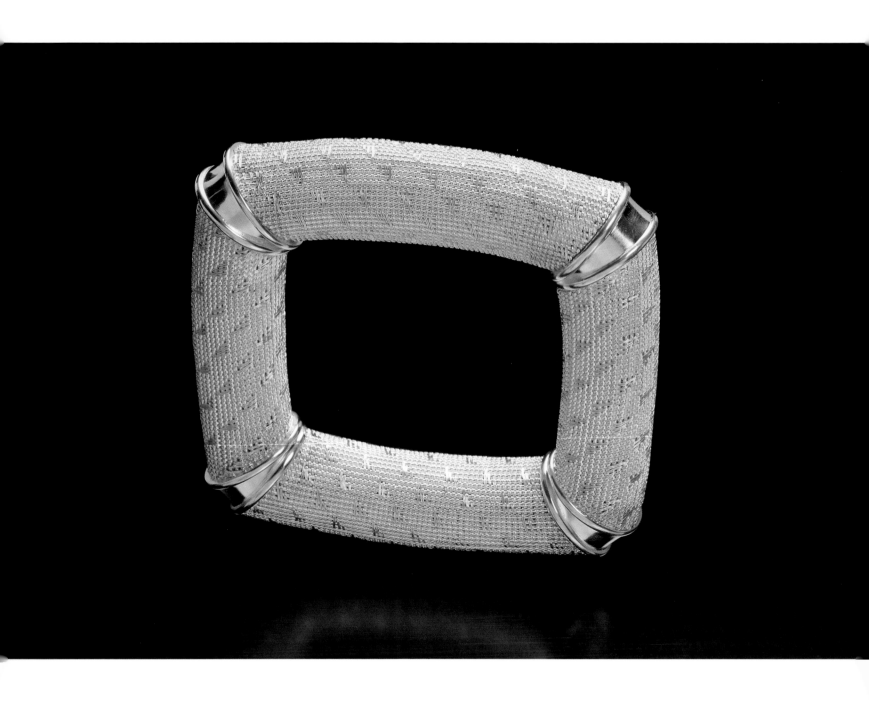

Bracelet #17
1982; Fine and sterling silver with 14K gold
3½ × 4 × ¾ in. Collection of the artist

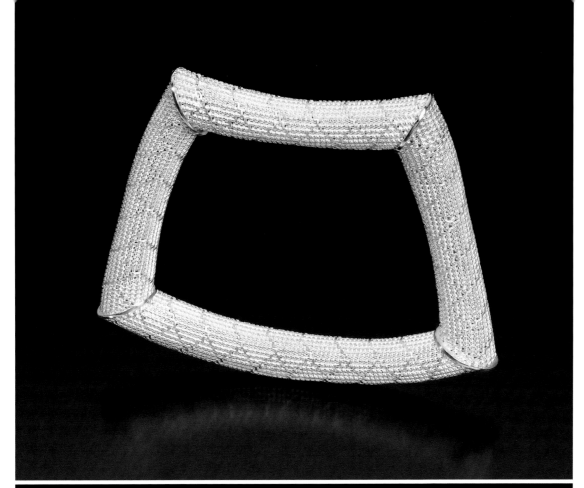

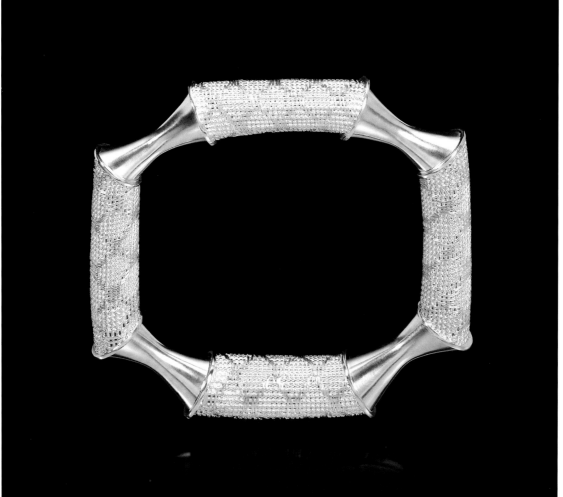

**Bracelet #27**
1984; Fine and sterling silver
with 14K gold; 2¾ × 3½ × ½ in.
Collection of Leanette Bassetti

**Bracelet #30**
1984; Fine and sterling silver
with 14K gold; 3⅛ × 3⅞ × ⅝ in.
Collection of K. Raven Kim

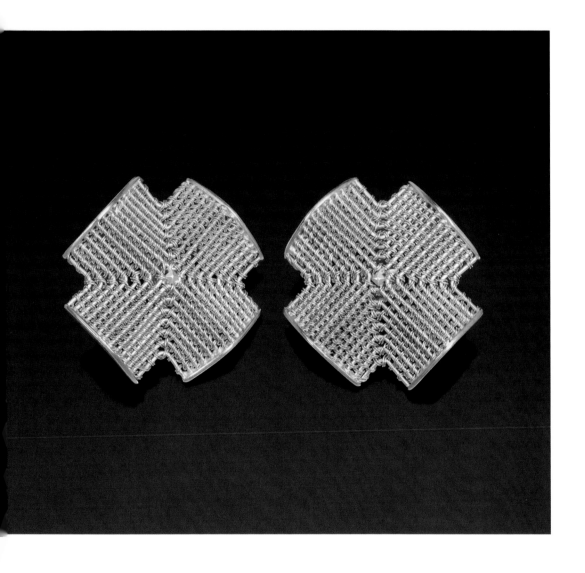

## Aida and Gold

In 1984 I was making earrings of small twined elements. As I was sanding down the edges of a pair of twined *X*s, they got pushed together on my bench and I fell in love with the diamond negative shape that formed between them, thinking what a great torque a row of them would make. A year later, Byzantium, my New York gallery, asked each of its jewelers to create a major piece in gold for an exhibition celebrating the 50th anniversary of the Metropolitan Opera Guild. I was assigned the soprano Elizabeth Rethberg in her role in *Aida*, and received a picture of her in her stage jewelry—a broad necklace made of tubular glass beads strung like mummy-bead netting—and full of diamond negatives. To see if I could actually do it, I made about a third of it in silver, and then took the plunge and ordered the ten ounces of gold it would need. I really liked the look of this repetition of forms that I called tessellation. And I loved working in gold! It demanded that I be a better craftsman, yet once I was used to working with it I actually found it much easier to work with than silver. I was soon making gold bracelets where I continued with the ideas of joining patterned tubes developed in the silver series (*Bracelet #27*, *Bracelet #41*, and *Bracelet #47*). I also used thinner slices for rings (*Ring #4* and *Ring #60*), and tiny tubes in some earrings (*Earrings #126* and *Earrings #132*).

**Earrings #120**
1986; 18K and 22K gold
1¹⁄₁₆ × 1¹⁄₁₆ × 1/4 in.
Collection of the artist

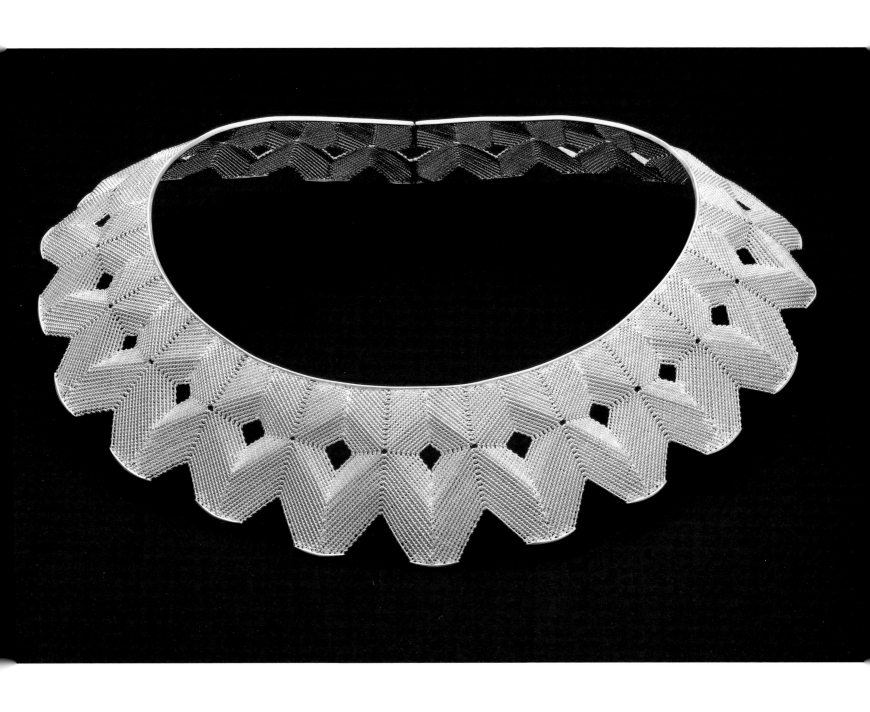

Choker #70
1985; 18K and 22K gold; 6 × 9½ × 3 in. Collection
of The Metropolitan Museum of Art; Gift of Donna
Schneier, 2007 (2007.384.22)

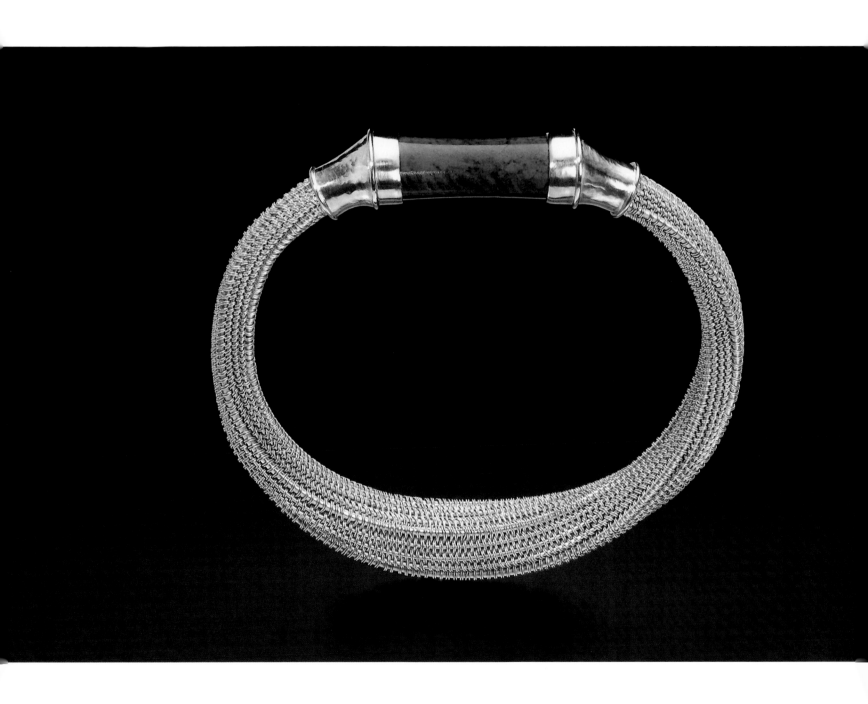

**Bracelet #37**
1986; 18K and 22K gold, lapis lazuli;
2¾ × 3¼ × ½ in. Collection of the artist

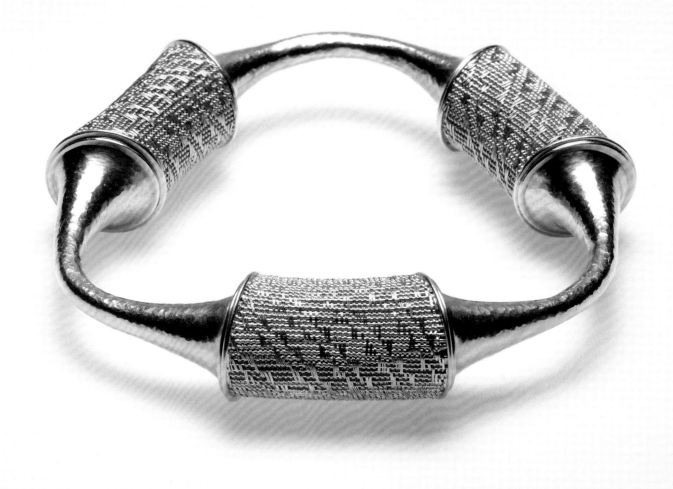

Bracelet #47
1992; 18K and 22K gold; 3½ × 3½ × ⅝ in.
Collection of Museum of Fine Arts, Boston;
The Daphne Farago Collection

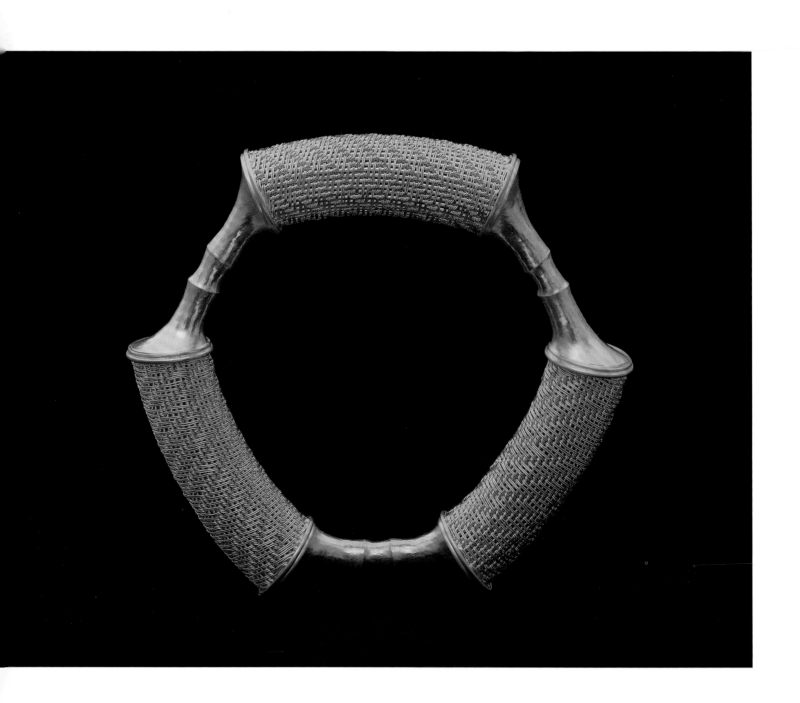

**Bracelet #41**
1988; 18K and 22K gold; 3½ × 3¾ × ⅝ in.
Collection of Museum of Arts & Design, New
York; Gift of Edward and Vivian Merrin, 1991

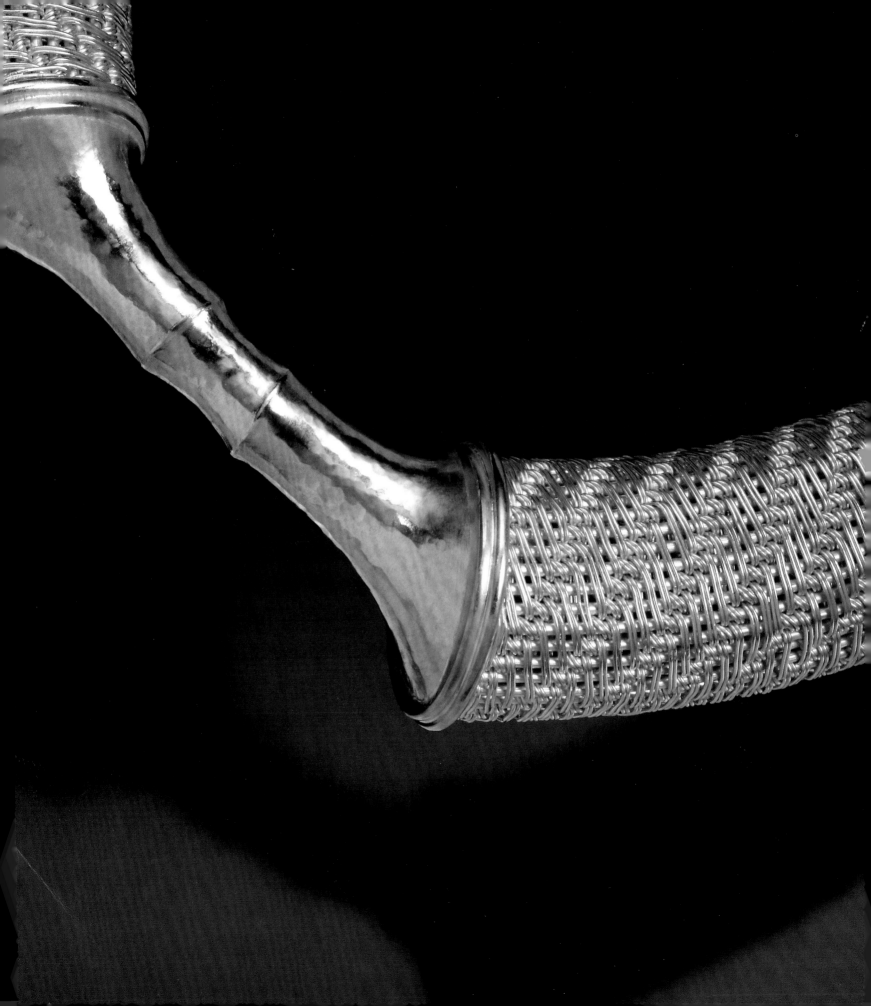

**Earrings #126**
1988; 18K and 22K
gold; 1¾ × ½ × 1¼ in.
Collection of the artist

**Earrings #132**
1989; 18K and 22K
gold; 1¾ × 1¾ in × ¼ in.
Collection of the artist

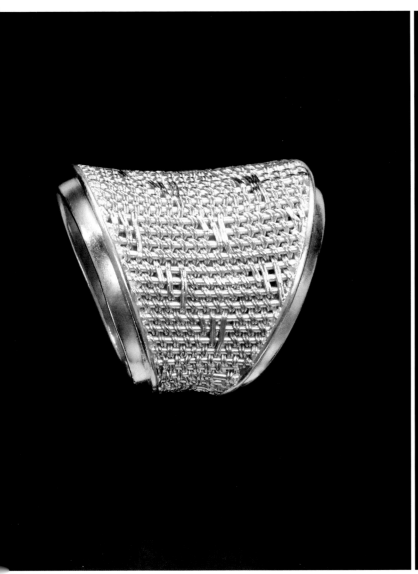

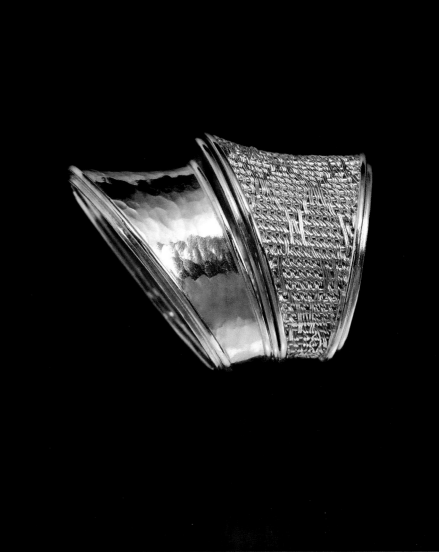

Ring #4
1985; 18K and 24K gold
1 × ¾ × ¾ in. Collection
of the artist

Ring #60
1994; 18K and 22K gold
1 × 1⅛ × ⅞ in. Collection
of Susan C. Beech

## String of Pearls

A year after I made *Choker #70* it sold. This gave me the reinforcement I needed to know that my switch to gold was both possible financially and right aesthetically. After all, the inspiration for my torques had come from the ancient gold ones, and so I thought, mine really should be in gold. Twining the small shapes and then soldering them together while controlling the negative shape that formed was challenging. My chokers had always tapered toward the back, and so each element now needed to be made just a bit smaller as they progressed from front to back. Then, still more care was needed in sanding adjacent elements so that they fit closely for soldering; if I sanded too much the negative shape would distort the symmetry of my design. So, the challenge I gave myself with *Choker #73* was to have an evenly graduated row of circles —like a traditional string of pearls.

**Choker #73**
1988; 18K and 22K gold
6 × 9 × 2 in. Collection
of Dorothy R. Saxe

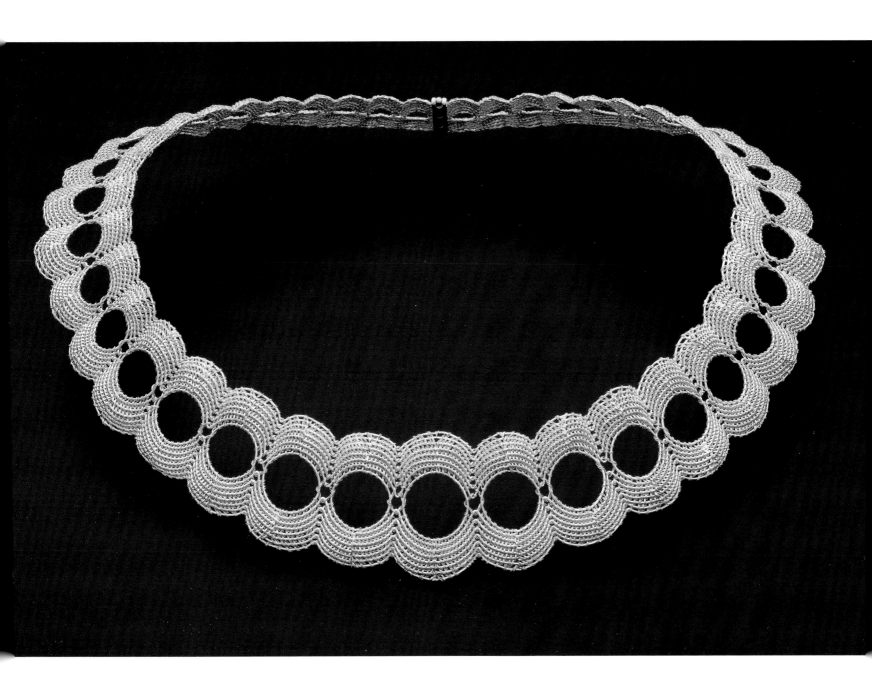

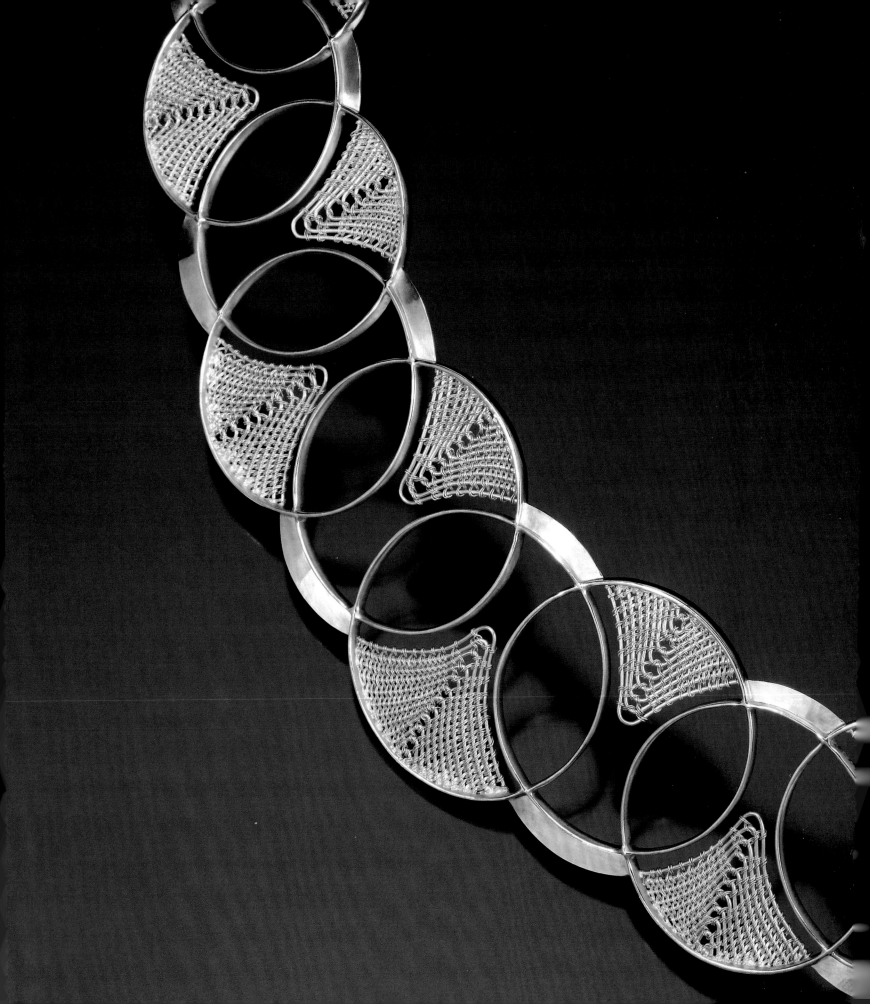

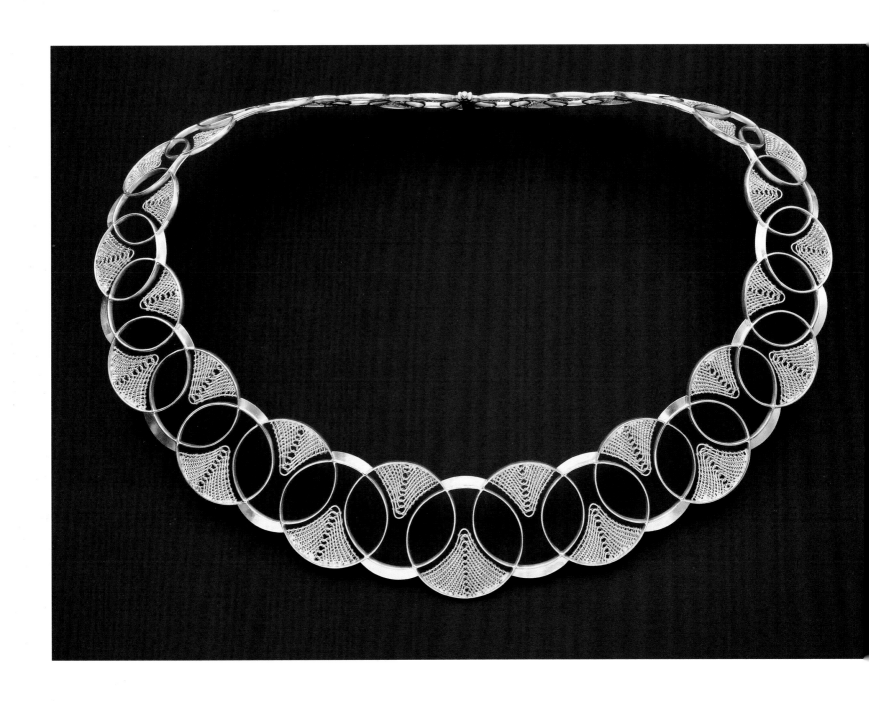

Choker #79
1992; 18K and 22K gold
6 × 8⅞ × 1⅝ in. Collection
of Catherine Mouly

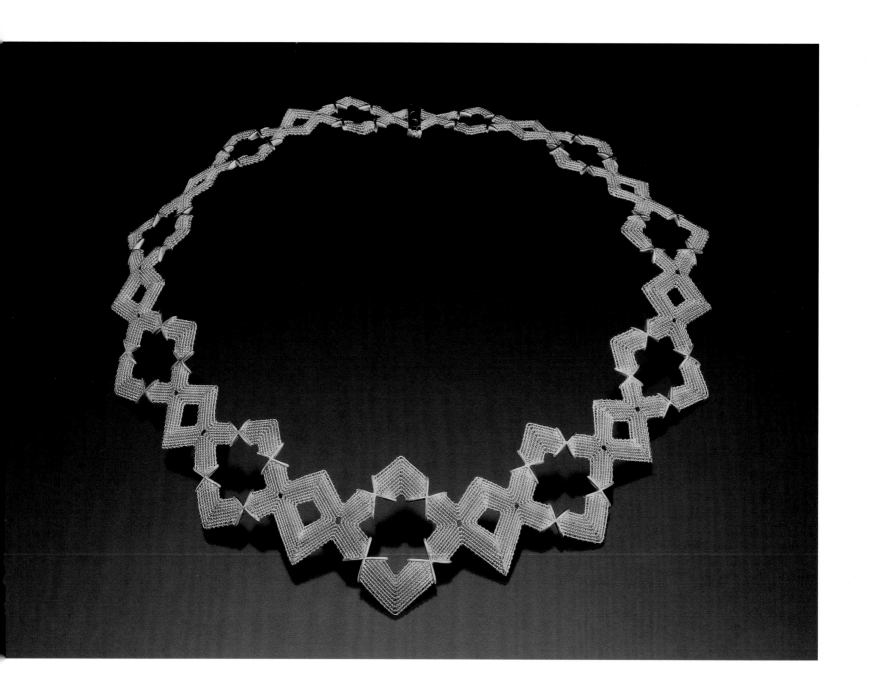

**Choker #81**
1993; 18K and 22K gold; 6½ × 7 × 1 in.
Collection of The Newark Museum, Purchase 2007,
Helen McMahon Brady Cutting Fund

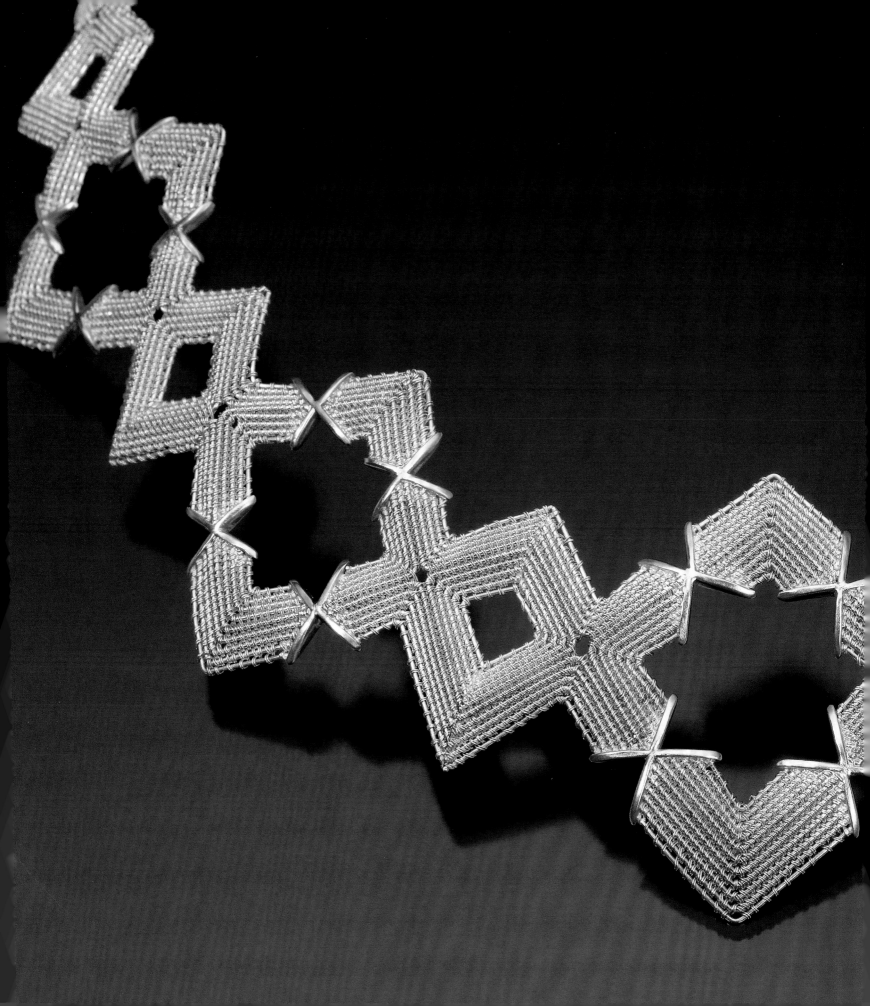

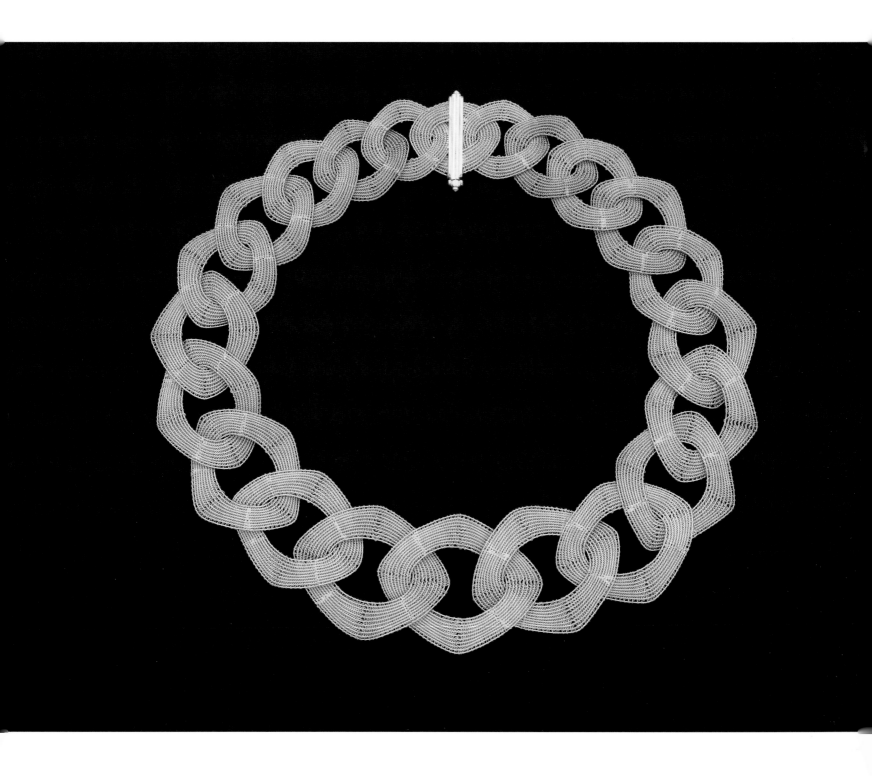

Choker #80
1992; 18K and 22K gold
7 × 8 × ¼ in. Private collection

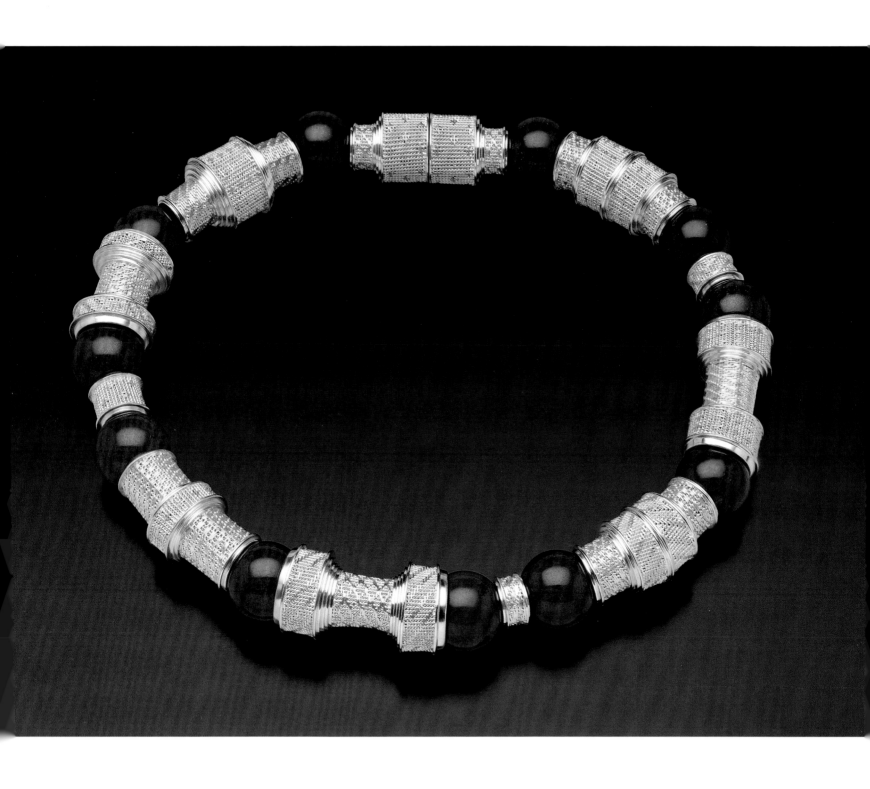

**Choker #82**
1997; 14K, 18K, and 22K gold, lapis lazuli; 7 × 7 × 1 in.
Collection of Museum of Fine Arts, Boston; The Daphne
Farago Collection

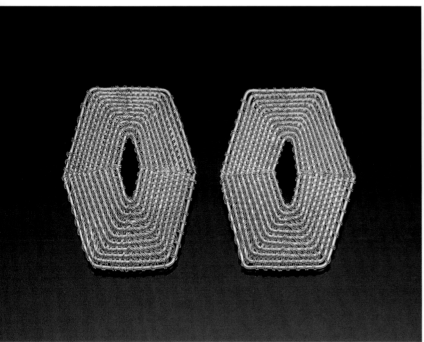

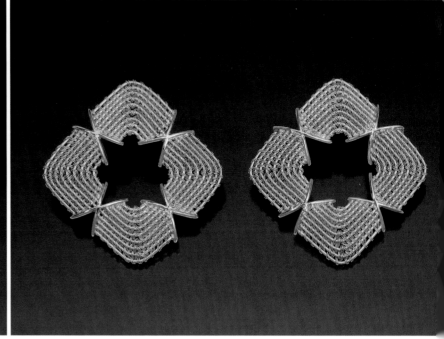

Earrings #130
1989; 18K and 22K gold; 1 1/16 × 1 1/8 × 1/2 in.
Collection of Susan Edelheit

Earrings #138
1996; 18K and 22K gold; 1 1/4 × 1 1/4 × 1/2 in. Collection
of Racine Art Museum; The Donna Schneier Jewelry
Collection, Gift of Donna Schneier and Leonard Goldberg

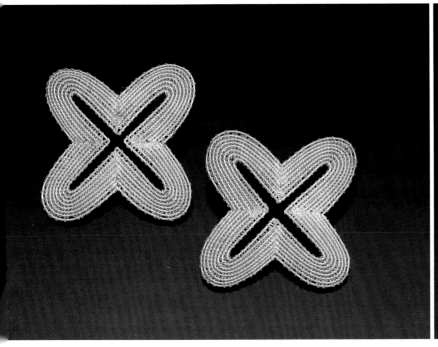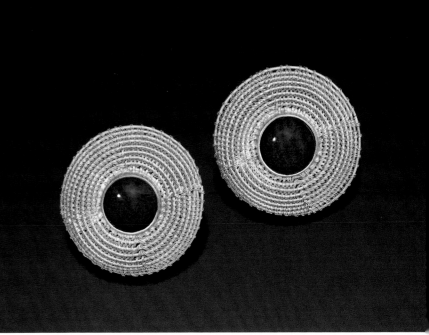

Earrings #146
1993; 18K and 22K gold
1⅝ × 1⅝ × ½ in. Collection
of Jane Korman

Earrings #156
1996; 18K and 22K gold, lapis
lazuli; 1 × 1 × ½ in. Collection
of Mrs. Rita Rosen

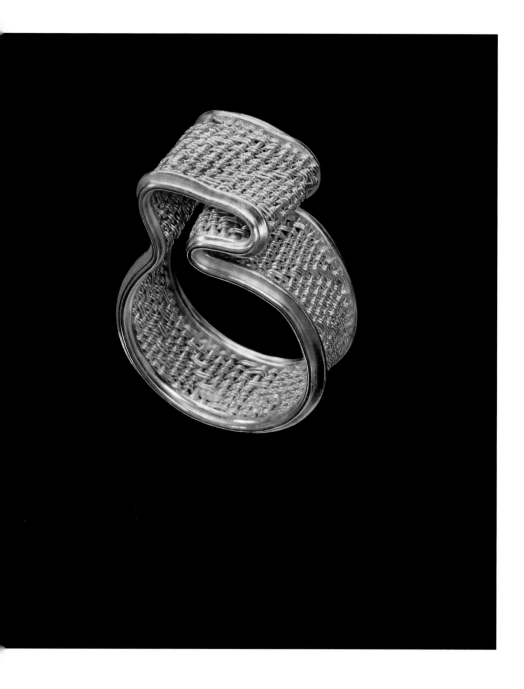

## Catharsis

In the mid-1990s, while preparing to teach my History of Body Adornment course at the university, I did very little bench work. So when I returned to prepare for a solo show, I thought ideas would come flooding in. But no . . . it seemed I was still where I had left off earlier—making permutations of X combinations. I wanted something else, and thought, I've been making rings from slices of a tube, how about trying the same thing for bracelets? I twined a tube large enough to be a bangle bracelet and took off a couple of slices, but they were just bangles. For the third slice, I inserted concave sections of a smaller tube, making three reversed areas in the bracelet's main convex curve (*Bracelet #54*). But I still had one piece of the smaller tube left. It was too big for a ring and too small for a bracelet, and I did not need a gold napkin ring. One day I slid it onto the mandrel to my finger size and hit it with my mallet until it was small enough to fit my finger (*Ring #90*). That felt great! There was an element of spontaneity, daring, even danger to it that had been lacking in my work. It became the beginning of a whole new series that carried me back to using curves after all the tight geometry of the previous decade.

*Ring #90*
1998; 18K and 22K gold
1⅜ × 1 × ¼ in.
Collection of the artist

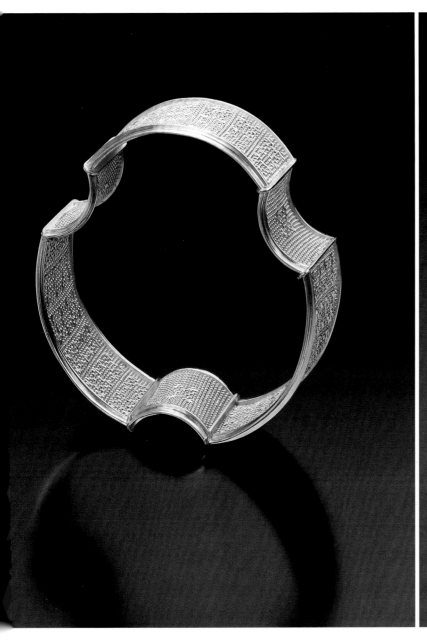

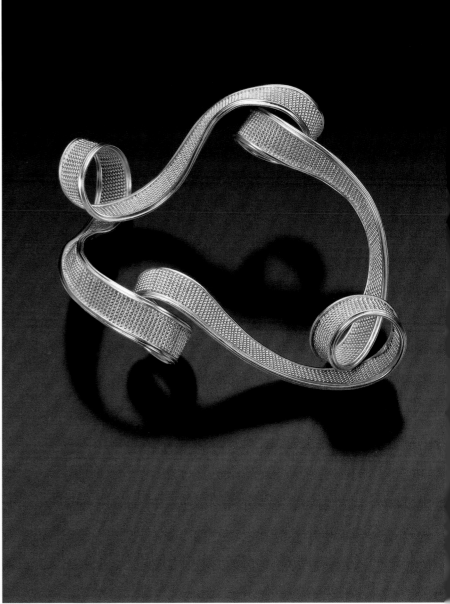

Bracelet #54
1998; 18K and 22K gold; 3 × 3 × ⅞ in.
Collection of Susan C. Beech

Bracelet #57
1999; 18K and 22K gold; 2½ × 4½ × 1½ in.
Collection of Dorothy R. Saxe

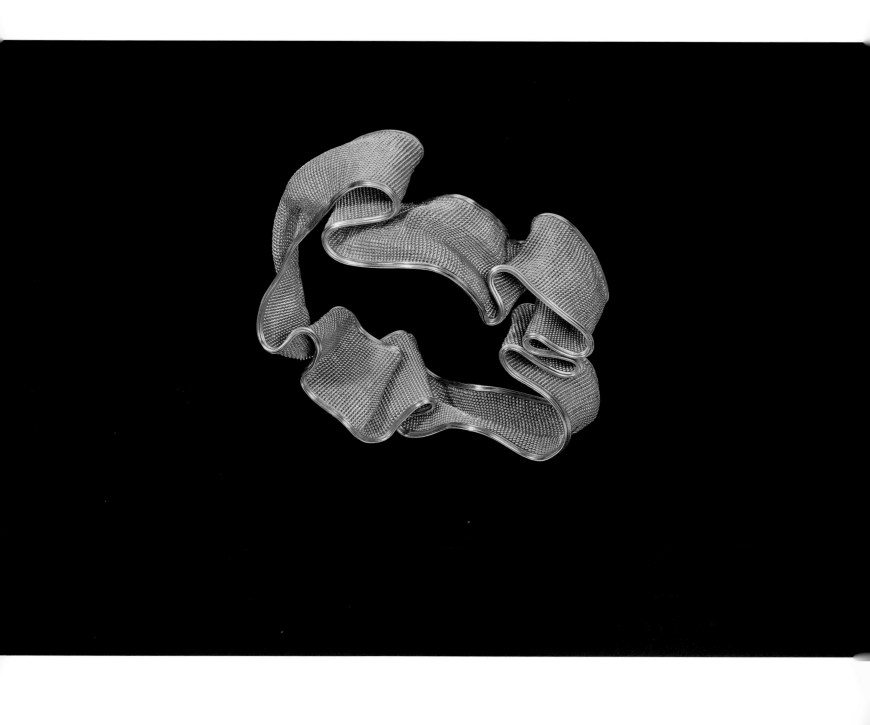

**Bracelet #60**
1999; 18K and 22K gold
3⅝ × 4 × 1⅝ in. Collection
of Elise B. Michie

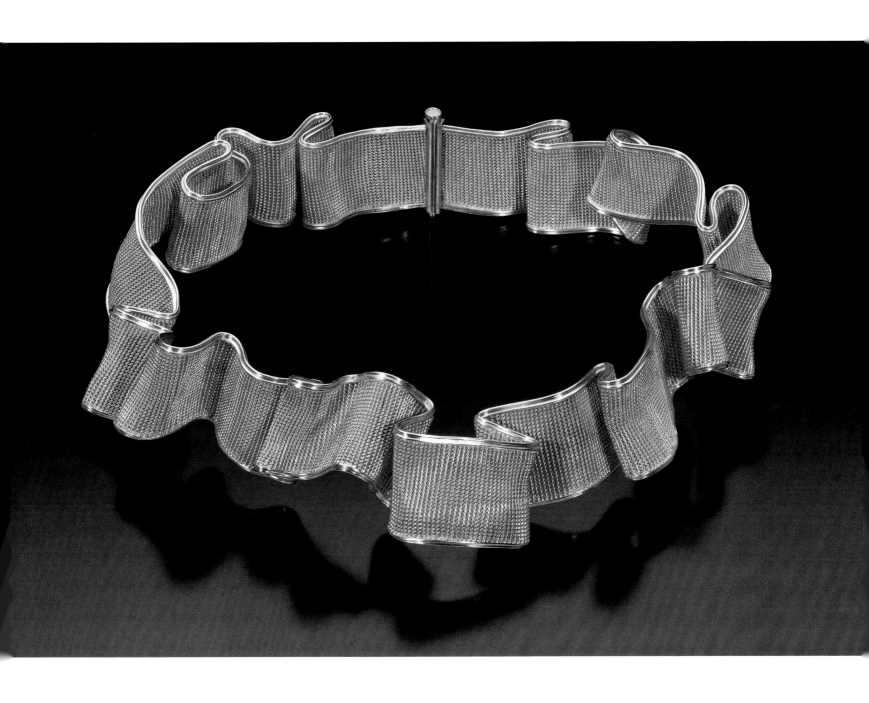

**Choker #83**

2000; 18K and 22K gold; 6⅛ × 6¼ × 1 in. Collection of Tacoma Art Museum; Museum purchase with funds from the Rotasa Foundation and Susan Beech, with additional contributions from the Art Jewelry Forum, Sharon Campbell, Lloyd E. Herman, Karen Lorene, Mia McEldowney, Mobilia Gallery, Flora Book, Ramona Solberg, Judy Wagonfeld, Nancy Worden, and the Romana Solberg Endowment, 2006.10

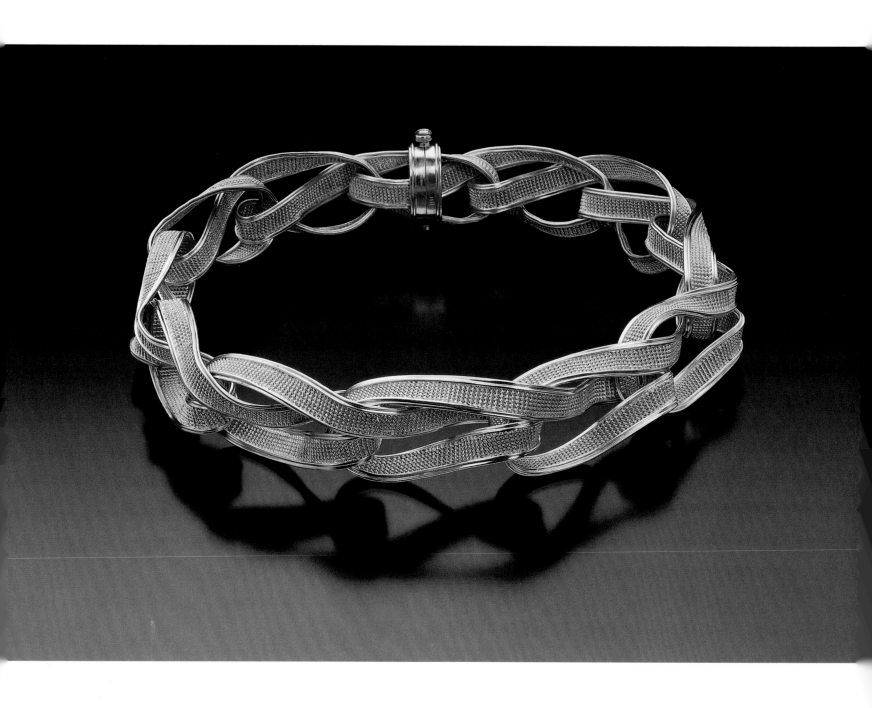

Choker #84
2000; 18K and 22K gold
5½ × 5½ × 1⅛ in.
Private collection

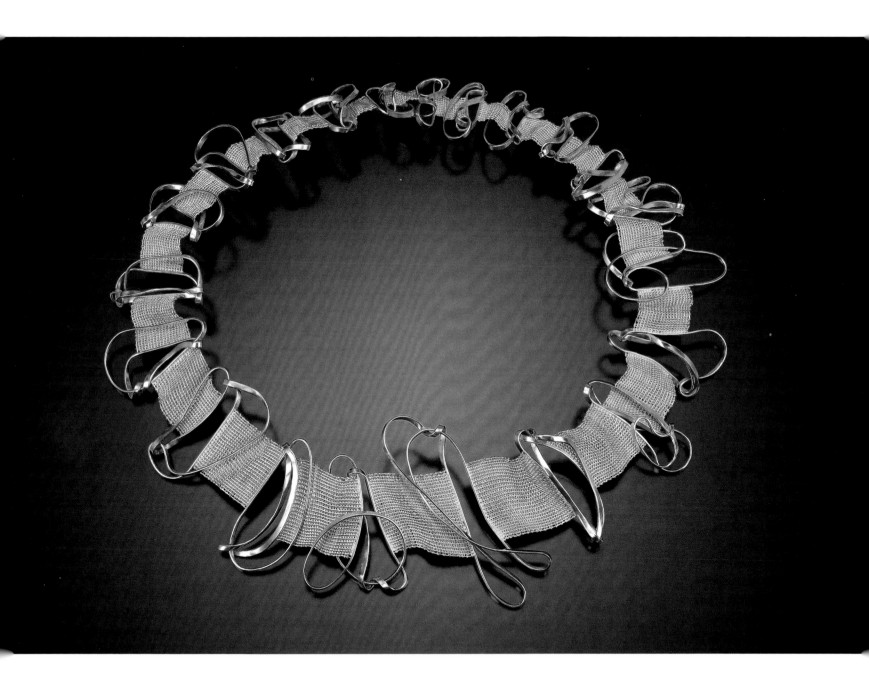

101

Choker #87
2002; 18K and 22K gold
6¾ × 8¾ × 1 in. Collection
of Marion W. Fulk

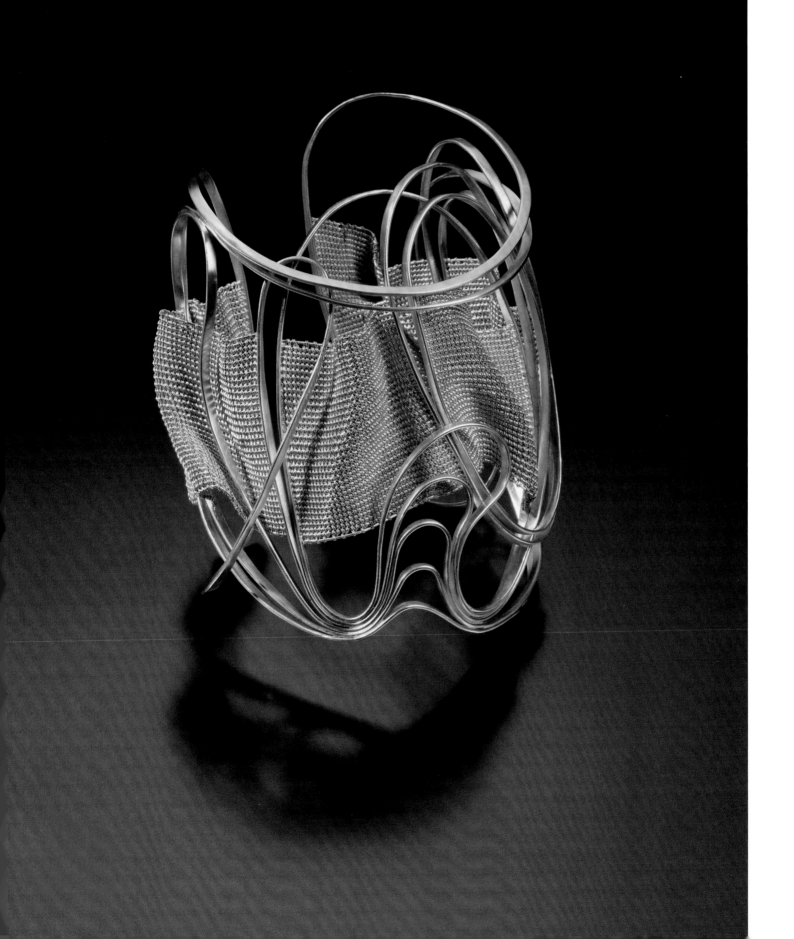

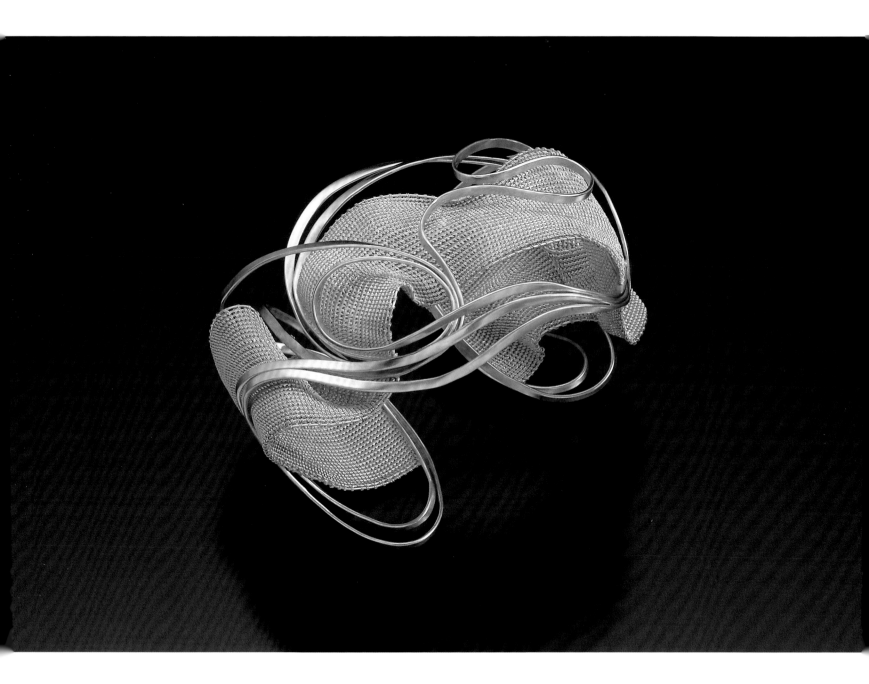

Bracelet #61
2001; 18K and 22K gold; 3 × 3¾ × 3 in. Collection of the artist

Bracelet #62
2002; 18K and 22K gold; 2¾ × 3½ × 2¾ in. Collection
of Museum of Arts & Design, New York. Museum Purchase
with funds provided by Ann Kaplan, 2002

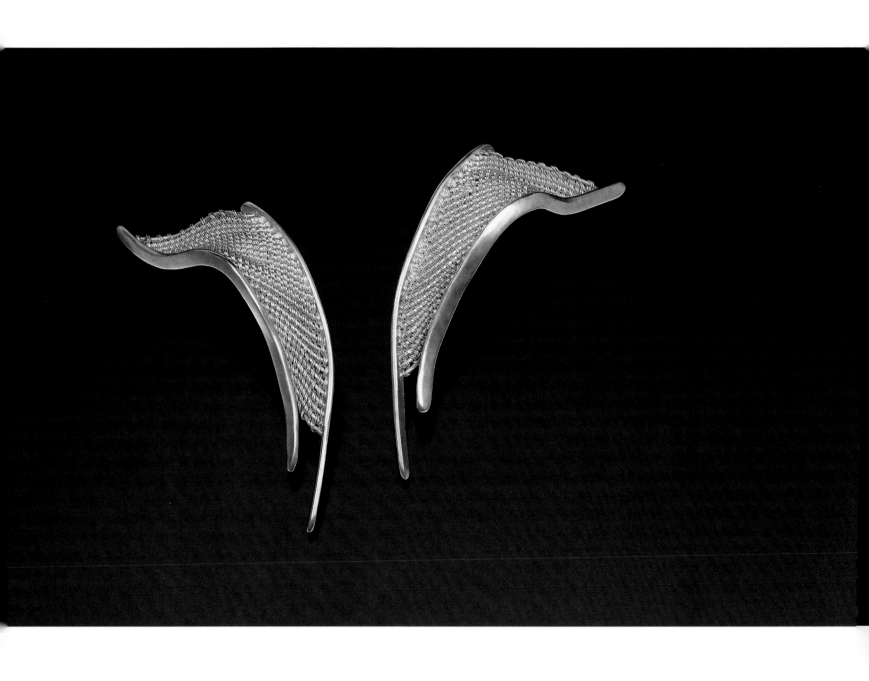

**Earrings #184**

2001; 18K and 22K gold; 1⅞ × 1 × ½ in.

Collection of Nancy Lee Worden

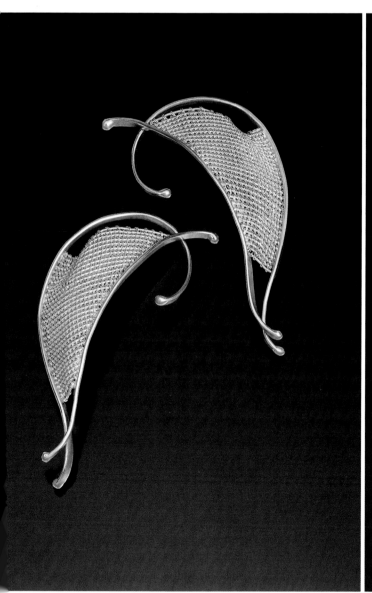

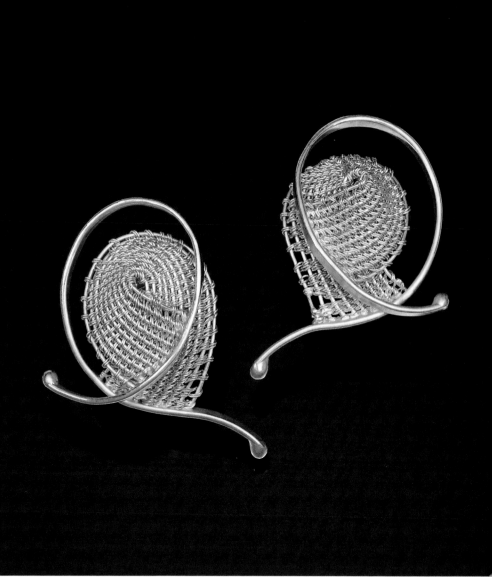

Earrings #193
2002; 18K and 22K gold; 2¼ × 1⅛ × ¼ in. Courtesy
of Mobilia Gallery, Cambridge, Massachusetts

Earrings #199
2009; 18K and 22K gold; 1¾ × 1 × ½ in. Courtesy
of Mobilia Gallery, Cambridge, Massachusetts

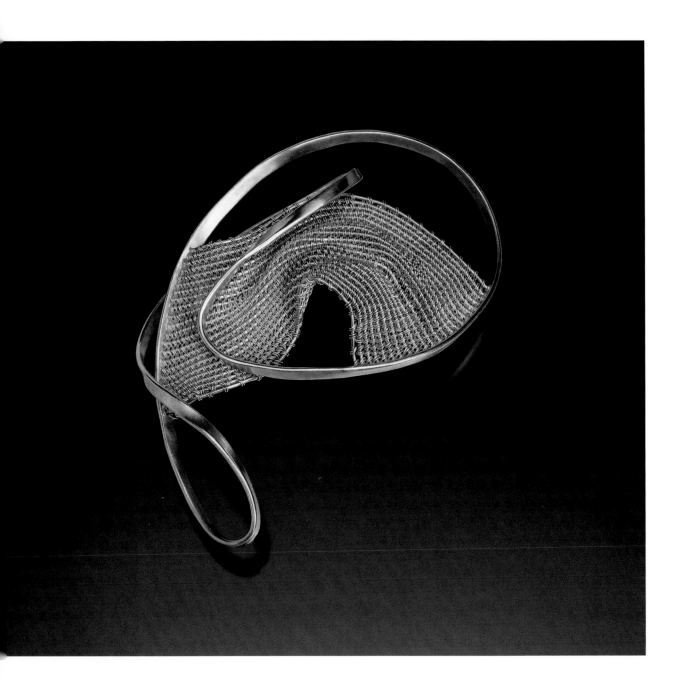

**Brooch #10**
2002; 18K and 22K gold
2½ × 2 × ½ in. Collection
of the artist

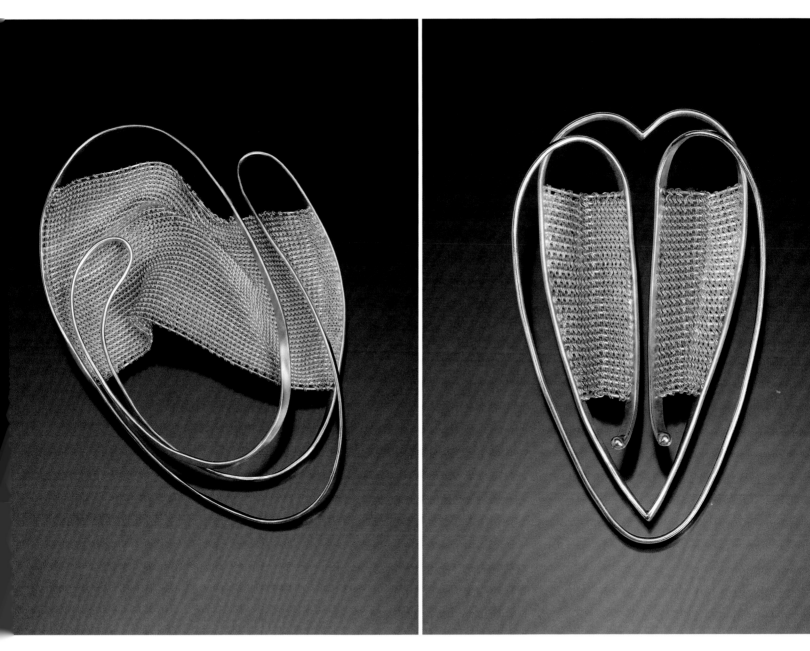

Brooch #18
2007; 18K and 22K gold; 3⅜ × 2¼ × ½ in.
Collection of Rebecca and Alexander Stewart

Brooch #9
2002; 18K and 22K gold; 2½ × 1½ × ½ in.
Collection of Susan Edelheit

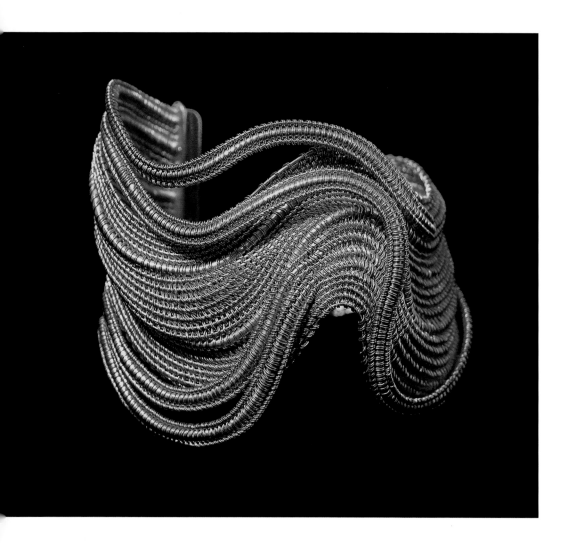

## A Family's Story

One day, a man from New York called me and said he wanted to commission a very special present for his wife on the occasion of the marriage of their forth and last child. We decided on a cuff bracelet. I was touched by the story of their family and got the idea of doing a narrative piece, working from one end with two heavy warp wires to represent the two of them, while the smaller warps would stand for the milieu of their household. I soon added another heavy warp wire—the first child—that rose from the twined surface and "ran around." A bit further a second heavy warp also came up, and finally two more emerged together— their twins. When I asked him where they all lived, his response was a surprise—"One lives upstairs in the building, one around the corner . . ."—all very near each other. So the four wandering wires come together to join alongside the two original ones at the other end of the bracelet. I loved making this piece—and love that his wife would not part with it for my show. This piece exemplifies my hope for my work: that beyond what I put into it, it comes to mean something much more precious to its owner than its material value, and may even become a family heirloom.

**Bracelet #64**
2004; 18K and 22K
gold; 2¼ × 2½ × 2 in.
Private collection

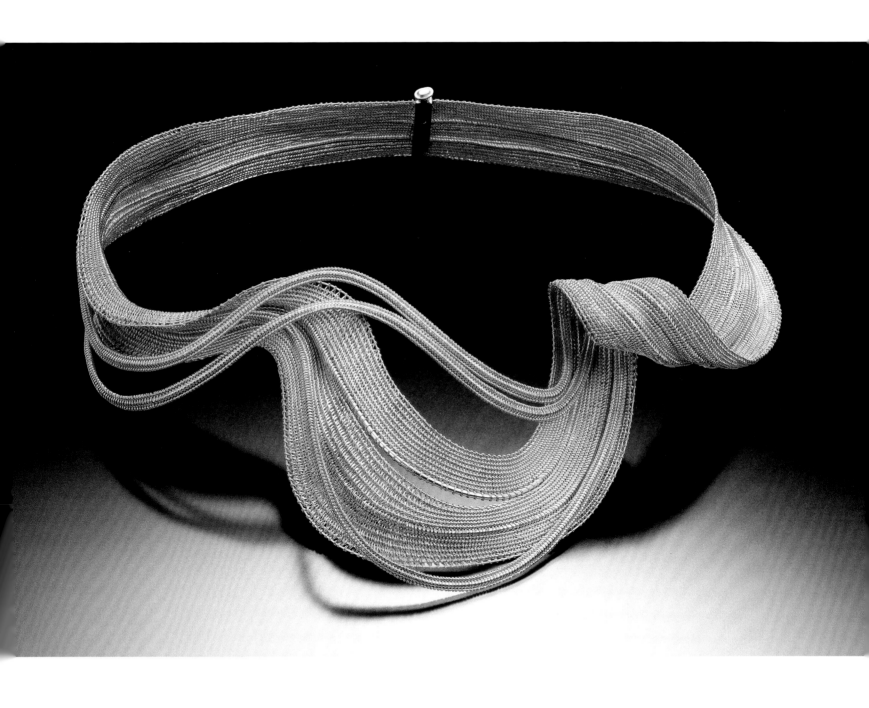

Choker #88
2005; 18K and 22K gold; 8 × 8½ × ½ in. On loan
from The Daphne Farago Collection, Promised
gift to the Museum of Fine Arts, Boston

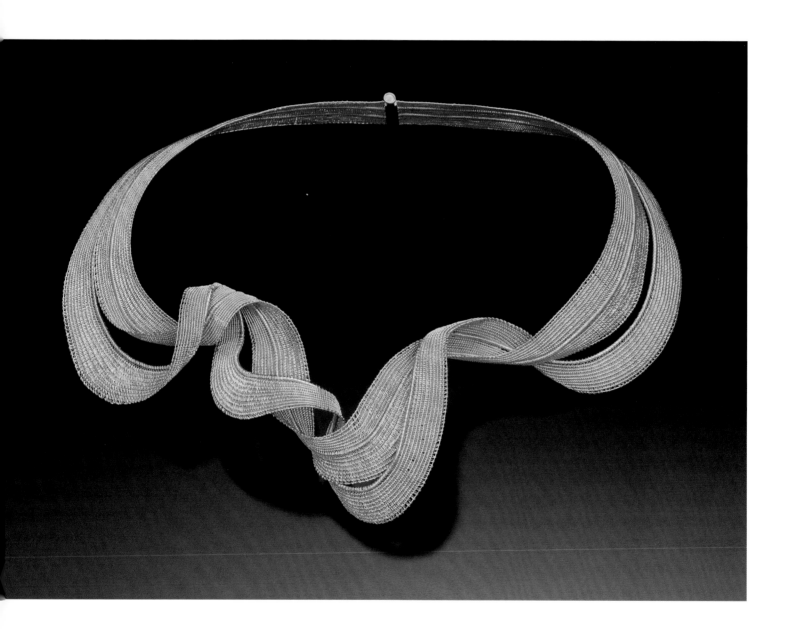

**Choker #90**
2008; 18K and 22K gold; 9 × 11 × 2 in.
Courtesy of Mobilia Gallery, Cambridge,
Massachusetts

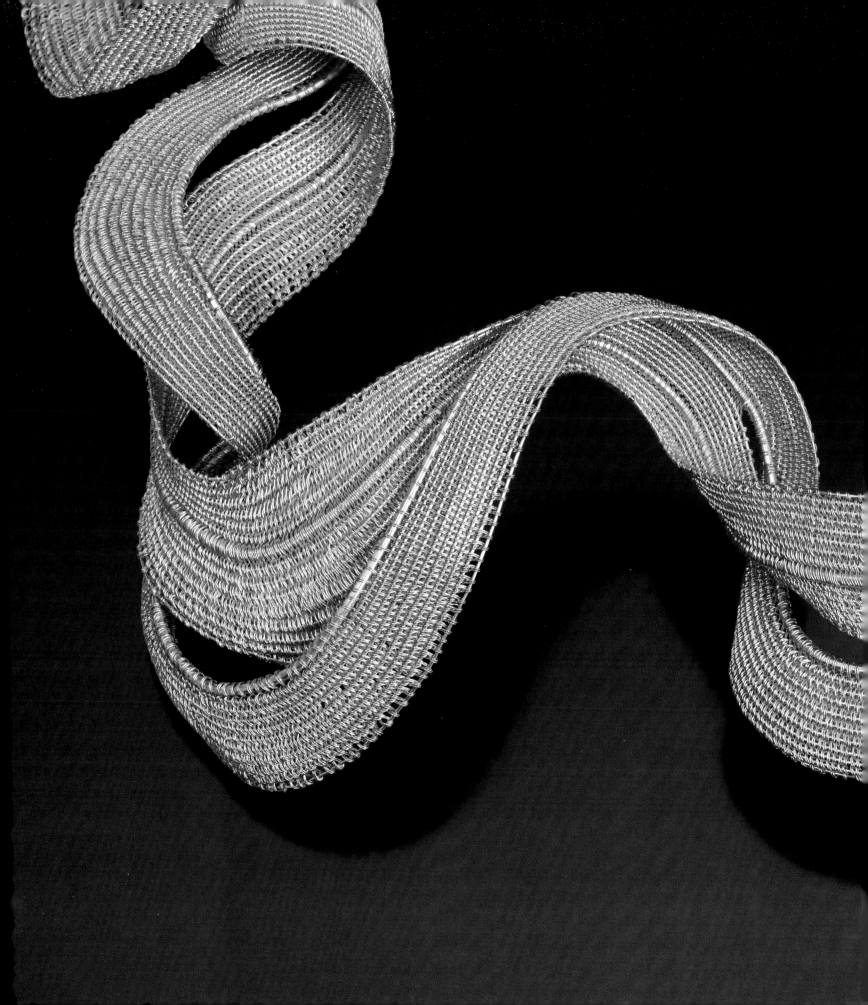

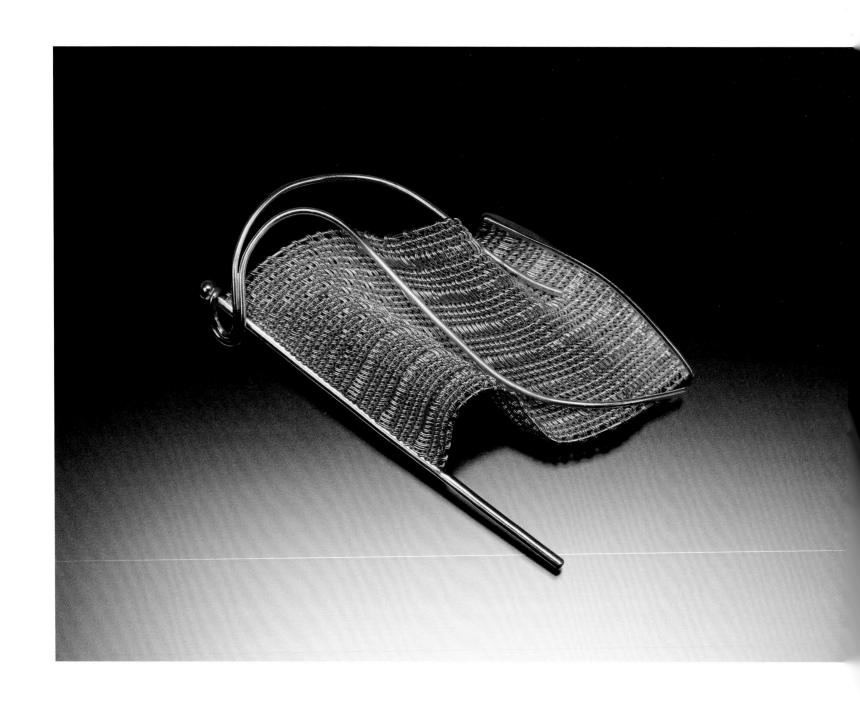

**Brooch #12**
2002
18K and 22K gold
2½ × 1½ × ½ in.
Private collection

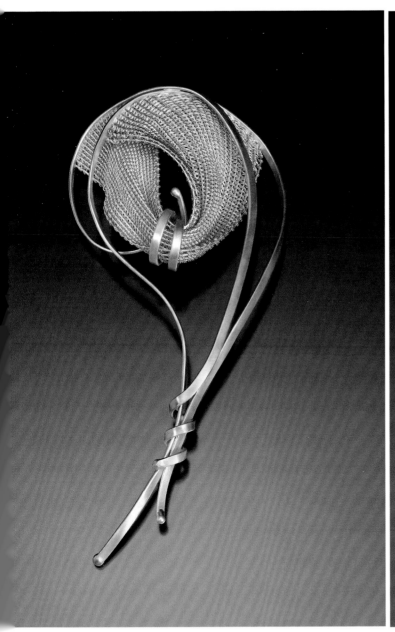

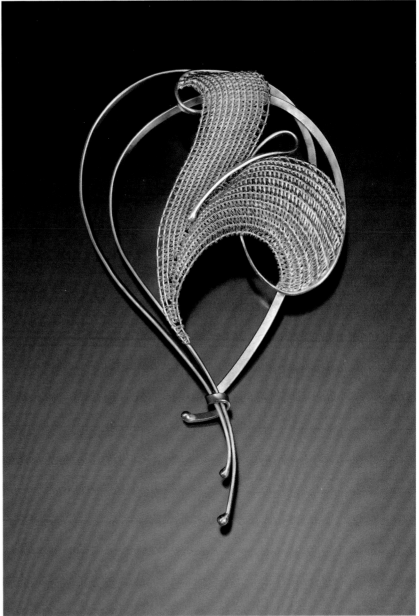

**Brooch #27**
2009; 18K and 22K gold; 4⅜ × 2 × ¾ in.
Collection of the artist

**Brooch #32**
2009; 18K and 22K gold; 4⅝ × 2½ × ⅝ in.
Collection of Arkansas Arts Center Foundation, Gift
of John and Robyn Horn

## A Life with Wally

Karen Lorene, the owner of Facèré Jewelry Art, turned seventy in 2010. To celebrate the occasion the gallery invited seventy of its stable of jewelers to each make a piece inspired by something that happened to us during one of those seventy years. I was assigned the year 2008. I had retired from teaching in 2006, anticipating more time for bench work, my garden, cooking, and travel. I had often said while teaching that all I did was work, I did not have a life. My brooches had been looking more and more like floral or marine forms, especially my recently finished *Brooch #32*. In 2008, after I had been a widow for thirty-six years, a decades-long friend and recent widower, James A. Wallace, blacksmith and founding director of the National Ornamental Metal Museum in Memphis, Tennessee, and I decided to get together. He came to visit on the occasion of my being awarded the Washington Artist Trust Twining Humber Award for Lifetime Artistic Achievement and gave me an orchid to wear that evening. Now at last I feel I do have a life and have someone to share it with (*Brooch #33*).

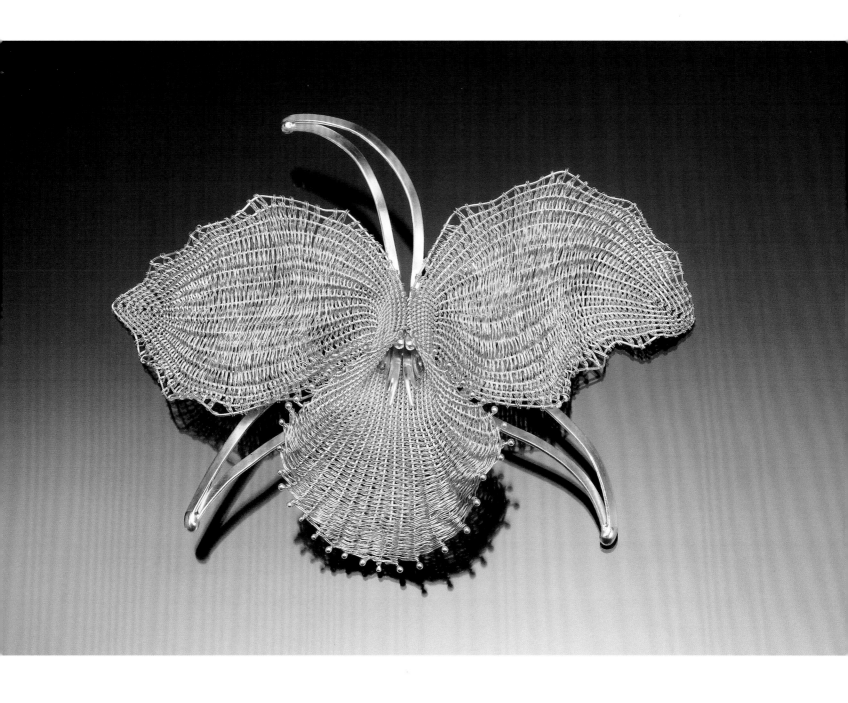

Brooch #33
2010; 18K and 22K gold
3¾ × 4¾ × 1 in. Collection
of the artist

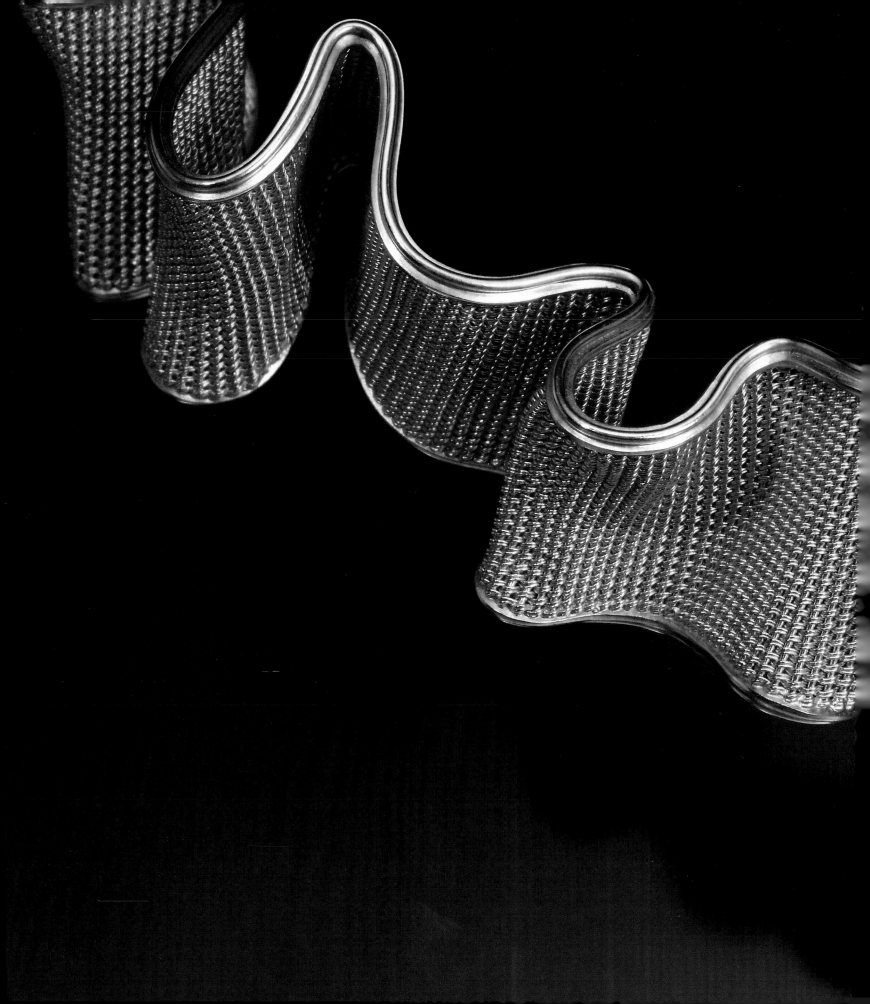

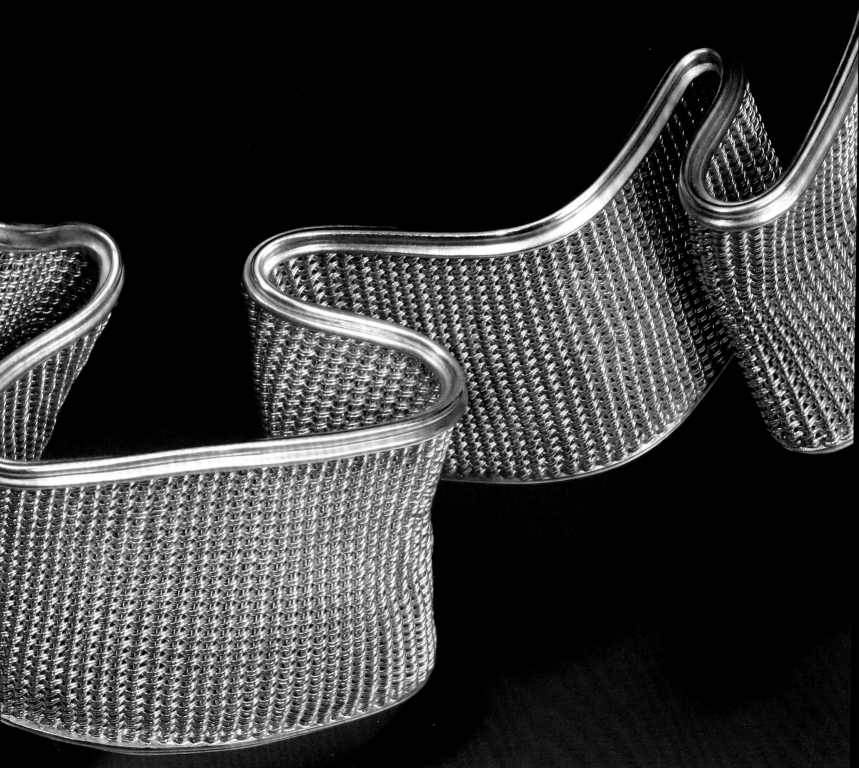

# CHRONOLOGY, EXHIBITIONS, AND COLLECTIONS

## BIOGRAPHY

Born 1943, Lakewood, Ohio

Graduated Olmsted Falls High School, Olmsted Falls, Ohio, 1961

Married Tah-Kai Hu, September 9, 1967; widowed, 1972

Lives and works in Seattle

### Education

MFA, Metalsmithing, Southern Illinois University, Carbondale, Illinois, 1967

BFA, Metalsmithing, Cranbrook Academy of Art, Bloomfield Hills, Michigan, 1965

Metalsmithing, summer session, Rochester Institute of Technology, Rochester, New York, 1963

Miami University, Oxford, Ohio, 1961–1963

### Teaching

University of Washington, Seattle, Professor of Art, 1980–2006

Michigan State University, East Lansing, Professor of Art, 1977–1980

University of Wisconsin-Madison, Madison, Instructor of Art, 1976–1977

Kansas State University, Manhattan, Kansas, Instructor of Art, 1976 (summer)

University of Iowa, Iowa City, Instructor of Art, 1975 (fall)

Southern Illinois University–Carbondale, Carbondale, Illinois, Instructor of Art, 1968–69

Studio metalsmith and jeweler, 1967–present

### Grants, Awards, Honors

2009  Oral Interview for the Nanette L. Laitman Documentation Project in Craft and Decorative Arts in America, Archives of American Art, Smithsonian Institution, Washington, DC.

2008  The National Metalsmiths Hall of Fame, Artist/Arts Educator category. The Arts Center, St. Petersburg, Florida.

Twining Humber Award for Lifetime Artistic Achievement, Artist Trust, Washington.

2006  Lifetime Achievement Award, Seattle Metals Guild.

2004  Invited to donate personal papers to start a Mary Lee Hu research collection at The Archives of American Art,

Smithsonian Institution, Washington, DC, as part of the Nanette L. Laitman Documentation Project for Craft and Decorative Arts in America.

2002  Donald E. Peterson Endowed Fellowship for Excellence, College of Arts and Sciences, University of Washington.

2001–2002  Flintridge Foundation Award for Visual Artists.

1999  "Master of the Medium" (metals), James C. Renwick Alliance, the Renwick Gallery, National Museum of American Art, Washington, DC.

1996  College of Fellows, American Craft Council.

1988  Alumni Achievement Award, Southern Illinois University–Carbondale.

1985  Oral interview for the Columbia University Oral History Research Office Collection.

1976  National Endowment for the Arts Individual Crafts Fellowship. Also in 1984, 1992.

1975  Beaux Arts Designer/Craftsman '75 purchase award, Columbus Museum of Fine Arts, Columbus, Ohio.

### Public Collections

Arkansas Art Center, Little Rock, Arkansas

Art Institute of Chicago, Chicago, Illinois

Charles A. Wustum Museum of Fine Arts, Racine, Wisconsin

Columbus Museum of Fine Arts, Columbus, Ohio

Goldsmiths' Hall, London

Illinois State University, Normal, Illinois

Metal Museum, Memphis, Tennessee

Metropolitan Museum of Art, New York City

Museum of Arts & Design (formerly American Craft Museum), New York City

Museum of Fine Arts Boston, Boston, Massachusetts

Museum of Fine Arts Houston, Houston, Texas

Newark Museum, Newark, New Jersey

Renwick Gallery, National Museum of American Art, Washington, DC

Tacoma Art Museum, Tacoma, Washington

Victoria and Albert Museum, London

University Museum and Art Gallery, Southern Illinois University–Carbondale

University of Indiana Art Gallery, Bloomington, Indiana

Yale University Art Gallery, New Haven, Connecticut

## Solo Exhibitions

2012 *Knitted, Knotted, Twisted & Twined: The Jewelry of Mary Lee Hu*. Bellevue Arts Museum, Bellevue, Washington.

2002 *Summer Arts Festival Mirabela Arts Exhibit, Mary Lee Hu*, Odegaard Undergraduate Library, University of Washington, Seattle.

2000 *Curves Revisited*, Susan Cummins Gallery, Mill Valley, California.

1994 *Mary Lee Hu: Master Metalsmith*, National Ornamental Metal Museum, Memphis, Tennessee.

1989 *Mary Lee Hu: Goldsmith*, The Merrin Gallery, New York City.

1988 Concepts Gallery, Carmel and Palo Alto, California.

1984 The Hand and the Spirit Gallery, Scottsdale, Arizona.

1983 University of Southwest Louisiana, Lafayette.

1982 Middle Tennessee State University, Murfreesboro.

1981 University of North Dakota, Grand Forks.

1980 Arts & Crafts Center of Pittsburgh, Pittsburgh, Pennsylvania.

1979 Eastern Kentucky University Gallery, Richmond.

1977 Illinois State University, Normal.

1977 University of Wisconsin–Madison, Madison.

1974 University of Iowa, Iowa City.

1967 Crafts Alliance Gallery, St. Louis, Missouri.

## Selected Group Exhibitions

* indicates that a catalogue was published to accompany the exhibition.

**2010** *Celebrating 70: 70 Years by 70 Artists*, Facèrè Jewelry Art Gallery, Seattle, Washington.*

**2009** *The Donna Schneier Collection Arrives at the Racine Art Museum: Art Jewelry of the 1980s and 1990s*, Racine Art Museum, Racine, Wisconsin.

*Seattle Metals Guild 20th Anniversary Show*, Seattle Metals Guild, Anderson Center, Edmonds, Washington.*

*For Artists, By Artists*, Yuma Art Center, Yuma Arizona.

**2008** *Masterpieces of Modern Design: Selections from the Collection*, Metropolitan Museum of Art, New York City.

*Rococo: The Continuing Curve, 1730–2008*, Cooper-Hewitt, National Design Museum, New York City.*

*Women of Metal*, Crossman Gallery, University of Wisconsin–Whitewater, Whitewater, Wisconsin.*

*21st Century Jewelry Exhibition*, The Gallery at Bainbridge Arts and Crafts, Bainbridge Island, Washington.

**2007** *Jewelry by Artists: The Daphne Farago Collection*, Museum of Fine Arts Boston, Boston, Massachusetts.*

*Craft in America: Expanding Traditions*, organized by Craft in America, Inc., Los Angeles.* (traveled)

**2006** *Metalisms: Signature Works in Jewelry and Metalsmithing*, Center for Visual Art, Metropolitan State College of Denver, Denver, Colorado.

**2005** *Looking Forward, Glancing Back: Northwest Designer Craftsmen at 50*, Bellevue Arts Museum, Bellevue, Washington.*

**2004** *Korean & American Metalsmithing Exhibition*, Kepco Plaza Gallery, Seoul, South Korea.*

*The Nature of Craft and the Penland Experience*, Mint Museum of Craft & Design, Charlotte, North Carolina.*

*Treasures From the Vault*, Museum of Arts & Design, New York City.

*The Perfect Collection: A Shared Vision for Contemporary Craft*, Fuller Museum, Brockton, Massachusetts.

*Seattle Metals Guild Biannual Members Show*, Washington State Convention Center.*

*Upper Left, Cranbrook Academy of Art Alumni from Washington State*, Network Gallery, Cranbrook Art Museum, Bloomfield Hills, Michigan; Gulassa & Company, Seattle.*

**2003** *The Art of Gold*, organized by the Society of North American Goldsmiths.* (traveled)

*Adornment: Fine Art Jewelry*, Columbus Museum of Fine Art, Columbus, Ohio.

*Craft Transformed: Program in Artisanry*, Fuller Museum, Brockton, Massachusetts.*

*Arm Work Faculty Exhibition*, Robert E. and Martha Hull Lee Gallery, Hiestand Hall, Miami University, Oxford, Ohio.

*SOFA/NY* (Sculpture Objects Functional Art), 7th Regiment Armory, New York City; represented by Mobilia Gallery.* Also in 2004,* 2005,* 2007.*

**2002** *Exuberance*, two-person exhibition, Facèrè Jewelry Art Gallery, Seattle (with Kevin Glen Crane).

*Metalsmiths from the American West*, Helen E. Copeland Gallery, Montana State University, Bozeman, Montana.

*Textile Techniques in Metal*, Mobilia Gallery, Cambridge, Massachusetts.

*SOFA/CHICAGO* (Sculpture Objects Functional Art), Navy Pier, Chicago; represented by Mobilia Gallery.* Also in 2003,* 2004,* 2005.*

**2001** *Flet/Braid*, Nordjyllands Kunstmuseum, Aalborg; Tonder Museum, Tonder, Denmark.*

*The Ring*, Mobilia Gallery, Cambridge, Massachusetts. (traveled)

**2000** *Women Designers in the USA, 1900–2000: Diversity and Difference*, Bard Graduate Center for Studies in the Decorative Arts, Design and Culture, New York City.*

*The Fine Art of Metal*, Art Gallery, Montgomery College, Rockville, Maryland.

*Marked by Media: An Exhibition of Contemporary Jewelry*, Bruce Gallery, Edinboro University of Pennsylvania, Edinboro.*

*Adorning the Body*, Michael and Barbara Dennos Museum Center, Northwestern Michigan College, Traverse City.

*Under the Influence*, Tacoma Art Museum, Tacoma, Washington.

**1999** *Beadz! New Work by Contemporary Artists*, American Craft Museum, New York City.

**1998** *SOFA/NY*, 7th Regiment Armory, New York City; represented by Susan Cummins Gallery. Also in 1999,* 2000,* 2002.*

*Craft Is a Verb*, Mississippi Museum of Art, Jackson, Mississippi.

*Weaving Washington*, Washington State Capital Museum, Olympia.

*Torch Songs: Fifty Years of Northwest Jewelry*, Tacoma Art Museum, Tacoma, Washington.

*Explorations: An Invitational Exhibit of Forms in Metal*, University Art Gallery, Cal Poly, San Luis Obispo, California.

**1997** *Celebrating American Craft*, Kunstindustrie Museum, Copenhagen, Denmark.*

*Formulations: A Metals Invitational*, Carroll Reece Museum, East Tennessee State University, Johnson City.

*Jewelry*, Albertson-Peterson Gallery, Winter Park, Florida.

**1996** *3 Generations*, Mobilia Gallery, Cambridge, Massachusetts.

*Working Gold*, Susan Cummins Gallery, Mill Valley, California.

*Textile Techniques in Metal*, Mobilia Gallery.

*Issues & Intent*, Susan Cummins Gallery.

**1995** *SOFA Chicago*, Navy Pier, Chicago; represented by Susan Cummins Gallery.* Also in 1996,* 1997,* 2000,* 2001.*

*Jewelry From the Permanent Collection*, American Craft Museum, New York City.

*Making Connections V*, Life Hall, Montclair State University, Upper Montclair, New Jersey.

**1994** *1994 National Art Jewelry Invitational*, Connell Gallery, Atlanta, Georgia.

*Metallic*, Lee Hall Gallery, Northern Michigan University, Marquette.

*Contemporary Metalsmithing: Behind and Beyond the Bench*, Craft Alliance, St. Louis, Missouri.

**1993** *Sculptural Concerns: Contemporary American Metalworking*, organized by Fort Wayne Museum, Fort Wayne, Indiana.* (traveled)

*Ohio Metals: A Legacy*, organized by Ohio Designer-Craftsmen, Miami University, Oxford Ohio.* (traveled in Ohio)

*Documents Northwest: 6 Northwest Jewelers* (with Flora Book, Ken Cory, Robert Davidson, Kiff Slemmons, Ramona Solberg), Seattle Art Museum, Seattle.*

*The Weight of Gold*, Susan Cummins Gallery.

*Year of the Crafts*, King County Arts Commission Gallery, Seattle.

*Metal '93*, Tower Fine Arts Gallery, State University of New York at Brockport.

**1992** *Design Visions: The Second Australian International Crafts Triennial*, Art Gallery of Western Australia, Perth, Australia.*

*Helen Williams Drutt Collection*, Helsinki, Finland.

*Repair Days Reunion*, National Ornamental Metal Museum, Memphis, Tennessee.

*Chicago International New Art Forms Exposition*, Navy Pier, Chicago; represented by Susan Cummins Gallery.* Also in 1993.*

*Seven Contemporary American Metalsmiths*, Johnson County Community College, Overland Park, Kansas (with Chunghi Choo, Gary S. Griffin, William Harper, Lisa Norton, Sandra Jo Osip, and William Underhill).*

**1991** *The 20th Anniversary Show*, Electrum Gallery, London.

*Masterworks: Pacific Northwest Arts & Crafts Now*, Bellevue Art Museum, Bellevue, Washington.

*Artists at Work: 25 Northwest Glassmakers, Ceramists & Jewelers*, organized by Boise Art Museum, Boise, Idaho; traveled to Cheney Cowles Museum, Spokane, Washington.

**1990** *National Invitational Exhibition of Studio Art Jewelry*, Connell Gallery, Atlanta, Georgia.

*More Than Meets the Eye*, Helen Day Art Center, Stowe, Vermont.*

*Aha Hanalima, Gathering of the Crafts*, East West Center, Honolulu, Hawaii.

*US Metal/NW Metal*, Cheney Cowles Museum, Spokane.

**1989** *Craft Today USA*, organized by the American Craft Museum, New York City.* (traveled)

*Chicago International New Art Forms Exposition*, Navy Pier; represented by Martha Schneider Gallery.* Also in 1990,* 1991* by Schneider, Bluhm, Loeb Gallery.

*Washington Crafts Then & Now*, Tacoma Art Museum.*

*Hats, Helmets, and Other Headgear*, Faith Nightingale Gallery, San Diego, California.

*Artful Objects: Recent American Crafts*, Fort Wayne Museum of Art, Fort Wayne, Indiana.*

*Infinite Riches: Jewelry Through the Centuries*, Museum of Fine Arts, St. Petersburg, Florida.*

**1988** *Korean-American Contemporary Metalwork Exhibition 1988*, Walker Hill Art Center, Seoul, South Korea.

*Chicago International New Art Forms Exposition*, Navy Pier; represented by Concepts Gallery.*

*Silver in Service*, Bellevue Art Museum, Bellevue, Washington.

*School of Art* 1975–1988, SAFECO, Seattle.

*12 American Jewelers*, Pritam & Eames, East Hampton, New York.

*New Traditions / 1988*, Worcester Center for Crafts, Worcester, Massachusetts.

**1987** *The Eloquent Object*, organized by the Philbrook Museum, Tulsa, Oklahoma.* (traveled)

*Art in Craft Media II*, Bellas Artes Gallery, Santa Fe, New Mexico.

*American Artworks International*, Silo, New Milford, Connecticut.

*Metalsmithing/Western USA*, Missoula Museum of the Arts, Missoula, Montana.

**1986** *Craft Today: Poetry of the Physical*, organized by the American Craft Museum, New York City.* (traveled)

*Mary Lee Hu and Her Circle*, Carlyn Gallery, New York City.

*Gold Rush*, Quadrum Gallery, Chestnut Hill, Massachusetts.

**1985** *American Jewelry Now*, organized by the American Craft Museum, New York City.* (traveled internationally)

*Masterworks of Contemporary American Jewelry: Sources and Concepts*, Victoria and Albert Museum, London.*

*Barbara Rockefeller Associates Collection*, Anatole Orient Gallery, London.

*International Jewelry Invitational*, Rudolf Dentler Gallery, Ulm, Germany.

*Metropolitan Opera Guild 50th Anniversary Celebration Exhibition*, organized by Byzantium Gallery, New York City, for Metropolitan Opera Gallery, New York City. (traveled)

*Opening Exhibition*, Ostiano, Miami, Florida.

*Fine Art Jewelry in America*, Cross Creek Gallery, Malibu, California. Also in 1986, 1987.

*Masterworks of Contemporary American Jewelry*, College Art Gallery, State University of New York at New Paltz.

*Regional Jewelry Exhibition: Northwest*, Plum Gallery, Kensington, Maryland.

*New Visions, Traditional Materials*, Museum of Art, Carnegie Institute, Pittsburgh, Pennsylvania.

*Points of View*, Yaw Gallery, Birmingham, Michigan.

**1984** *Jewelry USA*, American Craft Museum, New York City.*

*International Jewelry Presentation*, Nan Duskin and the Helen Drutt Gallery, Philadelphia, Pennsylvania.

*Multiplicity in Clay, Metal, Fiber*, Skidmore College, Saratoga Springs, New York.*

*Society of North American Goldsmiths Distinguished Member Exhibition*, Mitchell Museum, Mt. Vernon, Illinois; Fashion Institute of Technology, New York City.

*4 at the Academy of the Arts*, The Academy of the Arts, Easton, Maryland (with Marsha Sweet Welch, Elinor Roberts and Sica).

*Metals Invitational Exhibition*, Southwest Texas State University, San Marcos, Texas.*

*Northwest Fusion*, Visual Arts Center of Alaska, Anchorage, Alaska.

**1983** *Kyoto Metalwork Exhibition—Japanese/American Exchange*. Kyoto Municipal Museum of Traditional Industry, Kyoto Japan.

Two-person exhibition (with Sirpa Yarmolinsky), Plum Gallery, Kensington, Maryland.

Two-person exhibition (with Layne Goldsmith), Southwest Missouri State University Art Gallery, Springfield.

*Regional Crafts: A Contemporary Perspective*, Bellevue Art Museum, Bellevue, Washington.

*Art: The Textile Reference*, Artifacts Gallery, Indianapolis, Indiana.*

*Contemporary American Jewelers*, The Hand and the Spirit Gallery, Scottsdale, Arizona.

*Metals Invitational Exhibition*, Clara M. Eagle Gallery, Murray State University, Murray, Kentucky.

**1982** *Invitational Jewelry Exhibition*, Huntington Galleries, Huntington, West Virginia.

*Northwest Crafts Exhibition*, Museum of History and Industry, Seattle.

*Other Baskets*, Craft Alliance, St. Louis, Missouri.

*20 Years of Metal*, University Museum, Southern Illinois University, Carbondale, Carbondale, Illinois.*

*Made in the USA*, Gallery 8, La Jolla, California.

*Great Southwest Jewelry/Metals Symposium*, Art Gallery, University of Northern Arizona, Flagstaff.

*Metal*, 10 Arrow Gallery, Cambridge, Massachusetts.

*National Metals Invitational 1982*, University of Texas at El Paso Art Gallery.*

*The Washington Year: A Contemporary View, 1980–81*, Henry Art Gallery, University of Washington, Seattle.*

*Washington Craft Forms: Creators and Collectors*, State Capitol Museum, Olympia.

**1981** *Good as Gold: Alternative Materials in American Jewelry*, organized by The Renwick Gallery, Smithsonian Institution, Washington, DC.* (traveled)

*Tenth Anniversary Exhibition*, Electrum Gallery, London.*

*Der Goldene Faden: Textures in Gold*, Stadischen Museum, Schwabisch Gmund, Germany.* (traveled in Europe)

*The Animal Image*, The Renwick Gallery, Smithsonian Institution.*

*Fisch and Hu*, Contemporary Crafts Gallery, Portland, Oregon.

*Beyond Tradition: 25th Anniversary Exhibition*, American Craft Museum, New York City.*

*Beaux Arts Designer-Craftsman Update*, Columbus Museum of Art, Columbus, Ohio.

*30 Americans—An Invitational Exhibition*, Galveston Arts Center, Galveston, Texas.*

*Metalsmith '81*, The University of Kansas, Lawrence.*

*5th National Crafts Invitational Exhibition*, Skidmore College Art Gallery, Saratoga Springs.*

*Embellishment Beyond Function*, Henry Art Gallery, University of Washington, Seattle.*

**1980** *International Jewellery 1900–1980*, Kunslerhaus, Vienna, Austria.*

*Selection Committee: Young Americans: Metal* (with Alma

Eikerman, Albert R. Paley), American Craft Museum, New York City.

*Contemporary Jewelry*, Synopsis Gallery, Winnetka, Illinois.

*National Invitational Exhibition of Metalsmithing*, Kipp Gallery, Indiana University of Pennsylvania, Indiana, Pennsylvania.

*Opening Exhibition*, Greenwood Gallery, Washington, DC.*

*1980 Michigan State University Faculty Exhibition*, Kresge Art Center Gallery, Michigan State University, East Lansing.*

*2nd Annual LSU Metalsmithing Exhibition*, Anglo-American Art Museum, Louisiana State University, Baton Rouge, Louisiana.*

*Metalsmithing Invitational*, Murray State University, Murray, Kentucky.

**1979** *Society of North American Goldsmiths*, organized by the Society of North American Goldsmiths and the Schmuckmuseum, Pfortzheim, Germany.* (traveled in Europe)

*Fourth International Jewellery Art Exhibition*, Japan Jewellery Designers Association, Mikimoto, Tokyo, Japan.

*Women Artists*, Springfield Art Association, Springfield, Illinois.*

*Brookfield—A 25th Anniversary Exhibition*, Brookfield Craft Center, Brookfield, Connecticut.*

*National Crafts Invitational*, Art and Crafts Center of Pittsburgh.

*Four Michigan Faculty Members*, Flint Institute of Arts, Flint, Michigan (with James Adley, George Mason, Ted Ramsay).

*Metalworks Invitational 1979*, Ball State University Art Gallery, Muncie, Indiana.*

*A Detailed Look: National Jewelry Invitational*, Crossman Gallery, University of Wisconsin–Whitewater, Whitewater, Wisconsin.

**1978** *Silver in American Life*, organized by Yale University Art Gallery, New Haven, Connecticut.* (traveled)

*Modern American Jewelry Exhibition*, Mikimoto & Company, Tokyo, Japan.

*American Crafts at the Vatican Museum*, Vatican Museum, Vatican City.*

*Rattlesnakes: Exhibition of Modern American Jewellery*, Goldsmiths' Hall, London (with Bill Harper, Mary Ann Scherr, Heikki Seppä).*

*Clay, Fiber, Metal by Women Artists*, Bronx Museum, Bronx, New York.

*The Goldsmith/78*, Minnesota Museum of Art, St. Paul, Minnesota.

*American Goldsmiths—Now*, Steinberg Gallery, Washington University, St. Louis, Missouri.

*Metal Art Exhibition*, State University College, Oneonta, New York.*

*National Metalsmiths Invitational*, Creative Arts Workshop, New Haven, Connecticut.*

*For Collectors*, Florence Duhl Gallery, New York City.

*1978 Faculty Exhibition*, Kresge Art Center Gallery, Michigan State University, East Lansing.*

**1977** Two person exhibition, Columbus Museum of Fine Arts, Columbus, Ohio (with Jon Wahling).

*Creative Jewelry*, Design Center, Manila, Philippines.*

*Vice Presidential Holiday Tree Ornament Collection*, The Vice President's Residence, Washington, DC.

*The Makers: Fiber, Clay, Metal*, Georgia State University, Atlanta.*

*The Philadelphia Craft Show*, Philadelphia Museum of Art, Philadelphia.*

*Craft Design 24*, Eastern Illinois University, Charleston.*

*Heirs Apparent to Cellini's Art or Smiths Strut Their Stuff*, Humbolt State University Main Gallery, Humbolt State University, Arcata, California.

*Focus on Crafts: An Exhibition*, Goldstein Gallery, University of Minnesota, St. Paul.*

*Currents '77, 5th Annual Mid-South Crafts Show*, Middle Tennessee State University, Murfreesboro.*

*Metalwork and Jewelry by Jackie Fosse, Mary Lee Hu, Garret DeRuiter*, Krannert Gallery, University of Evansville, Evansville, Indiana.

*The Metalsmith*, organized by Phoenix Art Museum, Phoenix, Arizona.* (traveled)

**1976** *6 Contemporary American Jewellers*, Electrum Gallery, London (with Arline Fisch, Richard Mawdsley, Eleanor Moty, Gene and Hiroko Pijanowski).*

*Precious Metals, The American Tradition in Gold and Silver*, Lowe Art Museum, University of Miami, Miami, Florida.*

*Box*, John Michael Kohler Art Center, Sheboygan, Wisconsin.

*Ohio Artists and Craftsmen Invitational Show*, Massillon Museum, Massillon, Ohio.*

*American Crafts '76: An Aesthetic View*, Museum of Contemporary Art, Chicago, Illinois.*

*American Metal Work: 1976*, Sheldon Memorial Art Gallery, University of Nebraska, Lincoln.*

*Craftworks*, Summit Art Center, Summit, New Jersey.

*Jewelers*, USA, Art Gallery, California State University, Fullerton.*

*Emphasis on the Arts '76 Crafts Invitational*, Hiestand Hall Gallery, Miami University, Oxford, Ohio.*

**1975** *Forms in Metal: 275 Years of Metalsmithing in America*, organized by the Museum of Contemporary Crafts, New York City.* (traveled)

*Contemporary Crafts of the Americas: 1975*, Colorado State University, Fort Collins.* (traveled)

*Beaux Arts Designer/Craftsman '75*, Columbus Gallery of Fine Arts, Columbus, Ohio.*

*Headdress: A History of American Headgear*, John Michael Kohler Art Center, Sheboygan, Wisconsin.

*American Craft Council Northwest Regional Metals Traveling Exhibition*. (traveled in Alaska)

*Silver and Goldsmithing in America*, Lowe Art Museum, The University of Miami, Coral Gables, Florida.*

*Uncommon Smiths of America: An Invitational Exhibition of Jewelry and Metalsmithing*. Sill Hall Gallery, Eastern Michigan University, Ypsilanti.*

*Reprise*, Cranbrook Academy of Art Museum, Bloomfield Hills, Michigan.*

*Emphasis Art '75: Miami University Crafts Invitational*, Heistand Gallery, Miami University, Oxford, Ohio.*

*Three Women from the Craft Tradition*, Hillyer Hall, Smith College, Northampton, Massachusetts (with Ruth Ginsberg-Place and Susan Parks).

*2nd Annual National Exhibition in Contemporary Jewelry*, organized by Georgia State University, Atlanta.* (traveled in Georgia)

*Miniature and Delicate Object Exhibition*, Galeria del Sol, Santa Barbara, California; Fairtree Gallery, New York City.

*Invitational Jewelry Exhibition*, Visual Arts Gallery, Pensacola Junior College, Pensacola, Florida.*

**1974** *The Goldsmith: An Exhibition of Work by Contemporary Artists-Craftsmen of North America*, organized by the Minnesota Museum of Art, St. Paul, and the Renwick Gallery, Smithsonian, Washington, DC.* (traveled)

*World Silver Fair*, Taxco and Mexico City, Mexico.

*Profile 1974*, Humber College, Rexdale, Ontario, Canada.

*Metal '74*, Brockport College Fine Arts Gallery, State University of New York at Brockport.

*Basketry/Artistry*, Birmingham Bloomfield Art Association, Birmingham, Michigan.*

*Marietta College Craft National '74*, Marietta College, Marietta, Ohio.*

*The Uncommon Smith*, John Michael Kohler Arts Center, Sheboygan, Wisconsin.

*American Metalsmiths*, DeCordova Museum, Lincoln, Massachusetts.*

**1971** *Object Makers 1971*, Utah Museum of Fine Arts, The University of Utah, Salt Lake City.*

**1970** *Goldsmith '70*, Minnesota Museum of Art, St. Paul, Minnesota.*

*Face Coverings*, Museum of Contemporary Crafts, New York City.*

*7th Annual Southern Tier Arts and Crafts Show and Sale*, Corning Glass Center, Corning, New York. Also in 1973.

*6th National Arts and Crafts Exhibition*, Mississippi Arts Festival, Jackson, Mississippi.*

*7th Annual Small Sculpture and Drawing Exhibition*, Western Washington Gallery, Western Washington State College, Bellingham.*

**1969** *Young Americans '69*, organized by the Museum of Contemporary Crafts, New York City.* (traveled)

*30: An Invitational Jewelry Show*, Cotton Memorial Galleries, University of Texas at El Paso.

**1968** *The 1968 Regional Craft Biennial*, The J. B. Speed Art Museum, Louisville, Kentucky.*

**1967** *Mississippi River Craft Show*, Brooks Memorial Art Gallery, Memphis, Tennessee.*

**1966** *Illinois Craftsmen's Biennial 1966*, Illinois State Museum, Springfield, Illinois.*

*XIXth Wichita National Decorative Arts and Ceramics Exhibition*, Wichita Art Association, Wichita, Kansas.*

*Mid-States Craft Exhibition*, Evansville Museum of Arts and Sciences, Evansville, Indiana.* Also in 1967, 1968.*

**1965** *American Jewelry Today*, Everhart Museum, Scranton, Pennsylvania.* Also in 1967.*

*Baycrafters' Fourth Annual Juried Art Show*, Bay Village, Ohio.* Also 1968,* 1970,* 1974.*

## SELECTED BIBLIOGRAPHY

### Books

Biskeborn, Susan. *Artists at Work: 25 Northwest Glassmakers, Ceramists, and Jewelers*. Seattle: Alaska Northwest Books, 1990: 142–47.

Blauer, Ettagale. *Contemporary American Jewelry Design*. New York: Van Nostrand Reinhold, 1991: 54–57.

Bovin, Peter M. *Jewelry Making for Schools, Tradesmen, Craftsmen*. Rev. ed. Forest Hills, NY: Bovin Publishing, 1978: 243.

Cartlidge, Barbara. *Twentieth Century Jewelry*. New York: Abrams, 1985: 190–91, 208.

Cass, Peggy, producer. *Mary Lee Hu*. Seattle: KCTS television, 1993 (Short Video).

Chamberlain, Marcia. *Metal Jewelry Techniques*. New York: Watson-Guptill Publications, 1976: 59.

*Contemporary American Crafts, The Renwick Gallery of the National Museum of American Art, Smithsonian Institution 1993 Calendar*. (September).

*Dictionnaire International du Bijou*. Paris: Editions du Regard, 1998: 282.

English, Helen Drutt, and Peter Dormer. *Jewelry of Our Time: Ornament and Obsession*. New York: Rizzoli, 1995: 239, 304–05.

Ferre, R. Duane. *How to Make Wire Jewelry*. Radnor, PA: Chilton, 1980: 158

Fisch, Arline M. Textile Techniques in Metal for Jewelers, Sculptors and Textile Artists. New York: Van Nostrand Reinhold, 1975: 59, 70, 94, 95, 133, 149, 154.

———. Textile Techniques in Metal for Jewelers, Textile Artists and Sculptors. New York: Lark Books, 1996: 41, 55, 67, 68, 114–15, 117, 150–51.

Foote, Theodore P. *Jewelry Making: A Guide for Beginners*. Worcester, MA: Davis Publications, 1981: 23.

Hall, Julie. *Tradition and Change: The New American Craftsman*. New York: E. P. Dutton, 1978: 42.

Halper, Vicki, and Diane Douglas, eds. *Choosing Craft: The Artist's Viewpoint*. Chapel Hill, NC: University of North Carolina Press, 2009: 48–50.

Ilse-Neuman, Ursula. *Inspired Jewelry from the Museum of Arts and Design*. New York: Museum of Arts & Design, 2009: 12, 186.

Koplos, Janet. *Knitted, Knotted, Twisted & Twined: The Jewelry of Mary Lee Hu*. Bellevue, WA: Bellevue Arts Museum, 2012.

Koplos, Janet, and Bruce Metcalf. *Makers: A History of American Studio Craft*. Chapel Hill, NC: University of North Carolina Press, 2010: 439.

L'Ecuyer, Kelly. *Jewelry by Artists in the Studio 1940–2000, Selections from the Daphne Farago Collection*. Boston, MA: Museum of Fine Arts Boston, 2010: 15, 28, 116–17, 241, 247–48, cover.

Le Van, Marthe. *21st Century Jewelry: The Best of the 500 Series*. New York: Lark Books, 2011: 344, 397.

———. *Masters. Gold: Major Works by Leading Artists*. New York: Lark Books, 2009: 24–31.

Le Van, Marthe, ed. *500 Earrings: New Directions in Contemporary Jewelry*. New York: Lark Books, 2007: 14, 213.

———. *500 Necklaces: Contemporary Interpretations of a Timeless Form*. New York: Lark Books, 2006: 11, 297, 311.

Lewin, Susan Grant. *One of a Kind: American Art Jewelry Today*. New York: Abrams, 1994: 48, 120–21.

Mayer, Barbara. *Contemporary American Craft Art: A Collector's Guide*. Salt Lake City, UT: Gibbs M. Smith, 1988.

McLaughlin, Jean W. *The Nature of Craft and the Penland Experience*. New York: Lark Books, 2004: 103.

Mitchell, Ben. *The Yuma Symposium Thirty Years After*. Yuma, AZ: Yuma Art Symposium, 2009: 20–21, 44.

Morton, Philip. *Contemporary Jewelry*. 2nd ed. New York: Holt, Rinehart and Winston, 1976: 56, 58, 66, 135.

Newman, David. *An Illustrated Dictionary of Jewellery*. London: Thames & Hudson, 1979: 158–59.

Newman, Jay, and Lee Newman. *Wire Art*. New York: Crown, 1975: 14, 20, 63–64, 68–70, 72–75, 78, 85, 194, 224–26.

Phillips, Clare. *Jewelry from Antiquity to the Present*. London: Thames & Hudson, 1996: 207, 210.

Quickenden, Kenneth. *The Virtual Gallery of Contemporary Jewellery*. (CD-ROM) Birmingham, United Kingdom: University of Central England, Birmingham Institute of Art and Design, 2000.

Risatti, Howard. *Skilled Work: American Craft in the Renwick Gallery*. Washington, DC: Renwick Gallery of the National Museum of American Art and the Smithsonian Institution Press, 1998: 140, 186.

*Smithsonian: Treasures from the Smithsonian Institution 2010.* Smithsonian Institution, Washington, DC. (2010 weekly calendar): 4–5 (December 27–January 2).

Sprintzen, Alice. *Jewelry: Basic Technique and Design*. Radnor, PA: Chilton, 1980: 177–79, cover.

———. *The Jeweler's Art: A Multimedia Approach*. Worcester, MA: Davis Publications, 1994.

Trapp, Kenneth R. *Masters of Their Craft: Highlights from the Smithsonian American Art Museum*. Washington, DC: Smithsonian Institution, 2003: 52–53.

Tropea, Jan. *American Craft Museum 25*. New York: American Craft Council, 1981: 7.

Untracht, Oppi. *Jewelry Concepts and Technology*. Garden City, NY: Doubleday, 1982: 207, 209, 213–14, 216–219, 228, 230, cover.

Watkins, David. *The Best in Contemporary Jewelry*: Mies, Switzerland: Rotovision, 1993: 102–03, 215.

Wilcox, Donald. *Body Jewelry: International Perspectives*. Chicago: Henry Regnery, 1973: 64–69.

## Selected Exhibition Catalogues

*6 Contemporary American Jewellers*. London: Electrum Gallery, 1976: unpaginated.

*Beaux Arts Designer/Craftsman '75*. Columbus, OH: Columbus Gallery of Fine Arts, 1975: 5, 14–15.

Bober, Harry. *The Goldsmith: An Exhibition of Work by Contemporary Artist-Craftsmen of North America*. St. Paul, MN: Minnesota Museum of Art; Washington, DC: Renwick Gallery, National Collection of Fine Arts, Smithsonian Institution, 1974: 55–56.

Bohan, Peter, Bob Ebendorf, and Henry P. Raleigh. *Precious Metals: The American Tradition in Gold and Silver*. Miami, FL: Lowe Art Museum, University of Miami, 1976: 28–29, 42.

Brodie, Regis, Dore Ashton, C. E. Licka, Michael McTwigan, and Ellen Schwartz. *Multiplicity in Clay, Metal, Fiber: Skidmore College Craft Invitational 1984*. Saratoga Springs, NY: Skidmore College Art Center, 1984: 58, 96–97.

Cardinale, Robert L., and Lita S. Bratt. *Copper 2: The Second Copper/Brass/Bronze Exhibition*. Tucson, AZ: University of Arizona Museum of Art, 1980: 50–51.

Denman, Martha Hendrix. *30 Americans: An Invitational Exhibition of Clay, Fiber, Glass, Metals and Wood*. Galveston, TX: Galveston Arts Center, 1981: 15.

Dietz, Ulysses G., Sarah Bodine, and Michael Dunas. *Ohio Metals: A Legacy*. Columbus, OH: Ohio Designer-Craftsmen, 1993: 78–79.

Duval, Cynthia. *Infinite Riches: Jewelry Through the Centuries*. St. Petersburg, FL: Museum of Fine Arts, 1989: 78.

Elson, Susie, and Paul J. Smith. *Celebrating American Craft: American Craft 1975–1995*. Copenhagen: Danish Museum of Decorative Art, 1997: 19, 55.

Fairbanks, Jonathan Leo. *Craft Transformed: Program in Artisanry.* Brockton, MA: Fuller Museum of Art, 2002: 15, 54.

Falino, Jeannine, and Jan Brooks Loyd. *Sculptural Concerns: Contemporary American Metalworking.* Fort Wayne, IN: Fort Wayne Museum of Art, 1993: 68–69.

Falk, Fritz, and Thomas R. Markusen. *SNAG: Jewelry and Metal Objects from the Society of North American Goldsmiths.* Pforzheim, Germany: Schmuckmuseum, 1979: 34–35.

Faris, Teresa, Susan Messer, and Melanie Anne Herzog. *Women of Metal.* Whitewater, WI: Crossman Gallery, University of Wisconsin-Whitewater, 2008: 18, 19, 52–53.

Feeley, Ricka. *2nd Annual National Exhibition in Contemporary Jewelry.* Atlanta, GA: Gallery of the Art Department, Georgia State University, 1975: 10–11.

Fisch, Arline M. *Jewelers, U.S.A.* Fullerton, CA: Art Gallery, California State University, 1976: 16.

———. *American Jewelry Now.* New York: American Craft Council, 1985: 67, 69.

Garrett, Paula B. *20 years of Metal from Southern Illinois University at Carbondale.* Carbondale, IL: University Museum, Southern Illinois University at Carbondale, 1982: 15.

Herman, Lloyd E. *Good as Gold: Alternative Materials in American Jewelry.* Washington, DC: Smithsonian Institution Traveling Exhibition Service, 1981: 4.

Hickman, Ronald D. *The Metalsmith: Society of North American Goldsmiths Exhibition.* Phoenix, AZ: Phoenix Art Museum, 1977: 8, 36.

Hill, Trudee. *Celebrating 70: 70 Years by 70 Artists.* Seattle: Facèré Jewelry Art Gallery, 2010: 140–41.

Hull, Lynne. *Seattle Metals Guild 20th Anniversary Show.* Edmonds, WA: Anderson Center, 2009: 29.

*Jewelry USA.* New York: Society of North American Goldsmiths and American Craft Museum II, 1984: 86.

Kelso, Jim, and Jean Sousa. *More Than Meets the Eye: Small Treasures by 29 Contemporary American and Japanese Master Craftspeople.* Stowe, VT: Helen Day Art Center, 1990: 39–40, cover.

Kester, Bernard. *American Crafts '76: An Aesthetic View.* Chicago: Museum of Contemporary Art, 1976: 6, 19, 32–33.

Kirkham, Pat, ed. *Women Designers in the USA 1900–2000: Diversity and Difference.* New York: Bard Graduate Center for Studies in the Decorative Arts, 2000: 214–15, 239, 243.

Litsheim, James E., and Joseph C. Ordos. *Focus on Crafts: An Exhibition.* St. Paul, MN: Goldstein Galleries, McNeal Hall, University of Minnesota, 1977: 10, 13.

Loucas, Penelope, ed. *Washington Crafts Then and Now.* Tacoma, WA: Tacoma Art Museum, 1989: 12.

Luck, Robert H. *Forms in Metal: 275 Years of Metalsmithing in America.* New York: Museum of Contemporary Crafts, and Finch College Museum of Art, 1975: 17, 31.

Manhart, Marcia, and Tom Manhart. *The Eloquent Object: The Evolution of American Art in Craft Media Since 1945.* Tulsa, OK: Philbrook Museum of Art, 1987: 46, 63.

*Marietta College Crafts National '74.* Marietta, OH: Grover M. Hermann Fine Arts Center, Marietta College, 1974: 1

McDonnell, Patricia, Ivan Doig, and Rock Hushka. *Building Tradition: Gifts in Honor of the Northwest Art Collection.* Tacoma, WA: Tacoma Art Museum, 2003: 84.

Monroe, Michael W. *The Animal Image: Contemporary Objects and the Beast.* Washington, DC: Renwick Gallery of the National Museum of American Art, 1981: 30.

Monroe, Michael W., and Bruce Metcalf. *The Art of Gold.* Kansas City, MO: Society of North American Goldsmiths, and ExhibitsUSA, Mid-America Arts Alliance, 2003: 21, 32, 34, 38.

*National Metals Invitational 1982.* El Paso, TX: Fox Fine Arts Center, University of Texas at El Paso, 1982: 9, cover.

Oshima, Chiya. *Creative Jewelry.* Manila, Philippines: Design Center Philippines, 1977: cover.

Peterson, Allan. *Invitational Jewelry Exhibition.* Pensacola, FL: Visual Arts Gallery, Pensacola Junior College, 1975: 4, cover.

Petrova, Sylvia, Sarah Bodine, Michael Dunas, and Jenny Zimmer. *Design Visions: International Directions in Glass, American Jewellery and Metalwork, Australia—New Design Visions.* Perth, Australia: Art Gallery of Western Australia, 1992: 80, 100,165.

Ronte, Dieter, Friedrich Becker, Eugen Mayer, Vera Vokacova, and Peter Skubic. *Schmuck International 1900–1980.* Vienna: Kunstlerhaus, 1980: 113, 219.

*Seven Contemporary American Metalsmiths.* Overland Park, KS: Gallery of Art, Johnson County Community College, 1992: 3.

Smith, Paul J. *Craft Today USA.* New York: American Craft Museum, 1985: 117, 133, 145.

Smith, Paul J., and Edward Lucie-Smith. *Craft Today: Poetry of the Physical.* New York: American Craft Museum, 1986: 241.

Story, William E. *Metalworks Invitational 1979.* Muncie, IN: Art Gallery, Ball State University, 1979: 21.

Strauss, Cindy. *Ornament as Art: Avant-Garde Jewelry from the Helen Williams Drutt Collection, Museum of Fine Arts Houston.*

Stuttgart, Germany: Museum of Fine Arts Houston and Arnoldsche Art Publishers, 2007: 31, 377, 452–58, 476, 480.

*The Makers: Fiber, Clay, and Metal.* Atlanta, GA: Gallery of the Art Department, Georgia State University, 1977: 16.

Thomas, Richard. *Reprise, Metalsmiths, Cranbrook, 1948–1975.* Bloomfield Hills, MI: Cranbrook Academy of Art Museum, 1975: 9, back cover.

Tolstrup, Lisbeth. *Flet/Braid.* Aalburg, Denmark: Nordjyllands Kunstmuseum; Tonder, Denmark: Tonder Museum, 2001: 64–67.

Untracht, Oppi, and Toni Lesser Wolf. *Masterworks of Contemporary American Jewelry: Sources and Concepts.* London: Victoria and Albert Museum, 1985: 9, 22–23, cover.

Ward, Barbara McLean, and Gerald W. R. Ward. *Silver in American Life.* Boston: Yale University and The American Federation of Arts, 1979: 188–89, back cover.

West, Harvey. *The Washington Year: A Contemporary View, 1980–81.* Seattle: Henry Art Gallery, University of Washington, 1982: 6, 13.

Yuen, Kee-Ho. *2004 International Metal Artists Invitational Exhibition.* Seoul, South Korea: Kepco Plaza Gallery, 2004: 19.

**Articles**

"1996 American Craft Council Awards." *American Craft* 56(5) (October–November 1996): 58.

Aalund, Nanz. "Hu's Who?" *Art Jewelry Magazine* 2(4) (May 2006): 29–34.

Becker, Missy. "The Artist-Craftsmen." *Town & Country* (October, 1977): 179.

Birnbaum, Jesse. "Crafts: Five Artists in 5 Mediums." *Leisure* 2(1) (October 1986): 51.

Breckenridge, Elizabeth. "Mary Lee Hu: High on the Wire." *Craft Horizons* 37(2) (April 1977): 40–43, 65.

Capps, Sarah, and George Arndtt Civey III. "Mary Lee Hu, Works, 1974–1979." *Goldsmith Journal* 5(3) (June 1979): 4–5.

"Contemporary Metalcraft in America: 24 Artists." *Monthly Crafts* [South Korea] 4(6) (1988): 44–45.

"Correction." Metalsmith 9(3) (Summer 1989): 54.

Cullinan, Helen. "Silver Threads Are Growing Bold." *The [Cleveland] Plain Dealer*, March 24, 1974: 7-E.

DuPriest, Karen. "Craft Into Art: Mary Lee Hu Takes Gold and Silver Jewelry in a New Direction." *Connoisseur* 216(897) (October 1986): 138–41.

Fitzpatrick, Kathleen. "Mesh Maker." *Departures* 86 (September 2003): 66.

"Guest Artist: Mary Lee Hu, Fiber Techniques in Metal." *Concepts: Focus on Fiber* 5(1) (1976): 6–7.

Hadley, Wayne. "Metal-Weaving." *Rock and Gem* 13(3) (March 1983): 40–43, 45–46.

Hu, Mary Lee, with Nanz Aalund. "Train the Brain: Design Challenges Ignite Your Creativity." *Art Jewelry Magazine* 2(4) (May 2006): 35–37.

"Interview." *Jewel* (Japan) 17(9) (September 1989): [text in Japanese] 33.

Jordan, Carol. "Artist Creates Beauty in Silver Sculpture." *The News Sun* [Cleveland], January 27, 1977: B1.

Klemperer, Louise. "Mary Lee Hu Metal Weaving." *Willamette Week's Arts & Entertainment* Guide (March 3–9, 1981).

Liu, Robert K. "Retrospective, Mary Lee Hu." *Ornament* 18(2) (Winter 1994): 54–55.

Lynn, Vanessa. "Mary Lee Hu." *American Craft* 50(1) (February–March 1990): 74–75.

Mahler, Annette. "Mary Lee Hu: The Purpose and Persistence of Wire." *Metalsmith* 9(1) (Winter 1989): 24–29.

"Modern American Jewelry Exhibition." *Jewel* (Japan) no. 45 (November 1977): 25–26.

Moskow, Shirley. "The Most Intimate Art: The American Studio Jewelry Movement Has Grabbed the Imagination." *AmericanStyle* 13(5) (June 2007): 76–77.

Muler-Wettbewerb, Friedrich Wilhelm. "Der Goldene Faden." *Goldschmiede Zeitung* (European Jeweler) (April 1981): 141.

Stein, Margery. "The World of Wearable Art." *New York Times Magazine*, November 12, 1989: 68, 71.

Sutton, Lyn. "Why Wire Works." *Wire Artist Jeweller* 7(9) (November 2004): 4–5.

Updike, Robin. "The Evocative Art." *Pacific Magazine, The Seattle Times* (December 1, 1996): 28–29, 31, 35–36.

———. "Weaving Metal." *Fiberarts* 24(1) (Summer 1997): 40–44.

Wagonfield, Judy. "In the Studio: Mary Lee Hu, The Golden Touch." *Metalsmith* 29(5): 18–19.

Wheaton, Hazel L. "Golden Threads." *Lapidary Journal* 56(2) (May 2002): 18.

# WORKING WITH WIRE

To make my jewelry and small objects, I have spent forty-seven years exploring various ways of using round wire with processes borrowed from the textile field. In planning this catalogue, it was thought that a short technical section might prove useful to others wishing to know how I did my work or wanting to try these processes themselves.

Working with wire has a historical tradition in many parts of the world. For example, twisted and wrapped wire patterns can be seen on the handles of swords, Viking torques and armbands are twisted or braided wires, knitted-wire chains are made in Tibet and India, and wire strips are plaited into jewelry and containers in Thailand and manuscript containers in Burma. Both containers and crowns or hair covers in Ming Dynasty China have been made of fine gold twisted wire mesh, and gold wire has been used extensively in embroidery, lacework, and the braid on military uniforms.

## TOOLS AND MATERIALS

My tool kit is simple. Wire cutters, pliers, and my fingers are my basic tools. My favorite pliers are chain-nosed, along with the round and flat and the half-round and flat-forming pliers. For sawing through twined sections, I use an 8/0 jeweler's saw blade. When soldering, I use a borax-based paste flux and am still using my acetylene air torch with its Smith handpiece, usually with the 0 or 00 tips.

I have drawplates and pull down my own wire to make it smaller when needed, and I have a rolling mill which helps me make the flattened wire frames for my twining and to forge down ingots when recycling my scrap. I use a flexible-shaft machine to polish some of the heavier wire edges of my twined work, but mostly just use a brass scratch brush for the finish on my pieces.

**Copper.** Copper can be used in almost all of the processes. In some, a stiffer material is preferable.

**Brass.** I found brass wire too stiff for my fingers in some of these processes where the very fine wire is used, so mostly used silver until I switched to gold. Brass can be used for the parts that need stiffer wire, like warp in basketry; it also works well for many of the braids.

**Magnet wire.** For a greater range of color, one can use magnet wire, a copper wire with a lacquer coating. It is used in electronics to wind the coils in electric motors. The lacquer acts as insulation, and I thought it was beautiful. I found it in electronics stores or especially electronics salvage places. Something like it is now available in craft stores in a wider range of colors, but supplied on small spools at a higher price. Since the lacquer cannot take the temperatures of annealing or hard soldering, designs have to be planned accordingly.

**Silver.** In silver I usually used a combination of sterling silver in the heavier gauges, and fine silver, which is pure silver, in the lighter ones. I would buy my sterling in 14 gauge, and 18 or 20 gauge, and my fine silver first in 26 gauge, later switching to 28 gauge.

**Gold.** I use both 18K for stiffness and 22K for its rich color and flexibility. For my twining, I generally use 24 gauge 18K warp and 30 gauge 22K weft. The heavier framing wires are all 18K.

## TWISTING AND WRAPPING

When I was first studying, jewelry textbooks would usually only talk about wire in connection with making chains; sometimes there were a few examples of twisted wires. For a very fine series of photographs of twisted and wrapped wires with instructions on how to make them, see Herbert Maryon's *Metalwork and Enamelling* (New York: Dover, 1947: 135–139). I began by making projects the way he outlined. Then I tried twisting them tighter than he illustrated, doing them in the opposite direction, or with square or flattened instead of round wire. I also tried using more wires than he listed, or made pieces with wires of different sizes. Some

did not work and I learned why he did not include them or said to do it differently! However, some were interesting variations on his ideas. Most could be used for hoop earrings—or, on a larger scale, for bangle bracelets or torque necklaces.

The more at right angles the wrapping wire is held to the core, the tighter the wrapping. By holding it closer to parallel with the core, the wrapping becomes much looser.

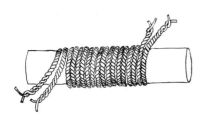

A type of work often used on sword handles is made by first twisting two small wires around each other clockwise, and another two counterclockwise. Wrapping these two twisted wires side by side around the handle gives a handsome, braided-wire look.

Tying knots in wire is fighting wire's natural tendency to harden as it is bent, so in my explorations I soon switched from macramé knots to wrapping one wire around several others, bringing them out from the wrapping where desired to arc through space, often to be caught up again in the

wrapping. This idea is also used in wicker furniture. A fine book on that subject with good pictures is Jeremy Adamson's *American Wicker* (New York: Rizzoli, 1993). Ideas can also be gotten from looking at antique tinker work. A good book on this is *Wire (Everyday Things Series)* by Suzanne Slesin et al. (New York: Abbeville Press, 1994).

**A few tips.** I quickly learned several things in my explorations. When wrapping one wire around another single wire, the core, or one being wrapped around, should be heavier or stiffer than the one doing the wrapping. Otherwise it will bend all over and be hard to control. I use a heavier, work-hardened sterling silver as the core, and the thinner annealed fine silver to do the wrapping. Often this is 20 gauge sterling and 28 gauge fine silver. If wrapping around a whole group of wires, they can all be the same size as the wrapper.

Most people will also find it easier to wrap in one direction or the other. I like to wrap away from me, down around the element and back toward me under the element.

This seems like a small thing, but it makes for a great savings of time when doing a lot of wrapping.

It is also desirable to think about things beforehand while designing, and to always try to be in a position to wrap close to the open end of the wire. I try not to design closed forms—such as circles—in which something will be wrapped. Trying to feed the end of the wrapping wire through and pulling it down tight will be extremely time-consuming: it will want to knot up. If wrapping a long length of wire, I wrap away from the open end of the core until it gets too long, then coil up the length already wrapped so the wrapping is again close to an "end."

When wrapping one wire around another, the wrapping wire becomes twisted. If round wire is used this will not be noticeable. However, if square or flat wire is the wrapper, this twist will be seen and have to be constantly battled against, or need to be incorporated into the design. When the wire twists, it will also be work-hardening. I usually have my wire on a small spool or wound into a small coil that I can hold in my hand, only letting out about a foot of wire at a time. I keep it pulled straight as I wrap it until it is almost used up and my hand is fairly close to my work, and then let out of the spool another freshly annealed length to use. This way I am not always battling the tendency for the twisting wire to want to loop around itself and get tangled, as it would if I were working with a long loose length.

**Finishing the ends.** I often finish off the ends of my wires by melting them. The molten wire forms a ball. In fine silver, this ball is round and does not oxidize as sterling does, but stays very shiny. To attach two or more wires by melting them all into one ball at their ends, they must all be touching one another. If one is not touching the others, it will tend to melt first. When attaching pieces this way I do not flux the wire because I don't want the wires to fuse together next to the melted ball. When using sterling silver, the ball will oxidize and need to be pickled—dipped into acid to dissolve off the oxide. Sterling will also tend to form a drop shape instead of a sphere, so I make sure to hold it so

that gravity pulls it into the shape I want as I melt it. The hotter it is, the more it will shrink and wrinkle upon cooling and need sanding and polishing. To better control the drop shape as well as the wrinkling, it is preferable to melt the wires with a cooler torch. I use a propane torch for this, whereas I use the hotter oxygen gas or oxyacetylene touch for melting the little balls that hover close to the larger coiled element, since that mass of metal conducts the heat away so quickly. (*Neckpieces #17, #19, #22, #26; Form #3; Headpiece #5*)

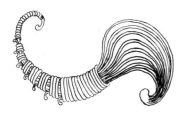

**Tapers and looping.** As I subtract wires from a wrapped bundle, it creates a taper. I often cut these wires short and melt them back to get rows of little balls along the taper, a technique I used in many pieces. (*Squid*)

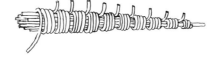

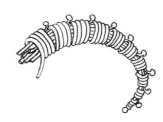

I also began taking one or several wires out from the wrapping, making a little loop, and then putting them back in. These loops then became dragon scales, bird feathers, or just a lacy element. (*Earrings #36* and *#37; Dragon; Neckpiece #9; Choker #1*) If the wires in the bundle are different colors, a pattern of different colored loops can be planned. (*Aquatic Insect*)

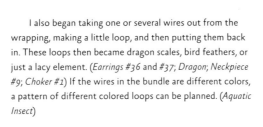

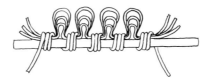

**Chain-link fence looping.** To "draw" the wing feathers on *Neckpiece #9*, I made rows of loops by inserting the end of the wire through the loop in the previous row and pulling the wire through, leaving only the correct sized and shaped loop. (*Neckpieces #9, #13, #17, #18; Choker #26*)

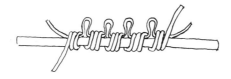

I used these ideas to make the insects and lizards. I would draw them out beforehand, planning how many wires and how long each would need to be to make the legs, wings, antennae, eyes, and so on. I usually began wrapping from the center, starting whenever possible with all the wires needed and pulling them out toward both ends as I worked. I found I could control things better when subtracting rather than adding wires. I then cut the wires to the needed length, bent them into position, and finished off the ends by melting them.

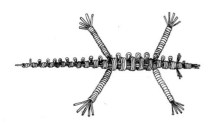

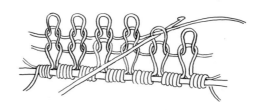

## COILING

As I looked at coiled baskets, they seemed very similar to my wrapping. Each new row was attached to the body of the basket by "sewing" the wrapper element to the levels below, and variations in the patterns came from how this was done. However, since sewing with long lengths of wire was something I tried to avoid, I used this process in shorter areas to tie together my wrapped lengths. (*Neckpieces #19, #22, #26; Headpiece #5; Choker #25*) If the areas of sewn joining stitches are all parallel, it allows a hinge-like flexibility. If they are at right angles to one another, the structure becomes quite rigid.

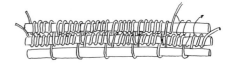

A lizard ready for the ends of the wires to be melted for his eyes, nose, toes, and tip of tail, and then bent into shape so he will not look like roadkill.

Above: If the stitch is a "figure 8" it is almost invisible; I usually used this. Below: It can also be made to show and become part of the design.

## KNITTING

Thin wire can be knit. I use 26 and smaller gauge. Arline Fisch has explored knitting wire with knitting needles, with round pegged spools, and with knitting machines. *Textile Techniques in Metal for Jewelers, Textile Artists, and Sculptors* (New York: Lark Books, 1996) is her excellent book on weaving, knitting, crochet, braiding, and some netting or interlace variations. I wanted to knit wire so that it would have the density of a Tibetan piece I had, and found I could use a crochet hook to pull the loops through the previous row of loops—or, in the case of the Tibetan piece, the row of loops three rows previous—overlapping the loops to achieve the density I wanted. (*Neckpiece #13; Earrings #83*)

Knitting can be started from any row of loops. I carry the wire at the back of the piece, pulling the loops toward me, not turning it over but always working from the front, left to right and back again right to left. This gives the herringbone pattern. The reverse side looks quite different —like the inside of socks.

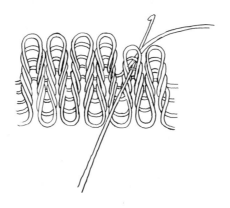

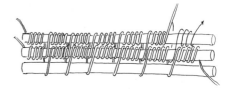

## BASKETRY

Because I wanted to create forms with my wire, I never investigated weaving on a loom but instead looked at baskets. There are many books on basketry, but I found that looking at the actual baskets was best for me. I began with the ones I had at home, but then found more in thrift shops. In studying them, I would look for several things. First, what was the basic process used? Was it coiled, plaited, soumak, woven, twined? Then I looked at the kinds of materials used. Some types of basketry are easier to translate into wire than others. I found that many baskets use multiples of short elements—pine needles, palm fronds, reeds, strips of bamboo or bark. In my work I prefer fewer, longer elements, so that I have fewer ends to hide or incorporate into the pattern. I explored both coiling and weaving before deciding that twining offered the most potential for my work.

## WEAVING

I began exploring basketry by using a warp and weft and doing a simple tabby weave—over one, under one. In loom weaving, the warp threads are the ones strung up on the loom. In my basketry, the warps are the heavier wires that give the basket its form. The weft wires are the smaller ones that interlace with the warps to hold them in place and give the surface texture. As in wrapping, I make my warp stiffer and heavier than my weft so as to better control it. I first draw a cross-sectional view of my intended form; that tells me how long the warps need to be, as they usually run straight through. I always add an inch or two to the top to allow for finishing them off if I am going to use traditional basketry finishing processes instead of soldering them. Also, I need to keep in mind that if I am weaving around a form, instead of back and forth on a flat piece, I need to plan for an odd number of warps so that the weft alternates and goes over the warps it went under in the previous row. Since it is harder to judge the length of weft required, I work from small spools or coils of wire and add more when needed.

To hold all the warps in place at the beginning, I first tried melting them together into a small ball at one end. This worked well for small forms with fewer warps, and especially for drop earrings where the ball was a nice ending. I also wrapped around a group of wires, then spread them all out to become the warps and started weaving with the wire that had been the wrapper.

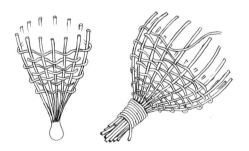

For flat sheets, I can tape the ends in a row, placing the tape on both sides of the piece so it holds together well enough to pick up and work in my hands. I never tried to use a loom setup. For forms needing a flat bottom, I cross two sets of three or four warp elements (twice the length needed) over each other at right angles and start weaving around this central overlap—keeping in mind that I will need an odd number, and so cutting one short, though I found this was harder to hold together to start. For an oval, I can start by wrapping around a group of wires and bring them out on either side of the taper to become the warps. This has the advantage of holding things together from the beginning. (Underside of *Turtle*)

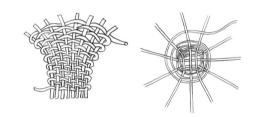

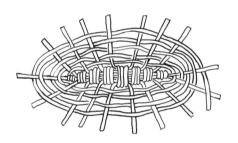

**Finishing off the warp ends.** Often, I just wrapped the ends of the warps. (*Neckpieces #5, #8*) However, many regular basketry solutions also work for wire. When I did pieces that were to look like baskets, I usually bent a warp at right angles, then crossed it in front of about five adjacent warps, and brought it in toward the center between the fifth and sixth warp and cut off any extra. I would handle each warp element in succession like this, which built up a bundle of warps around the rim that looked like a thick coil. The more warps that are crossed in front of, the thicker this coil or rim at the top becomes.

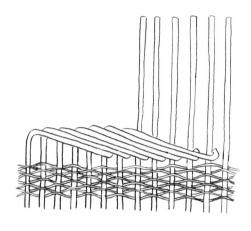

## TWINING

After I had been weaving for a while, I was examining a Northwest Coast cedar bark basket with a surface texture I liked and found that it used two wefts in each row that were twisting around each other as they went over and under the warps—one went over and the other went under each warp, then they passed each other as they went up and down so as to become twisted. This is called twining and it is used extensively in basketry and also to make loom-woven rugs. I fell in love with it. When twisting two elements, the tighter the twist, and the wider the flat elements are compared to their height, the more of a diagonal one will see in the twist. This diagonal is what attracted me to the way the surface of twining appeared. I wanted to replicate it, so I used two round wires running next to each other to make a wider weft element, and kept my warps closely spaced to give a tighter twist. Using double weft elements has been referred to by others as double twining and I have used it almost exclusively since 1976.

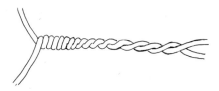

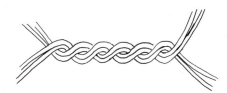

I found that twining has an advantage over tabby weaving as I am able to start out by picking up my warp wires one by one with the first row of twining and they will all hold together. In weaving, it takes at least three rows to start to get the warps to stay in place.

Another advantage is that I can use an odd or even number of warps as each element is gone over and under with a single row of weft. If the number of warps is even, the same weft goes over a particular warp in each row. If the two wefts are the same it's not noticeable, but if they are different colors, for example, I can get stripes. (*Choker #9; Form #3*)

Of course, one disadvantage is that the two wefts can get tangled around each other, and in addition, my choice of using two wires in each weft means that I also need to keep them running parallel and not twisting around each other.

To start a tube, I twine the first row by picking up each warp until I have them all, and then bend the end with the first warp down away from me and up around to meet up with the last one and continue twining on what is now the second row. I have found it helpful to put a pencil, dowel rod, or similar spacer into the top half-inch of the tube as I am twining. This helps to keep it an even size, but primarily it cuts down on the confusion; it means my eyes only see the warps in the front of the tube rather than seeing through them to all the ones at the back as well.

When beginning a round basket that will have what looks like a traditional basket bottom, I cross three or four warps over one another and twine around them as I did in the weaving. This can be started easily by picking up the six or eight warps in a straight row of twining, then bending the row so that half of the warps overlap the others at right angles, and then continuing to twine around the other two sides of what is now a square. After the first row of twining is completed, I spread out the warps so they radiate in a circle. Then as I work I always rotate the piece so that I am twining at the top—twelve o'clock high—which allows me to pack the new row down tightly next to the previous row.

Since I do not want to have ends to hide at the beginning or center of my twining, I double my wefts in half in order to start twining around the first warp.

The way I twine is to have both weft elements (A and B below) coming out toward me and parallel, separated by one warp. Working left to right, I take weft A, move it over the warp between the two wefts and also over weft B, then under the next warp and back to the front, placing it parallel to the B weft. I then drop A and pick up weft B and repeat the process, going over one warp and under one, dropping it and going back to A, and so on. A always needs to go over B, then B over A. This gives the twist to the two wefts. Keeping the two wefts parallel in front is important in getting them to twist.

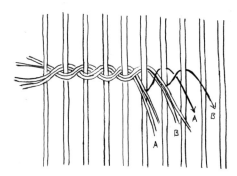

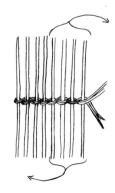

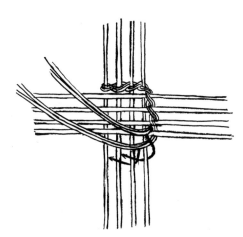

As the basket bottom is twined larger and larger, the warps get farther apart. This can work, but I always want them to be about as closely packed as the weft will permit, so I need to add more warp elements. Since I do not want to have ends down near the base of my form, I usually add a piece twice as long as needed that has been bent into a V shape, thus actually adding two warps. When I add it, I treat it like two warps, twining over one side and then the other. This way the addition is immediately held in place.

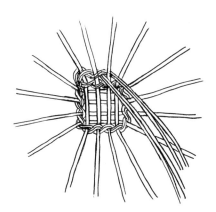

**Turning over at the end of a row.** I always twine left to right. When getting to the end of a row on a flat piece, I push the two pairs of wefts to the back, one between the last two warps and the other around the end one, as illustrated. Then when I turn the piece over they are in place, ready for me to start twining the next row with weft A. (*Choker #61*)

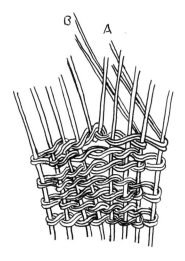

If I want a round form, I usually add a V between each of the original warps all the way around, and all at one time. The place where warps are added will show—it will be a disruption of the pattern—so I just use this disruption as a part of the pattern.

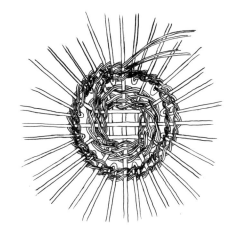

To get a square form, I start the piece like a circular one, but then instead of Vs, I add warps bent into a right angle or L in the four corners on every row.

When the bottom is large enough, the warp wires are bent down; they become the four sides.

The form will develop in any direction that the warps are bent as they are twined over. Flair them out and the form gets larger, push them inward and it will decrease in size. The important thing here is that the warp wires remain smooth and evenly spaced as they get twined upon. There is a limited ability to change things later.

I always try to work about two inches or less from the ends of my warp. This allows me to work more quickly, over the ends, but it also is easier to keep the short warps straight and even. In small pieces this is not a problem, but if I am working with long warps—twining a long tube or strip for instance—where the warps go fairly straight through the piece, I still always work about two inches from the end. When I have twined up close to the end, I pull each warp wire up through the system so that I am again about two inches back from the ends. However, if I have added Vs, this will not work and I have to be very careful of my long flopping warps so they do not become crumpled.

**Decreasing.** After adding warps, some might have to be subtracted so as to make the form smaller—to neck it in. There are several ways of doing this. Instead of twining over every warp, twining could be over two or three together, thus eliminating the space the weft took between them, although this only makes it a bit smaller. If warps have to be totally removed, they can be cut short and the twining just worked past the end, with the adjacent warps then brought together. Or, rather than cutting them off, they could be bent toward the outside where they will show. Something can then be done with them later as part of the design, and I have usually used this option. The wires could even become another system of warps for twining a plane that branches off from the original surface.

Adding the L-shaped warps when twining a square gave me the idea of just beginning with four L-shaped warps, with none of them crossed over in the center, and then adding more L shapes in each row. This was also what gave me the idea for twining X shapes. (Chokers #70, #78; Earrings #120)

Of course the piece can also be started with three, five, six, or more bent warps instead of four. If the work is done with only one group of bent warps, where they are all nesting one inside the other, I twine back and forth instead of around. (Choker #79; Bracelets #43, #44, #45; Brooch #33, Earrings #130, #146, #156, #194)

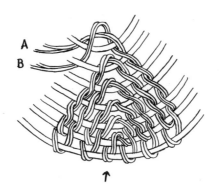

The piece is started at the arrow with two warps, adding one more in each row as shown, working with weft A and then B.

**Surface pattern.** Twining over two or three warps to reduce the size also gave me the idea of doing this for surface pattern. The effect is similar to damascene tablecloths where the material is all one color but the pattern shows up because of the play of light from the longer "floats" of weft over multiple warps. I began to draft these patterns on graph paper, having a horizontal row be my row of twining and each square be a place where the weft intersects a warp. If I leave it blank, that represents background or where the weft goes over a single warp, and I pencil in two or more adjacent squares in the row to indicate where I will float the weft over two or more warps. I find that floating over more than five warps at a time leaves such a long wire that it can get caught and pulled out of place. In all my twining, I have one of the two double weft wires going over

one or more warps while the other goes under the same ones. Therefore, the front and back of the piece always have the same pattern. This is the pattern used on *Bracelet #17*. (Chokers #62, #82; Bracelets #17, #27, #30, #41, #47, #54; Brooch #16; Rings #4, #60, #90)

**Annealing.** As stated above, if the warps are a heavier gauge and stiffer, they will hold their shape better as they are pulled against in twining. I usually draw down my warp wires to work-harden them.

The weft should be as soft as possible. I have found that even if wire is ordered from the supplier dead soft, it

will usually get softer if I anneal it before using it, so I always do. Annealing is the process of heating the metal to relieve stresses that build up while working with it and cause it to become harder. When I am annealing the fine-gauge weft, I first wind two wires together into a small coil. I wrap the length needed around three fingers, take it off my fingers, and bind the coil all the way around with the starting end, because, as with melting wire ends into balls, one does not want any single wire not touching the others or it is likely to melt. After being annealed, this will then be the coil that I twine with, unbinding it, letting out a length to twine with, and rebinding with this tail so it stays coiled as I work. When using fine silver, or 22K gold, it will not blacken or oxidize when annealed, so it will not need to be cleaned in the pickle. For the annealing itself, I use my torch to heat the coil on my soldering pad, looking carefully between the wires for the faint, hard-to-see orange glow to know when it has reached the annealing temperature, then I quench it in water. Or, the coil can be first coated with a paste flux. When the flux melts and "glasses out" the wire will be annealed. Pickle or hot water will dissolve off the flux. Sometimes just a short length of fine wire has to be annealed. For instance, if I made a mistake and had to un-twine a section, I might want to re-anneal that short length of weft before using it to twine again. When doing this it is very difficult to see the color change of the single wire, so I look for a color change in my blue torch flame. When the metal reaches the annealing temperature, the blue flame will change to orange as it comes off the piece. A chemist once told me he thought this might correspond to the burning of the sodium from my fingerprints on the surface of the wire. At any rate, it works for me.

**Soldering on a new weft.** When a weft wire breaks, or I need to add more length, I butt-solder on a new piece. To do this, I cut a very small chip of solder and melt it into a sphere. I flux the end of the new piece of wire and melt the ball of solder onto it. I then take my wire cutters and cut half of this solder off. No matter how small my ball of solder, I seem to have too much. But this also insures that there is solder at the very end of the wire. I do not bother filing the end square as I always have too much solder and the extra space between the nipped-off wires takes up

some of the excess. I flux both ends and hold the new wire with the solder up to the short end and play the torch up and down—not back and forth along the wires, but up and down over the wires—just to the short wire side of the joint, watching for movement in the lump of solder toward the joint and flame. As soon as I see this movement, I know the solder has melted and filled the joint and I quickly take away the flame.

**Soldering the frames.** I usually finish a piece of twining by soldering a heavier frame onto it. I saw the twined piece to shape, and then sand the surface smooth. To help keep the wires from pulling apart when I saw and sand them, I first coat the piece with paste flux and heat it until the flux melts and glasses out. I let the piece air cool and then cut and sand with the flux helping to hold the wires in place. I never file. The sheet or wire frame is made and laid onto pins on my soldering pad, so the flame can get underneath it. The twined piece is then balanced on top. I prefer to use gravity to hold the pieces together whenever possible. My usual frame is made of 14 gauge round wire put through the rolling mill set at 19 gauge. This gives me a flat surface that is a bit wider than my twined piece so I have a small ledge on front and back large enough on which to place my small balls of solder—one pushed up next to each warp wire. I flux the piece using a paste flux, glass-out the flux, place the solder while the flux is hot, and then solder them all at once by aiming the flame underneath the frame wire. Because the solder will follow the heat, this usually draws the solder under the wires and not up through the twining. Since I use very small balls of solder, there is no need for cleanup. I just pickle it and brush it with a brass scratch brush dipped into soapy water, burnishing the finished piece to a soft glow so the wires sparkle, rather than having the hard shine of a highly polished surface.

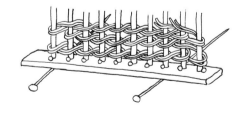

# GLOSSARY

**Anneal, annealing**
Many metals become harder because as they are bent or worked, stresses build up and they become work-hardened. Annealing relieves these stresses by heating the metal to a specific temperature.

**Bench, bench work**
A jeweler's bench is traditionally a fairly small, high table, often with a semicircular cutout in the front, and a bench pin (a fork-shaped piece of wood) sticking out from the center of the cutout. Bench work like sawing and filing takes place on this pin, and the filings and little pieces drop into a drawer below and not onto the floor—important if they are gold!

**Drawplate**
These are steel plates with a series of tapered, graduated holes; wire is pulled or drawn through the openings to make it thinner and longer.

**Electroforming**
A process that uses an electric current to deposit metal onto a matrix having a conductive surface. While similar to electroplating, it builds up such a thick deposit that the metal can stand on its own after the matrix has been removed.

**Fine silver and sterling silver**
Fine silver is pure silver. Sterling silver has 92.5% silver and 7.5% alloy, which is usually copper, to make it harder.

**Flux, paste flux**
A material that will keep metal clean when it is melted or soldered by absorbing oxidation. Flux often contains borax when used with copper, silver, and gold.

**Framing wires**
Heavier, 18K wires that I solder onto the cut edges of my twining so things do not unravel.

**Gauges for wire**
A specific system for measuring the thickness of sheet metal or diameter of wire. I use the Brown and Sharpe or B&S gauge system. The higher the number the thinner the metal, with 30 gauge equaling about one 100th of an inch, or one-fourth of a millimeter, and 18 gauge approximately one 25th of an inch or 1 millimeter, respectively.

**Gold filled wire**
Gold filled (sometimes referred to as G.F.) means that a layer of gold, usually 12K, is adhered to a base metal, usually brass, which is then rolled or drawn out thin. It is often described as 1/10 12K gold filled, meaning that 1/10th of the weight of the piece is 12K gold. The layer is much thicker than gold plating.

**Glassing out, glassed out**
When borax-based flux is heated, first the water boils off leaving the white flux powder; after the powder bubbles up as it melts, it looks like a glassy, viscous liquid.

**Granulation**
Describes a pattern on gold work created by adhering hundreds to thousands of minute gold spheres—some almost looking like grains of sand—to the surface without using a separate solder alloy. Western goldsmiths "rediscovered" how to do this in the twentieth century by mixing copper as a salt with organic glue and using this mixture to glue the balls onto the gold surface in the desired pattern. As the piece is heated, the glue burns and the carbon produced protects the surfaces from oxidization and reduces the copper from the salt, which then combines with the gold, slightly reducing the karat on the surfaces. Where two gold pieces are touching, they are physically joined when this alloying occurs.

**Inkle loom**
A narrow, often table loom.

**Mandrel**
A ring mandrel is a tapered rod of steel with finger ring sizes marked on it.

**Niello, niello technique**
An alloy of copper, silver, lead, and sulfur, niello has a shiny, dark gray color and melts at a relatively low temperature. In metalwork, it is usually melted into depressions of a design, giving a strong color contrast with the bright metal of the piece.

## Pickle, pickling

When sterling silver and karat gold are heated, they oxidize, producing a black layer on the surface. To clean this off and dissolve any remaining flux, the piece is soaked in an acid (made by mixing dry granular sodium bisulphate in water) afterward. Metalsmiths usually call this acid the "pickle."

## Planishing

Hammering the surface of a sheet of metal with a smooth-faced hammer to refine the surface, especially after working it with a coarser hammer.

## Raising (in holloware)

Hammering the outside of a disk of metal over a series of steel forms or stakes to compress the sides and bring them up, forming a vessel.

## Reticulation

A process used to create a wrinkled surface texture on a sheet of silver by heating it. The effect is achieved by first leaching some of the alloy out of the surface so that it will melt at a slightly higher temperature, then carefully heating the silver so that the molten metal in the interior of the sheet will flow and wrinkle this skin.

## Rolling mill

A rolling mill has two smooth steel rollers that can be adjusted to control the distance between them. It is used for pressing or rolling sheet metal to make it thinner and longer. Some rolling mills also have two rolls with a succession of graduated grooves so that rods can be rolled to become thinner and longer—especially in preparation for drawing the metal down into fine wire in drawplates. Most studio jewelers will have hand-cranked mills.

## Slit tapestry-weave

When creating a tapestry, weavers have two ways to place two colors side by side. One is to alternate the color of the left side with the color on the right over the warp thread between them, meaning that both must be built up simultaneously. Another way is to weave one color area completely, then the next one on the adjacent warps, without any overlapping at all. This leaves a space (or slit) between colors as wide as the warp threads are spaced.

## Solder

Hard solder (or brazing material, as opposed to the soft solder used in plumbing), is an alloy that melts at a slightly lower temperature than the metals it is intended to join. Silver solder is an alloy of silver with copper and zinc added to lower the melting temperature a few hundred degrees Fahrenheit. Gold solder is alloyed much the same way, but care is taken to match the karat and color of the gold being soldered.

## Soumak

A weaving technique where the weft element goes completely around the warp before proceeding to another warp, instead of only under or over as in regular weaving.

## Tinker work

Tinker, tailor, solder, spy . . . in Europe a tinker was an itinerant craftsman who would fix pots and pans and had a spool of wire from which he could fashion all sorts of useful household objects—from coat hangers to spoons and forks to pie racks to birdcages.

## Warp and weft

In weaving, the warp is the series of vertical elements that are set up on the loom before starting to weave. The weft is the element that interlaces with the warp to make the pattern and hold all the elements together in a fabric. In basketry the warp elements are often heavier, giving the basket its form, while the weft elements are worked around, holding the warp in place.

## To work-harden, work-hardening

When metal is worked—bent, hammered, forged, or pulled through a drawplate—it builds up stresses and becomes hard, or work-hardened.

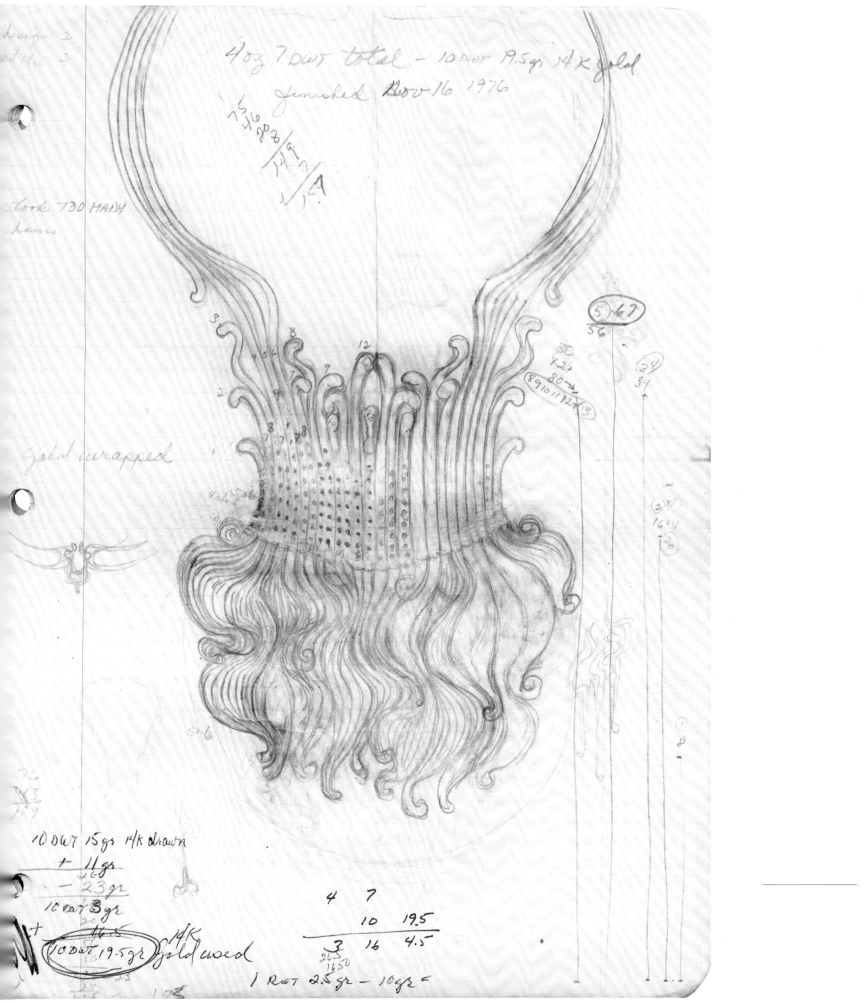

From Reptiles & Amphibians P. 181

Wood Tortoise

15 @ eye

8

# CHECKLIST OF THE EXHIBITION

Height precedes width precedes depth

## BRACELETS

**Bracelet #3**
1981
Fine and sterling silver
2¼ × 3½ × 1⅛ in.
Collection of Phillip Baldwin
Photo by Douglas Yaple

**Bracelet #11**
1982
Fine and sterling silver
3¾ × 3¾ × ¼ in.
Collection of K. Raven Kim
Photo by Douglas Yaple

**Bracelet #17**
1982
Fine and sterling silver with 14K gold
3½ × 4 × ¾ in.
Collection of the artist
Photo by Kim Zumwalt

**Bracelet #30**
1984
Fine and sterling silver with 14K gold
3⅛ × 3⅞ × ⅝ in.
Collection of K. Raven Kim
Photo by Douglas Yaple

**Bracelet #27**
1984
Fine and sterling silver with 14K gold
2¾ × 3½ × ½ in.
Collection of Leanette Bassetti
Photo by Douglas Yaple

**Bracelet #37**
1986
18K and 22K gold, lapis lazuli
2¾ × 3¼ × ½ in.
Collection of the artist
Photo by Richard Nicol

**Bracelet #41**
1988
18K and 22K gold
3½ × 3¾ × ⅝ in.
Collection of Museum of Arts & Design, New York;
Gift of Edward and Vivian Merrin, 1991
Photo by Richard Nicol

**Bracelet #43**
1989
18K and 22K gold
4¾ × 5⁹⁄₁₆ × ⅛ in.
Collection of Museum of Fine Arts, Boston;
The Daphne Farago Collection
Photo by Richard Nicol

**Bracelet #44**
1989
18K and 22K gold
5½ × 5½ × ⅛ in.
Collection of Museum of Fine Arts, Boston;
The Daphne Farago Collection
Photo by Richard Nicol

**Bracelet #45**
1989
18K and 22K gold
4½ × 5⅛ × ⅛ in.
Collection of Museum of Fine Arts, Boston;
The Daphne Farago Collection
Photo by Richard Nicol

**Bracelet #47**
1992
18K and 22K gold
3½ × 3½ × ⅝ in.
Collection of Museum of Fine Arts, Boston;
The Daphne Farago Collection
Photo © 2012 Museum of Fine Arts, Boston

**Bracelet #54**
1998
18K and 22K gold
3 × 3 × ⅞ in.
Collection of Susan C. Beech
Photo by Douglas Yaple

**Bracelet #60**
1999
18K and 22K gold
3⅝ × 4 × 1⅝ in.
Collection of Elise B. Michie
Photo by Douglas Yaple

**Bracelet #61**
2001
18K and 22K gold
3 × 3¾ × 3 in.
Collection of the artist
Photo by Douglas Yaple

**Bracelet #62**
2002
18K and 22K gold
2¾ × 3½ × 2¾ in.
Collection of Museum of Arts & Design, New York.
Museum Purchase with funds provided by Ann Kaplan, 2002
Photo by Douglas Yaple

## BROOCHES

**Cast Brooch #1**
1966
14K gold
2½ × 2 × ⅛ in.
Collection of the artist
Photo by Douglas Yaple

**Cast Brooch #2**
1966
14K gold
2¼ × 2¼ × ⅛ in.
Collection of the artist
Photo by Douglas Yaple

**Brooch #9**
2002
18K and 22K gold
2½ × 1½ × ½ in.
Collection of Susan Edelheit
Photo by Douglas Yaple

**Brooch #10**
2002
18K and 22K gold
2½ × 2 × ½ in.
Collection of the artist
Photo by Douglas Yaple

**Brooch #16**
2003
18K and 22K gold
2½ × 1½ × ½ in.
Collection of Donna Schneier

**Brooch #18**
2007
18K and 22K gold
3⅜ × 2¼ × ½ in.
Collection of Rebecca and Alexander Stewart
Photo by Douglas Yaple

**Brooch #27**
2009
18K and 22K gold
4⅜ × 2 × ¾ in.
Collection of the artist
Photo by Douglas Yaple

**Brooch #32**
2009
18K and 22K gold
4⅝ × 2½ × ⅝ in.
Collection of Arkansas Arts Center Foundation,
Gift of John and Robyn Horn
Photo by Douglas Yaple

**Brooch #33**
2010
18K and 22K gold
3¾ × 4¾ × 1 in.
Collection of the artist
Photo by Douglas Yaple

**CHOKERS**

**Choker #1**
1975
Fine and sterling silver
6½ × 5⅛ × 9/16 in.
Private Collection
Photo by Douglas Yaple

**Choker #9**
1975
Fine and sterling silver, lacquered copper
7¼ × 6 × ¼ in.
Collection of Robert M. and Jeanne Lurie
Photo by Douglas Yaple

**Choker #25**
1976
Fine and sterling silver
7¼ × 6½ × 1¼ in.
Collection of Nancy Demorest Pujol
Photo by Douglas Yaple

**Choker #26**
1976
Fine and sterling silver, 18K and 24K gold
9½ × 6½ × 1¾ in.
Collection of Christo Braun
Photo by Douglas Yaple

**Choker #40**
1978
Fine and sterling silver, 22K gold, lacquered copper
10 × 6½ × 1½ in.
Collection of Metal Museum, Memphis
Photo by Douglas Yaple

**Choker #48**
1979
Fine and sterling silver, 24K gold, lacquered copper
9¼ × 7 × 1¾ in.
Collection of Museum of Fine Arts, Boston;
The Daphne Farago Collection
Photo © 2012 Museum of Fine Arts, Boston

**Choker #55**
1980
Fine and sterling silver
6 × 8⅜ × 1 in.
Collection of Museum of Arts & Design, New York.
Purchased by the American Craft Council with funds pro-
vided by the National Endowment of the Arts, 1984
Photo by Douglas Yaple

**Choker #58**
1980
Fine and sterling silver, with 24K gold
6 × 7¾ × 1½ in.
Collection of the late Joy Rushfelt
Photo by Douglas Yaple

**Choker #59**
1980
Fine and sterling silver
8¾ × 7½ × 1½ in.
Collection of Ginny and Andy Lewis
Photo by Douglas Yaple

**Choker #61**
1981
Fine and sterling silver
7¾ × 8¼ × 1 in.
Collection of John and Jane Marshall
Photo by Douglas Yaple

**Choker #62**
1981
Fine and sterling silver
6¼ × 6¾ × 1 in.
Collection of K. Raven Kim
Photo by Douglas Yaple

**Choker #64**
1981
Fine and sterling silver with 22K gold
6¾ × 7½ × ⅜ in.
Collection of K. Raven Kim
Photo by Douglas Yaple

**Choker #65**
1981
Fine and sterling silver with 22K gold
7 × 8½ × 1 in.
Collection of Nancy A. Marks
Photo by Douglas Yaple

**Choker #67**
1984
Fine and sterling silver with 14K gold
6¾ × 8½ × 1 in.
Collection of K. Raven Kim
Photo by Douglas Yaple

**Choker #69**
1985
Fine and sterling silver with 18K gold
8 × 8 × 1 in.
Collection of Emily Gurtman
Photo by Douglas Yaple

**Choker #73**
1988
18K and 22K gold
6 × 9 × 2 in.
Collection of Dorothy R. Saxe
Photo by Richard Nicol

**Choker #78**
1991
18K and 22K gold
6⅜ × 8⅞ × 1½ in.
Collection of the artist
Photo by Richard Nicol

**Choker #79**
1992
18K and 22K gold
6 × 8⅞ × 1⅝ in.
Collection of Catherine Mouly
Photo by Richard Nicol

**Choker #81**
1993
18K and 22K gold
6½ × 7 × 1 in.
Collection of The Newark Museum, Purchase 2007,
Helen McMahon Brady Cutting Fund
Photo by Douglas Yaple; Photo © 2011 The Newark
Museum

**Choker #82**
1997
14K, 18K, and 22K gold, lapis lazuli
7 × 7 × 1 in.
Collection of Museum of Fine Arts, Boston; The Daphne
Farago Collection
Photo by Douglas Yaple

**Choker #83**
2000
18K and 22K gold
6⅛ × 6¼ × 1 in.
Collection of Tacoma Art Museum; Museum purchase
with funds from the Rotasa Foundation and Susan Beech,
with additional contributions from the Art Jewelry Forum,
Sharon Campbell, Lloyd E. Herman, Karen Lorene, Mia
McEldowney, Mobilia Gallery, Flora Book, Ramona Solberg,
Judy Wagonfeld, Nancy Worden, and the Romana Solberg
Endowment, 2006.10
Photo by Douglas Yaple

**Choker #87**
2002
18K and 22K gold
6¾ × 8¾ × 1 in.
Collection of Marion W. Fulk
Photo by Douglas Yaple

**Choker #88**
2005
18K and 22K gold
8 × 8½ × ½ in.
On loan from The Daphne Farago Collection,
Promised gift to the Museum of Fine Arts, Boston
Photo by Douglas Yaple

**Choker #90**
2008
18K and 22K gold
9 × 11 × 2 in.
Courtesy of Mobilia Gallery, Cambridge Massachusetts
Photo by Douglas Yaple

**SCUPTURAL WORKS**

**RIT Pendant**
1963
Sterling silver
3¼ × 1½ × ½ in.
Collection of the artist
Photo by Douglas Yaple

**Centipede**
1967
Fine silver
4⅜ × 1⅞ × ¼ in.
Collection of Laurie A. Lyall and Heikki M. Seppä
Photo by Douglas Yaple

**Cricket**
1967
Fine silver
4⅜ × 2 × 1 in.
Collection of Mary Lou Hopkins
Photo by Douglas Yaple

**Grasshopper**
1967
Fine and sterling silver
2¼ × ¾ × 1 in.
Collection of Pavia Kriegman
Photo by Douglas Yaple

**Lizard**
1967
Fine silver
4 × 1½ × ¾ in.
Collection of Laurie A. Lyall and Heikki M. Seppä
Photo by Douglas Yaple

**Lizard #3**
1967
Fine silver, iron
6¼ × 2⅞ × ½ in.
Collection of Laurie A. Lyall and Heikki M. Seppä
Photo by Douglas Yaple

**Lizard #9**
1967
18K and 24K gold
2¾ × 1⅝ × ¼ in.
Collection of Brent and Diane Kington
Photo by Douglas Yaple

**Mayfly**
1967
Fine silver
4 × 1 × 3½ in.
Collection of Laurie A. Lyall and Heikki M. Seppä
Photo by Douglas Yaple

**Squid**
1968
Fine silver, tourmaline
12¾ × 5 × ¾ in.
Collection of the artist
Photo by Douglas Yaple

**Turtle**
1968
Fine silver
7 × 1½ × 5 in.
Collection of the artist
Photo by Douglas Yaple

**Dragon #1**
1969
Fine and sterling silver, lacquered copper
8½ × 4 × 1 in.
Collection of the artist
Photo by Douglas Yaple

**Aquatic Insect**
1970
Fine and sterling silver, lacquered copper
10 × 1 × 3 in.
Collection of the artist
Photo by Douglas Yaple

**Praying Mantis #2**
1974
Fine and sterling silver
4½ × 3¾ × 1½ in.
Collection of Mary Jane Hashisaki
Photo by Douglas Yaple

**Form #1**
1974
Fine silver, lacquered copper
8 × 7½ × 7½ in.
Collection of the artist
Photo by Douglas Yaple

**Form #3**
1977
Fine and sterling silver, lacquered copper
6 × 18 × 18 in.
Collection of the artist
Photo by Douglas Yaple

**EARRINGS**

**Earrings #1**
1966
Fine silver
2¼ × ½ × ¼ in.
Collection of the artist
Photo by Douglas Yaple

**Earrings #2**
1966
Fine silver
3 × ⅞ × 1¼ in.
Collection of the artist
Photo by Douglas Yaple

**Earrings #36**
1967
14K and 24K gold
1⅛ × ½ × ¹⁄₁₆ in.
Collection of the artist
Photo by Douglas Yaple

**Earrings #37**
1967
24K gold
1⅝ × ⅜ × ⅜ in.
Collection of the artist
Photo by Douglas Yaple

**Earrings #83**
1975
Fine and sterling silver, glass beads
4½ × ½ × ⅞ in.
Collection of the artist
Photo by Douglas Yaple

**Earrings #120**
1986
18K and 22K gold
1¹⁄₁₆ × 1¹⁄₁₆ × ¼ in.
Collection of the artist
Photo by Douglas Yaple

**Earrings #126**
1988
18K and 22K gold
1¾ × ½ × 1¼ in.
Collection of the artist
Photo by Richard Nicol

**Earrings #130**
1989
18K and 22K gold
1⁷⁄₁₆ × 1⅛ × ½ in.
Collection of Susan Edelheit
Photo by Douglas Yaple

**Earrings #132**
1989
18K and 22K gold
1¾ × 1¾ in × ¼ in.
Collection of the artist
Photo by Douglas Yaple

**Earrings #138**
1996
18K and 22K gold
1¼ × 1¼ × ½ in.
Collection of Racine Art Museum; The Donna Schneier
Jewelry Collection,
Gift of Donna Schneier and Leonard Goldberg
Photo by Douglas Yaple

**Earrings #146**
1993
18K and 22K gold
1⅝ × 1⅝ × ½ in.
Collection of Jane Korman
Photo by Douglas Yaple

**Earrings #156**
1996
18K and 22K gold, lapis lazuli
1 × 1 × ½ in.
Collection of Mrs. Rita Rosen
Photo by Douglas Yaple

**Earrings #184**
2001
18K and 22K gold
1⅞ × 1 × ½ in.
Collection of Nancy Lee Worden
Photo by Douglas Yaple

**Earrings #193**
2002
18K and 22K gold
2¼ × 1⅛ × ¼ in.
Courtesy of Mobilia Gallery, Cambridge, Massachusetts
Photo by Douglas Yaple

**Earrings #199**
2009
18K and 22K gold
1¾ × 1 × ½ in.
Courtesy of Mobilia Gallery, Cambridge, Massachusetts
Photo by Douglas Yaple

**NECKPIECES**

**Neckpiece #5**
1969
Fine and sterling silver
8 × 6½ × 1 in.
Collection of the artist
Photo by Douglas Yaple

**Neckpiece #8**
1973
Fine silver, 12K gold filled wire, boar's tusks
10 × 5½ × 1½ in.
Collection of the artist
Photo by Douglas Yaple

**Neckpiece #9**
1973
Fine and sterling silver, 24K gold, 12K gold filled wire, pearls
12½ × 9½ × 7 in.
Collection of Museum of Fine Arts, Boston;
H. E. Bolles Fund and Anonymous gift
Photo © 2012 Museum of Fine Arts, Boston

**Neckpiece #13**
1974
Fine and sterling silver, 24K gold, 12K gold filled wire, ruby,
pearls
10 × 8½ × ½ in.
Collection of Florence Duhl Gallery
Photo by Douglas Yaple

**Neckpiece #17**
1974
Fine and sterling silver, garnets
10½ × 8½ × 1 in.
Collection of Pavia Kriegman
Photo by Douglas Yaple

**Neckpiece #18**
1974
Fine and sterling silver, 24K gold, and 12K gold filled wire
17 × 8 × ½ in.
Collection of Columbus Museum of Fine Art,
Curator's Committee for Decorative Arts Purchase Award
1975.039
Photo by Susan Dirk

**Neckpiece #19**
1975
Fine and sterling silver
11¼ × 6½ × ½ in.
Collection of Tacoma Art Museum, Gift of Flora Book,
1998.35.3A-C
Photo by Douglas Yaple

**Neckpiece #22**
1975
Fine and sterling silver
9 × 6 × 1 in.
Collection of Karen Johnson Boyd;
promised Gift to the Racine Art Museum
Photo by Douglas Yaple

**Neckpiece #26**
1976
Sterling silver and 14K gold
11¾ × 6⅜ x 1 in.
Yale University Art Gallery, Bradford, F. Swan,
B.A. 1929, Fund
Photo © 2012 Yale University Art Gallery

**Headpiece # 5**
1975
Fine and sterling silver
2½ × 6 × 7½ in.
Collection of the artist
Photo by Douglas Yaple

**RINGS**

**Cast ring**
1966
14K gold
⅞ × ⅞ × ⅞ in.
Collection of the artist
Photo by Douglas Yaple

**Ring #4**
1985
18K and 24K gold
1 × ¾ × ¾ in
Collection of the artist
Photo by Douglas Yaple

**Ring #60**
1994
18K and 22K gold
1 × 1⅛ × ⅞ in.
Collection of Susan C. Beech
Photo by Douglas Yaple

**Ring #90**
1998
18K and 22K gold
1⅜ × 1 × ¼ in.
Collection of the artist
Photo by Douglas Yaple

# BELLEVUE ARTS MUSEUM TRUSTEES AND STAFF

# ARTIST'S ACKNOWLEDGMENTS

How many people can one thank for a fulfilling career? Many more than I list here. But I must certainly start by thanking my parents who always encouraged my wish to study art. My teachers and others who inspired me, of course, Gary Turner who introduced me to negative space, Carlyle Smith who introduced me to making jewelry, John Paul Miller whose work made me believe living people could make timeless and beautiful goldwork, Hans Christensen who introduced me to metalsmithing, Richard Thomas who taught me there are many ways to skin a cat, Ruth Ginsberg in whose weaving class I started working with wire, Fred Fenster who taught me how to teach, and, most especially, my mentor Brent Kington, who gave me a model on which to build my career.

Over the years, many others have also helped me. Chunghi Choo, Elliott Pujol, and Eleanor Moty trusted me with their students; John Marshall brought me to Seattle to teach with him; Lynda Watson, Jane Gregorious, Jim Cotter, and Pete Jagoda welcomed me into the Summervail and Yuma Symposium communities, and all of SNAG has been a family to me over the years. Glenda Arentzin and Joy Rushfelt helped me navigate the American Crafts Council Board, and Jan Brooks's decades-long friendship and good council, especially in advising me to keep a collection of my own work—which made gathering the pieces for this exhibition so much easier—

was especially helpful. Collectors of my work have allowed me to move forward, and I am especially grateful to Bob Peterson whose purchase of my first major gold piece encouraged me to continue to work in gold. Daphne Farago and Donna Schneier have also been greatly supportive. Galleries have been my connection to collectors, and I thank my former gallerists Susan Cummins and Martha Schneider and especially my current galleries Facèré Jewelry Art and Mobilia.

Thanks to my husband TK for supporting my work and my penchant for collecting small things, to my mother-in-law, Shih-Chao Yang Hu for her love and compassion when I was so in need, and to my current partner, James A. Wallace, for making my life so much more interesting and for his patience while I undertook this new project, which has developed in more directions that I could ever have imagined.

This catalogue would not have been possible without the generous support from the Windgate Charitable Foundation for which I am truly grateful. I also wish to acknowledge the Flintridge Foundation and Washington State Artist Trust, as I have used their awards toward this publication. Thanks to Doug Yaple for his careful photographing of my work, to Jeannine Falino and Janet Koplos for their insightful essays, to Jeff Wincapaw and Ed Marquand of Marquand Books for their fine design, to my editor, Sigrid Asmus, and of course, the Bellevue Arts Museum and its staff, especially Director of Curatorial Affairs and Artistic Director Stefano Catalani and Registrar Ester Fajzi for making this project a reality.

This book is published in conjunction with the exhibition *Knitted, Knotted, Twisted & Twined: The Jewelry of Mary Lee Hu,* presented at Bellevue Arts Museum from February 7 through June 17, 2012.

All dimensions are given in inches, height precedes width precedes depth.

This exhibition and its accompanying publication have been made possible with generous support from Windgate Charitable Foundation.

This publication was made possible with additional support from: Susan C. Beech, Bernice Bennett, The Florence Duhl Gallery Collection, Susan and Lonnie Edelheit, Facèré Jewelry Art Gallery, Mary Jane Hashisaki, Mary Lee Hu, Jane Korman, Andy and Ginny Lewis, Nancy Abeles Marks, and Dorothy R. Saxe.

Director of Curatorial Affairs Stefano Catalani
Managing Director Larry Wright
Curated by Stefano Catalani
Editorial review by Sigrid Asmus

Published by Bellevue Arts Museum
www.bellevuearts.org

Produced by Marquand Books, Inc., Seattle
www.marquand.com

Design by Jeff Wincapaw
Typeset in Melior
Color Management by iocolor, Seattle
Printed and bound in China by C&C Offset Printing Co.

Distributed by University of Washington Press
www.washington.edu/uwpress

Photographer credits: All photographs by Douglas Yaple unless otherwise noted.

Carolyn DeMeritt, 118; Susan Dirk, 49, 65 (right); Arline Fisch, 13; Mary Lee Hu, 30, 108; Dana W. Lee, Mary's father, 27 (top); Metal Museum, Memphis, Tennessee, 14 (left); Museum of Fine Arts, Boston © 2012, 26 (right), 47, 66, 81; Richard Nicol, 17, 20, 79, 80, 82, 84 (top), 87, 89, 92; Smithsonian American Art Museum © 2012, 64; The Goldsmiths Company © 2012, 59 (left); The Metropolitan Museum of Art, Art Resource, NY, 61; The Newark Museum © 2011, 90; The Museum of Fine Arts, Houston, 14 (right), 18; Yale University © 2012, 12; Kim Zumwalt, 76; unknown photographers, 22, 26 (left), 28, 29.

Front cover: *Bracelet #60*, 1999, 18K and 22K gold, 3⅝ × 4 × 1⅝ in. Collection of Elise B. Michie
Frontispiece: *Choker #88*, 2005 18K and 22K gold, 8 × 8½ × ½ in. On loan from The Daphne Farago Collection, promised gift to the Museum of Fine Arts, Boston.
p. 128, Working drawing for *Neckpiece #17*, 1974; pencil, 8½ × 11 in. Collection of the artist.
p. 140, Working drawing for *Neckpiece #22*, 1975; pencil, 8½ × 11 in. Collection of the artist.
p. 141, Working drawing for *Neckpiece #26*, 1976; pencil, 8½ × 11 in. Collection of the artist.
p. 142, Preparatory sketches for *Turtle*, 1968; pen and ink, 8½ × 11 in. Collection of the artist.
p. 149, Preparatory sketches for earrings, ca. 1975; pencil, 8½ × 11 in. Collection of the artist.
Back cover: *Turtle*, 1968, Fine silver, 1½ × 5 × 7 in. Collection of the artist.

ISBN: 978-0-615-56156-1
Library of Congress Control Number: 2011946041

Bellevue Arts Museum illuminates and enriches the human spirit through art, craft and design.

Bellevue Arts Museum
510 Bellevue Way NE
Bellevue WA 98004
Phone: (425) 519-0770
Fax: (425) 637-1799

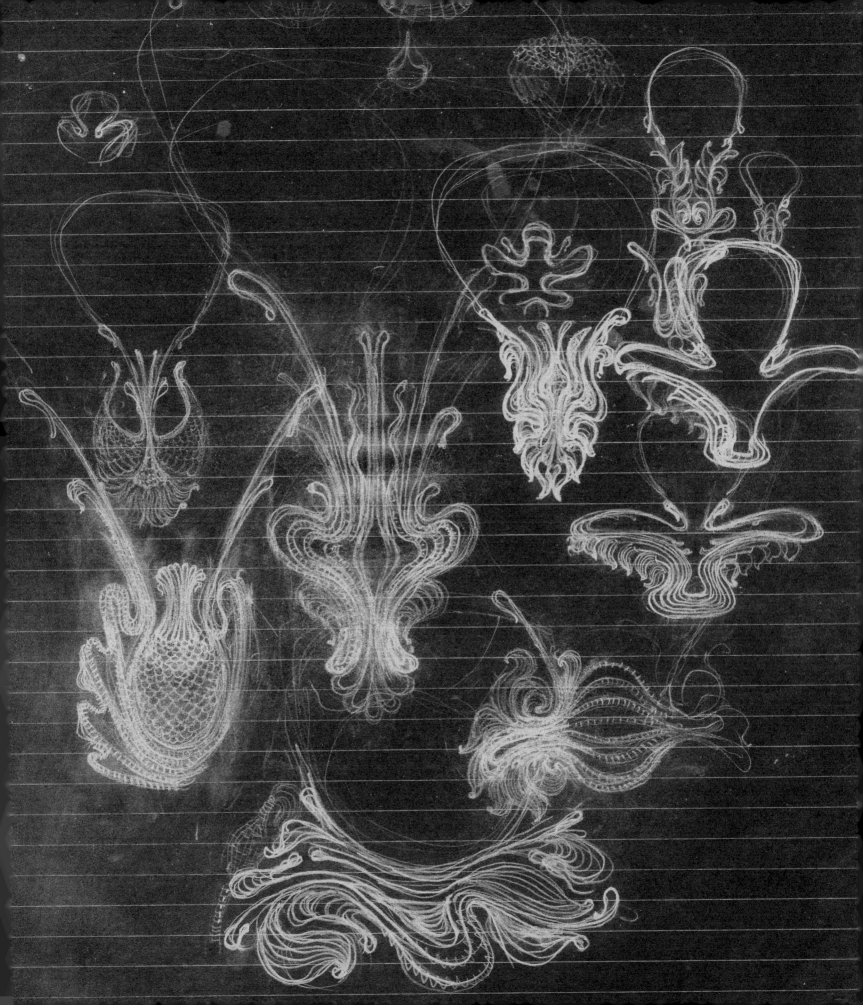

$13/32 \times 1/2$     tapering to $5/16 \times 13/32$

$8"$ pa

LAPIS
4 DWT 3.5 GRN
= 32.14 CARATS

18 4

#37 Aug 86

$-7 = 2B$

woven + junctures before sanding
& polishing 1·17·12 18+22

$-7·30$

$37$

$1·7$

$36 \wedge 42$

$30 \times 5$ lg